Museum Communication and Social Media

Visitor engagement and learning, outreach, and inclusion are concepts that have long dominated professional museum discourses. The recent rapid up-take of various forms of social media in many parts of the world, however, calls for a reformulation of familiar opportunities and obstacles in museum debates and practices. Young people, as both early adopters of digital forms of communication and latecomers to museums, increasingly figure as a key target group for many museums. This volume presents and discusses the most advanced research on the multiple ways in which social media operates to transform museum communications in countries as diverse as Australia, Denmark, Germany, Norway, the UK, and the United States. It examines the sociocultural contexts, organizational and education consequences, and methodological implications of these transformations.

Kirsten Drotner is Professor of Media Studies at the Institute of for the Study of Culture at the University of Southern Denmark and founding director of DREAM (Danish Research Centre on Education and Advanced Media Materials). Her recent books in English include *International Handbook of Children, Media and Culture* (2008, coeditor Sonia Livingstone) and *Digital Content Creation* (2010, coeditor Kim C. Schrøder).

Kim Christian Schrøder is Professor of Communication at the Department of Communication, Business and Information Technologies at Roskilde University, Denmark. His recent books in English include *Researching Audiences* (2003, coauthors Kirsten Drotner, Stephen Kline, Catherine Murray) and *Digital Content Creation* (2010, coeditor Kirsten Drotner).

Routledge Research in Museum Studies

Museum Communication and Social Media

The Connected Museum

**Edited by Kirsten Drotner and
Kim Christian Schrøder**

Routledge
Taylor & Francis Group

NEW YORK AND LONDON

First published 2013
by Routledge
711 Third Avenue, New York, NY 10017

Simultaneously published in the UK
by Routledge
2 Park Square, Milton Park, Abingdon, Oxon OX14 4RN

First issued in paperback 2017

*Routledge is an imprint of the Taylor & Francis
Group, an informa business*

Library of Congress Cataloging-in-Publication Data

Museum communication and social media : the connected museum / edited by
 Kirsten Drotner and Kim Christian Schrøder.
 pages cm. — (Routledge research in museum studies ; 6)
 "Simultaneously published in the UK"—Title page verso.
 Includes bibliographical references and index.
 1. Communication in museums. 2. Social media. 3. Museums—
Social aspects. 4. Museums—Public relations. I. Drotner, Kirsten.
II. Schrøder, Kim.
 AM125.M87 2013
 659.2'9069—dc23
 2012046148

ISBN 13: 978-0-8153-4682-1 (pbk)
ISBN 13: 978-0-415-83318-9 (hbk)

Typeset in Sabon
by Apex CoVantage, LLC

Contents

PART III
Facing Dilemmas, Designing Solutions

Figures

Acknowledgments

As editors, we would first like to thank our contributors for their inspiration and dedication to this project. From the outset Laura Stearns at Routledge supported our visions to provide theory-based empirical evidence to social media and museums—and to what at first glance may seem a slippery, transmuting phenomenon. The Danish Research Council for Strategic Research is thanked for support of the expert summit that gave an important impetus to the formation of the book. We would also like to thank our junior and more seasoned colleagues at the national research center DREAM: Danish research centre on education and advanced media materials, for their unfailing enthusiasm in supporting discussions on the sociality of museum communication and interaction.

Introduction
Museum Communication and Social Media
The Connected Museum

Kirsten Drotner and Kim Christian Schrøder

This book is about the relations between social media and museums. It is about ways in which museums use social media for communication and for forging new social connections; and it is about ways in which users of social media take up and appropriate these services for museum-related issues. This focus immediately raises a number of key questions, which the chapters to follow will discuss and exemplify. First, what are social media, and how are they used in museums? Second, which modes of museum communication do social media facilitate, and what are their constraints? Last, but not least, what forms of social connection can, and do, museums shape through the use of social media, and what are the implications of these connections for museum organization and practices on a daily basis?

As is indicated by these questions, this book is not about the use of technologies in museums and other heritage institutions. Rather it is about the manners and modes of communication and the types of social connection that result from the appropriation by museums of particular technologies and their affordances. While the impact of social media on heritage cultures has recently been explored as an example of so-called participatory cultures (Giaccardi, 2012), this book offers a systematic examination of the communicative options and obstacles that these services entail for museums. As such, the book follows a trend in recent museum studies where we see a move from treating the use of (digital) technologies as an "add on" to existing problematics and practices, on to more integrative approaches that see technologies as means of communication, interaction and exchange. Consider, for example, how book titles in museum studies are changing from what may be termed hyphenated titles ("museums and . . .") to titles that signify changing conceptions of what museums are and could be—such as the engaging museum (Black, 2005), the responsive museum (Reeve & Woollard, 2006), the digital museum (Din & Hecht, 2007) and the participatory museum (Simon, 2010), to name but a few.

While we realize the complexity in addressing the major questions noted above, we find it in order in this introduction to map some of the key markers of interest that will be taken up in a richer fashion in the ensuing chapters. These markers are primarily of a conceptual nature—identifying the widely

used, some would say misused, notion of social media; specifying aspects of museum studies where the appropriation of social media is of particular relevance; and discussing theoretical challenges in seeking to analyze and understand how social media catalyze transformations in the museum sector and, on a grander canvas, in the natural and cultural heritage domains.

SOCIAL MEDIA ARE NOT MEDIA

Some social media have gained phenomenal popularity over the last decade across many parts of the world, and across boundaries of class, gender and generation. Today, social media are used by individuals, by corporate firms and by the public sector. Social media are hyped as a victory of individual users over corporate power, and as the privileging of user-led, two-way, many-to-many, communication rather than mass mediated, one-way, one-to-many, communication. Conversely, social media are deplored as catalysts of performative egotism and as instigators of an everflowing deluge of banal communication.

In a less normative sense, the term social media encompasses a wide range of quite diverse Internet-based and mobile services that facilitate users' shaping and sharing of content and participation in online communities. Related terms are "the participative web" (OECD, 2007), web 2.0 (O'Reilly, 2005), and "the social web", a term attributed to the American media researcher Howard Rheingold (Quittner, 1996)—all indicating the main characteristics of these services. They are web-based and they accelerate easy user interaction in terms of networking, collaboration around affinities of interest, and sharing and commenting on self-created or self-edited content. As such, these services are not new media technologies, rather they expand and popularize potential uses inherent to the Internet. From a rather slow start in 1997 with the creation of social network sites (boyd & Ellison, 2007), social media currently include the following categories:

Blogs (short for weblogs) and micro-blogs. Online journals allowing users to create and share brief personal comments, for example to current topics, or short personal updates, and to see the contents posted by others. Usually displayed in reverse chronological order. The most popular micro-blog is Twitter, whose messages are called tweets

Media-sharing sites. Allow users to upload, rate and comment on visuals. Popular examples are YouTube (videos) and Flickr (still images)

Social bookmarking sites. Here users may organize and share links to websites. Popular examples are Delicious, Digg, and reddit

Social network sites (SNS). The most popular form of social media and often taken as their equivalent. SNS are defined as "web-based services that allow individuals to (1) construct a public or semi-public profile within a bounded system, (2) articulate a list of other users with whom they share a connection, and (3) view and traverse their list of connections and

those made by others within the system" (boyd & Ellison, 2007: n.p.). The most popular examples are Facebook and MySpace

Virtual world sites. Offer game-like environments for user interaction, for example through the construction and manipulation of avatars (a virtual representation of the user), and often as part of online gaming

Wikis. Sites for collective creation and modification of content. The most popular example is Wikipedia.

These categories constantly evolve and to some degree overlap. Twitter, for example, is both a micro-blogging service and an SNS; and users of the SNS Facebook can share photographs, just as users of the photo-sharing sites Flickr and Instagram can create lists of contacts. Despite their transmuting character, social media share modes of communication that provide a useful basis of definition. According to the Danish media researcher Stine Lomborg (2011, pp. 65–6), social media are a particular subgenre of digital media that may be characterized with a view to familiar communicative distinctions of sender, text, and user dimensions. Social media seem to de-institutionalize and de-professionalize the producer, or sender, dimension, since professional and ordinary voices have equal access to the often free software. In terms of the text dimension, social media serve to destabilize textual properties, through the options for collaborative content creation where focus is on the production of meaning (blogs, wikis, virtual worlds). In terms of the user dimension, social media privilege symmetrical communicative relations formed around what Lomborg terms "everyday togetherness and relationship maintenance among participants" (Lomborg, 2011, p. 65). This symmetricality is particularly evident with SNS, where focus is on the display and exchange of social contacts and contexts; and in content sharing sites where focus is on the exchange and use of texts, images and sound (for example Flickr and YouTube). All social media invite and allow easy interaction and exchange between one and a few users (some SNS); between a few and many users (some wikis); and between one and many users (blogs, content sharing sites).

MODES OF COMMUNICATION WITH SOCIAL MEDIA

Seen from a museum perspective, it is important to reach beyond the normative, and often binary, understanding of social media as a cause of celebration or concern, and to acknowledge the possibilities fashioned through their diversity of services and modes of communication. In terms of museum communication, social media fundamentally invite museums to re-orchestrate their communicative models away from a transmission model defined from an institutional perspective (what we want to impart) on to a user perspective (what people may want to know). This reorchestration lets museums begin to find new answers to what they communicate, how and to whom they communicate, where and when their communication takes

place, and, importantly, for what ends. In terms of the whats and hows of communication, social media catalyze modes of communication that consist less of unilateral communication processes (information about the museum and its objects), and are more concerned with interactive communication processes (involving external stakeholders as resources). In terms of the whos of communication, social media allow museums to redefine, and refine, their potential and actual partners of communication from being identified as audiences making sense of information and entertainment as defined by the museum, on to being cocreators of communicative processes. Centrally, social media serve to advance museum presence where and when actual and potential visitors and their communicative networks are already active ("find us on Twitter, YouTube, Facebook") rather than amassing all communicative efforts into the physical museum spaces and an informative homepage. Last, but not least, in answering all of these questions as to the what, how, who, when and where as they embark on more systematic appropriation of social media, museums are given a chance to redefine why they want to communicate in the first place, thereby also allowing, and demanding, a possible reformulation of their visions and goals: are museums institutions in their own right serving their own ends? Or are they a means to an ulterior end?

In exploring the options offered by social media, museums also need to understand the possible obstacles to their systematic uptake and uses. In doing so, it is useful to keep in mind that these services share important aspects with other web-based content of a digital nature. What gets uploaded, in principle has eternal life; it can be copied and shared, often without the producer knowing; and it may be accessed across boundaries of space and time. So, permanence, replicability and accessibility are important features of all digital content on the Internet. So is its commercial nature. Unlike popular conceptions of the democratic web, most Internet services are owned by large, corporate companies, and this is certainly true of the most popular social media. Much has been made of the possible complicity of major players in terms of censoring sites and content on the request of autocratic governments and regimes. Much less is made of the more mundane lack of transparency and accountability for end users in terms of data ownership and management. Likewise, owners' data mining for sale and their options of surveillance escape most ordinary users' attention. Such constraints question the apparent trends to de-institutionalize and de-professionalize the producer dimensions, noted above; and commercial ownership of social media may fundamentally challenge the aims of many museums, who are committed to being in the service of the public at large or of local communities, a commitment that may involve legal obligations, too. In adopting and advancing their use of social media, do museums at the same time, and perhaps unwittingly, compromise on their aims of public accountability, service to the community, and social inclusion? In attempting to answer such questions, museums would do well to keep in mind their legacies and draw on theoretical insights already gained in museum studies.

WHAT IS NEW WITH SOCIAL MEDIA IN MUSEUM STUDIES?

As noted, social media may serve to advance museums in their efforts to nurture stakeholder commitment, community involvement and public engagement and learning. Such efforts have been well documented by museums over the last two decades, just as the concepts that go along with these efforts have long dominated professional museum discourses particularly with respect to visitor studies (Black, 2005; Lang, Reeve & Woollard, 2006). It is important, however, to understand that social media potentially impact all of the five dimensions that make up a museum according to the standard definition offered by the statutes of the International Council of Museums (ICOM): acquisition, conservation, research, exhibition and communication (International Council of Museums, 2007). In terms of acquisition, museum professionals may adopt social media as means to extend their own communicative network and involve the public, for example in locating objects or trace routes of transmission from one location to another. In terms of conservation, social media are means of activating community resources, for example for collaborative classification thorough so-called folksonomy (a term conflating folk and taxonomy, see Wal, 2007; Peters, 2009). Categorization of content, for example through the use of wikis, may be considered part of conservation or research depending on the actual processes involved; and such overlaps indicate how the main dimensions of museum work have always fed into, and depended on, one another.

Certainly, in terms of the research dimension social media prompt museum researchers to invite ordinary people to become part of the research process in a manner similar to traditions developed in action research (Reason & Bradbury-Huang, 2008). So, museum researchers may request specialist online communities of, for example, bird watchers to co-collect data on migration patterns and comment on each other's observations and the researchers' work-in-progress; or local community groups are invited to co-create personal narratives as preparation for exhibitions (Turmin, 2012). Also, the presence of particular museums on social media may prompt unsolicited user questions and comments on museum content, thus offering potential new research perspectives if such questions and comments are taken up by the museum researchers and made part of ongoing dialogues.

Social media equally play into exhibition and curatorial practices. On site, museum professionals may for example invite visitors to rank or comment on objects and issues raised in actual exhibitions. If the visit is contextualized as part of a learning process, social media offer means for visitors to share their interactions with the learning objects and to network with each other, thus advancing what the American media researcher Henry Jenkins terms a participatory culture (Jenkins, Clinton, Purushotma, Robison, & Weigel, 2006). Crucially, these services may also play into visitors' self-directed visitor experiences, for example through tweets, thus serving to re-contextualize the museum experience. On line, both museum professionals and users may

appropriate social media as easy means of sharing, re-posting and bookmarking items and elements from particular exhibitions, processes that do not so much serve to re-contextualize the museum experience as to augment it.

As is indicated by the examples just listed of the impact of social media on research, museum communication may focus on research communication that is traditionally directed at more specialist publics; or it may focus on public communication about exhibitions and about the museum itself. In addition, museums naturally also perform internal communication that we will leave aside here. In museum studies, discourses on the uptake and use of social media are particularly vibrant in relation to public communication, and this focus is also reflected in the priorities of the present volume.

Public museum communication focuses on communication with actual and potential visitors, and this focus has gained increasing importance since the 1990s. The combined, and contentious, discourses on knowledge societies and experience economies, have served to put a premium on the communities that museums serve and are a part of. While knowledge society discourses tend to define these communities in terms of publics to be engaged for enlightenment and learning, the experience economy discourses tend to define the communities that museums may serve in terms of customers and stakeholders to be engaged for entertainment and enjoyment. In practical terms, most museums do not operate according to these discursive binaries for the simple reason that they are at pains to live up to ICOM's mission statement whereby museums should work for "the tangible and intangible heritage of humanity and its environment for the purposes of education, study and enjoyment" (International Council of Museums, 2007). Still, the two discourses are helpful when attempting to map how social media impact public communication at museums because they illuminate key dilemmas for museums in adopting these services.

Social media hold tremendous promise for museums in advancing visitor involvement and in forging engagement for potential visitors and society at large. Equally, these services offer their users new means of interaction, participation and networking with particular museums when and where users wish. These potentials primarily rest on the communicative modes that social media provide in terms of presence where people are already busy communicating; in terms of easy feedback from and dialogue with a diversity of social fora; and in terms of the options of collaboration and cocreation of content. Through these options museums may demonstrate their continued importance for people's understanding of themselves and the world and thereby strengthen their public connections and enduring social relevance.

Still, the uptake and use of social media by museums equally creates obstacles that throw into relief how communicative practices are by necessity implicated by larger socio-economic contexts. The commercial nature and communicative rationale of most social media with their quantitative rankings and evaluations play into existing pressures for museums to treat (potential) visitors as consumers of particular services and to think in terms

of visitor volume (clicks, "likes", unique views) as indicators of communica-tive success. Also, the user-orientation that comes with social media easily feeds into a corporate discourse that "the customer is always right", an as-sociation that in museums may imply decreasing legitimacy of professional insights in favour of visitor satisfaction. In addition, when museums apply social media they disband with authority over the data generated through in-teraction with users, a situation that museums have barely begun to address, but which is a core concern in many of the contributions to this volume (see for instance the chapters by Meecham and by Marselis & Schütze).

What has been more openly discussed by museum professionals are the challenges posed to organizational forms of authority within the museum. First, the adoption and development of social media by museums require substantial resources and a sustained effort. Dialogic connections with the public need to be maintained in order for non-professionals to engage in them and feel that they are being taken seriously. Allocation of such re-sources naturally invite discussions about organizational priorities, for ex-ample on the resources needed for public communication relative to those needed for the other dimensions of museum work that tend not to be associ-ated with the use of social media. Second, social media allow and demand other models of communication which challenge the established authority of voice for museums. How to monitor, manage and balance professional insight and public dialogue is clearly high on the agenda for many museums and mobilizes considerable professional efforts as several chapters in this volume demonstrate. Studying social media and museum communication equally challenges established professional boundaries whose connection requires innovative approaches.

STUDYING THE CONNECTED MUSEUM

As we have seen, social media are means of catalyzing more holistic ap-proaches to museum communication by taking visitor engagement and, on a grander canvas, community connections as baselines of communication, thereby challenging former distinctions between on site and online commu-nication, between actual and potential visitors. Analysing and attempting to understand such holistic approaches equally requires new forms of scien-tific collaboration and interaction, both between academic researchers and professional groups inside museum institutions, and between academic re-searchers from different disciplinary backgrounds. In general terms, schol-ars and practitioners in museum studies need to team up with colleagues from ICT and media studies; and important, if short-lived, fora of interac-tion across familiar disciplinary boundaries are offered at conferences such as Museums and the Web and MuseumNext with their related online fora, and Nodem (Network of Design and Digital Heritage). Moreover, in recent years interdisciplinary research groups and centres have emerged focusing

on the study of digital cultural and natural heritage, including the appropriation of social media in these sectors.

In more concrete terms, and acknowledging the key importance played by social media in innovating public communication at museums, the established traditions of visitor studies (Lang, Reeve & Woollard, 2006; Reussner, 2010) and audience studies (Alasuutari, 1999; Nightingale, 2011) could benefit from closer and more sustained dialogue. Originating in museum studies and media studies, respectively, both traditions share important theoretical and conceptual tenets, just as they share key methodological issues in terms of empirical analysis and interpretation. What would merit particular scrutiny is their shared focus on segmenting their objects of study—be they visitors or audiences—and their joint focus on analysing visiting/audiencing as contextualized practices of meaning-making that emerge through the interaction between particular contents and users. While these links still wait to be forged in more systematic ways, several chapters in this volume testify to their scholarly adoption and relevance en route to developing holistic research on the connected museum.

In general terms, the book aims to promote a much-needed dialogue within and across research traditions, and to develop dialogue between professional stakeholders such as museum researchers, educators, designers and policy makers.

Through these dialogues, we hope to begin to reorient academic and professional perspectives towards the communicative, rather than the technological, dimensions of social media for engagement, learning and inclusion. As the chapter authors will demonstrate, the use of social media for museum communication operates as a catalyst for this reorientation rather than as an entirely new discourse or set of practices.

THE ORGANIZATION OF THE BOOK

Most of the chapters that make up this book originate in a symposium hosted by the Danish Research Centre on Education and Advanced Media Materials (DREAM) in October 2010. All contributions have a strong visitor, or audience, orientation, and they could all subscribe to the assertion, reminiscent of the American semiotician Charles Peirce's definition of the sign, that 'connected' museums must transform themselves from "being about something to being for somebody" (Weil 1999, p. 229).

The composition of the book reflects three complementary perspectives on the connected museum as it addresses the communicative challenges of deploying digital and social media strategies.

Part One, *Framing the Dilemmas: Curation or Cocreation?*, comprises three chapters, each of which presents its own original take on the programmatic and conceptual discussion of how contemporary museums may position their communication strategies on a number of related continua—authority

versus playfulness, authentic versus surrogate experiences, the real versus the virtual and information versus entertainment.

In chapter 1, "The Trusted Artifice: Reconnecting with the Museum's Fictive Tradition Online", Ross Parry argues that in spite of their multifaceted ways of embarking on the affordances of digital technologies, museums are too concerned to preserve their curatorial and communicative chastity and authority when they take initiatives in the area of digital and social media. Locating his argument in a conceptual redefinition of the conventional—but, since postmodernist thought became hegemonic in cultural research, also highly controversial—core value of 'authenticity', and a repositioning of the virtual and the simulated as part of 'the real', Parry invites museums to more boldly embrace the fictive and illusory dimensions of web culture. Rather than being alien to the traditional curatorial and communicative practices of museums, Parry suggests, the pursuit of this path will serve to "reconnect with the playful, illustrative, fictive and theatrical qualities that have come to define the museum".

In chapter 2, "Social Work: Museums, Technology, and Material Culture", Pam Meecham discusses the manifold challenges which museums are encountering on their way to becoming more democratized, visitor-engaging cultural institutions. The chapter pinpoints a series of crucial issues in these developments, as they affect both the 'inside' of museums and art galleries (the breakdown of high/low; the ambiguity of the buzzword 'social'), and the consequences of 'externalizing' their collections when they go online and global (such as the issue of 'authentic' versus 'surrogate' art experiences). Fundamentally skeptical of the wholesale enthusiasm for the digital museum in many quarters, Meecham argues that we should seriously consider "what is sustained, gained and lost in translation when embodied communication becomes digital and divested of the physical social interaction that occurs in the gallery space that hosts the unique artifact". The argument is illustrated through several striking examples, notably the Google Art Project, and the *Van Gogh Alive* exhibition, which offers visitors an immersive, walk-through experience of the painter's works, as projected in fractured form on to the walls and floors of the hall accompanied by classical music. The chapter also discusses the possible implications of non-authentic, but engaging and entertaining art experiences for cognitive and affective learning.

Chapter 3 by Lynda Kelly, "The Connected Museum in the World of Social Media", is a strong programmatic statement for the determined visitor orientation of the connected museum, as it emphasizes the necessity to enable synergies between the material, online and mobile visitor experiences. Kelly is particularly keen to systematically explore the new forms of interaction between museums and their audiences, as the emergence and consolidation of social and mobile media offer applications which are revolutionizing the dialogical and participatory dimensions of the museum/audience nexus. Kelly argues programmatically that these ongoing transformations can be fruitfully grasped through six key themes, which collectively encapsulate the universe

of transformations, to do with mobility, the social dimension, digital learning, participation, combining tradition and innovation, and organizational change. To some extent Kelly sees these themes as a necessary survival strategy for museums, which increasingly depend on engaging a generation who not only embraces participatory forms of digital communication, but who expects them 24/7.

The second part of the volume, *Researching the Dilemmas: The Iterative Design/Research Process*, features three chapters which, while sharing the gamut of themes running through the book as a whole, emphasize the benefits to be reaped from developing exhibition designs in close collaboration between researchers and museum curators and designers, through research which illuminates usability as well as sense-making dimensions of digital applications.

The chapter by Randi Marselis and Laura Maria Schütze, " 'One Way to Holland': Migrant Heritage and Social Media", explores how museums of cultural history can deploy social media strategies in order to connect in a two-way communication process with source communities, such as ethnic minority, immigrant groups. The chapter relies on research conducted at the large, ethnographic Tropenmuseum and the minority Museum Maluku in the Netherlands, in connection with the development of an exhibition of historical photographs of post-World War II waves of immigration from the former Dutch colonies in Indonesia to the Netherlands. In addition to raising important questions to do with engagement strategies towards potential stakeholder groups, and the balancing of the museum's factual authority and credibility versus the authenticity of memory-based contributions from community members, the chapter also offers a word of caution against easy optimism with respect to social media solutions to sensitive communicative processes. In many cases contact between the museum and immigrant stakeholders was established through mainstream print media that disseminated information about the photo exhibition, and often individual immigrants were reluctant to post their information straight on to a Twitter or Facebook site, opting for less public channels such as good old email.

Karen Knutson's chapter, "Exploring Art and History at the Warhol Museum Using a Timeweb", discusses the design and evaluation of the Warhol Museum's Timeline project—an initiative which is educational in an innovative way that adopts a rhizomatic design framework, which enables the visitor's interest-driven exploration of Warhol's life and times. The chapter analyzes the lessons to be learned from launching an iterative design/research interactive online project in museums, and also addresses basic questions about how realistic our expectations should be of visitor involvement and participation, as well as the extent to which evaluative research on visitor experiences should ultimately determine the design solutions for interactive and social media applications. One significant empirical finding highlights the fact that the needs and experiences of onsite visitors and offline-online users may not be served by the same digital applications.

In their chapter about visitors as dialogue partners titled "Informal, Participatory Learning with Interactive Exhibit Settings and Online Services", Monika Hagedorn-Saupe, Lorenz Kampschulte, and Annette Noschka-Roos argue that museums are cultural hubs in modern society, and that therefore the four dimensions of cultural and science policy, democratic engagement, visitor participation and involvement (museums being *for* someone), and digital learning are essential parameters for conceptualizing museum exhibitions and museum communication in the years ahead. Within this framework the authors argue that one way to engage visitors is to build participatory strategies around delicate ethical, or even conflictual issues, which reside in many contemporary arenas, from nano-technology to Middle East archeology. They support their argument with visitor research at the Deutsches Museum about how museum visitors handled the hypothetical dilemmas of testing for genetic defects presented to them at a dialogical, interactive station. Their second example discusses research on user involvement in connection with the portal *Europeana*, an informative and collaborative access-point to digital cultural heritage in Europe.

The chapter by Glynda Hull and John Scott titled "Curating and Creating Online: Identity, Authorship and Viewing in a Digital Age", can be seen as a bridge between Part II and Part III, as it shares insights from a cross-cultural research project about young people's multimodal identity narratives in a social media universe, with the purpose of distilling from this project a strategy which will enable art museums to reconceptualize the dilemma of authority versus audience empowerment when they launch social media applications. Yet their analysis does not go so far as to suggest specific design solutions. The lessons learnt from the project opens up a best-of-both-worlds strategy, which both enables the museum to maintain the essentials of its archival and authorial curating role in communicating the voice of art history while simultaneously empowering visitors to curate their identity narratives from and into this history. Hull and Scott paint a rich picture of the bricolage-like creativity and curatorship practiced by the young participants in *Space2Cre8*, an international experimental social media universe with Facebook-like properties, and demonstrate how the multimodal meaning-making hybridizes the roles of author and recipient in a way that museums can appropriate to engage youth in meaningful participatory learning activities.

The book's third and final part, *Facing Dilemmas, Designing Solutions* brings together three chapters which highlight the development of creative digital solutions to handle the dilemmas of institutional control versus visitor empowerment and learning versus entertainment. In their chapter "Communication Interrupted: Textual Practices and Digital Interactives in Art Museums", Palmyre Pierroux and Sten Ludvigsen present ways of implementing multimodal and dialogical interactives that 'interrupt' and extend conventional communication practices in art museum gallery settings. Collaborating with interaction designers and education curators, Pierroux and Ludvigsen show how different art historical perspectives on Edvard Munch's art and its

contemporary context can be activated among visitors by different interactive stations, such as a game on a multi-touch table that invites collaborative reasoning, and visitors' photographic mimicking of the mood in a Munch self-portrait for sharing on the museum's Flickr stream. The chapter thus demonstrates how multimodal interactive devices and social media can be used in innovative ways to promote art historical learning through the playful engagement of young people's digital literacies.

The chapter by Mike Sharples, Elizabeth FitzGerald, Paul Mulholland and Robert Jones, "Weaving Location and Narrative for Mobile Guides", presents a number of ways in which different narrative models can be utilized creatively for the design of location-based mobile guides in museums, galleries and heritage sites. Starting from the premise that talk is the social glue of museum experiences, the authors believe that the digital applications developed to enrich the museum experience should support collaborative (social) rather than individual use to the greatest extent possible, in the interest of learning outcomes as well as enjoyment. They propose four narrative structures (tree-branching, braided multi-linear, rhizome, and diary) for mobile guides, which represent a continuum of different solutions to the Interactive Dilemma of balancing authors'/curators'/designers' control versus interactors'/visitors'/users' agency in the museum experience. The four narrative models are systematically illustrated through a rich array of case studies of recent mobile learning projects, whose learning strengths as well as weaknesses are frankly shared with the reader. Importantly, the authors stress that the narrative structure inherent to the museum space itself should be taken into account when superimposing a mobile narrative structure on the visitors' tour, so that the joint effect does not become one of disorientation and contradiction.

Finally, drawing on the case of an exhibition in an art museum by the Japanese artist Mariko Mori, Bruno Ingemann in a reflective essay, "New Voices in the Museum Space: An Essay on the Communicative Museum", discusses the ways in which user–visitors may be involved as participants in creating their own art experiences. Circling around the notion of *voice* Ingemann argues that art museums must give up some of their traditional scholarly and communicative authority in order to afford participatory experiences with dialogical qualities.

CONNECTING MUSEUMS—CONNECTING MUSEUM RESEARCH?

In this volume we have collected eleven research articles, which all contribute their insights to the illumination of the diverse ways in which museums—due to their adoption of a multitude of digital applications and social media forms—have become 'connected' to a range of internal and external stakeholders, and to the public world at large. The articles demonstrate the potential and realized benefits for museums which accrue

from the quantitative increase and the qualitative innovations of these connecting technologies in years to come.

As noted above, most of the research reported is indebted to theories and methodologies drawn to some extent from an interdisciplinary research environment. However, the extent to which research on museum visitors, audiences, users, and participants continues to live a life of disciplinary segregation is remarkable. This means that cross-references and inspirations from parallel research undertaken in neighboring fields such as not only media studies, but also arts disciplines like music studies, theatre studies and performance design are few and far between. It is clear, however, that much is to be gained, in terms of theoretical shortcuts and methodological sophistication, from developing and sustaining connections between museum studies and these neighboring research arenas. In the offing we are able to discern embryonic initiatives, in the form of bridge-building research networks, conference sessions and special issues of journals. These initiatives promise to cross-fertilize audience, reception, visitor, user and participant research on a new shared platform for exploring how institutional communicators across media and the arts may engage in dialogic and participatory processes of learning and entertainment. In a not too distant future, no doubt, we shall see the publication of books devoted to the synergetic outcomes of 'connected museum research'.

REFERENCES

Alasuutari, P. (Ed.). (1999). *Rethinking the media audience: The new agenda*. Thousand Oaks, CA: Sage.

Black, G. (2005). *The engaging museum: Developing museums for visitor involvement*. London: Routledge.

boyd, d. m., & Ellison, N. B. (2007). Social network sites: Definition, history, and scholarship. *Journal of Computer-Mediated Communication, 13*(1), 11. Retrieved from http://jcmc.indiana.edu/vol13/issue1/boyd.ellison.html

Din, H., & Hecht, P. (Eds.). (2007). *The digital museum: A think guide*. Washington, DC: American Association of Museums.

Giaccardi, E. (Ed.). (2012). *Heritage and social media: Understanding heritage in a participatory culture*. London: Routledge.

International Council of Museums (2007). What is a museum? Retrieved from http://icom.museum/the-vision/museum-definition/

Jenkins, H., Clinton, K., Purushotma, R., Robison, A. J., & Weigel, M. (2006). *Confronting the challenges of participatory culture: Media education for the 21st century*. Building the field of digital media and learning. The John D. and Catherine T. MacArthur Foundation. Retrieved from http://digitallearning.macfound.org/atf/cf/%7B7E45C7E0-A3E0-4B89-AC9C-E807E1B0AE4E%7D/JENKINS_WHITE_PAPER.PDF

Lang, C., Reeve, J., & Woollard, V. (Eds.). (2006). *The responsive museum: Working with audiences in the twenty-first century*. Farnham: Ashgate.

Lomborg, S. (2011). Social media as communicative genres. *MedieKultur, 51*, 55–71.

Nightingale, V. (Ed.). (2011). *The handbook of media audiences*. Chichester: Wiley-Blackwell.

OECD. (2007). *Participative web and user-created content: Web 2.0, wikis and social networking*. Retrieved from http://www.oecd.org/internet/interneteconomy/38393115.pdf generation of software. http://www.oreillynet.com/pub/au/27

Peters, I. (2009). *Folksonomies: Indexing and retrieval in Web 2.0*. Berlin: De Gruyter.

Quittner, J. (1996, November 25) Mr. Rheingold's neighborhood, *Time Magazine*.

Reason, P., & Bradbury-Huang, H. (Eds.). (2008). *The SAGE handbook of action research: Participative inquiry and practice* (2nd ed.). Thousand Oaks, CA: Sage.

Reussner, E.M. (2010). *Publikumsforschung für Museen: Internationale Erfolgsbeispiele*. Bielefeld: Transcript Verlag.

Turmin, N. (2012). *Self-representation and digital culture*. Basingstoke: Palgrave-Macmillan.

Wal, T.V. (2007, February 2). Folksonomy coinage and definition. *Folksonomy*. Retrieved from http://vanderwal.net/folksonomy.html

Weil, S. (1999). From being *about* something to being *for* somebody: The ongoing transformation of the American museum. *Daedalus, 128*(3), 229–258.

Part I
Framing the Dilemmas
Curation or Cocreation?

1 The Trusted Artifice

Reconnecting with the Museum's Fictive Tradition Online

Ross Parry

In her subtle and original study of storytelling within social media, British sociolinguist Ruth Page (2012, p. 168) draws attention to the part of 'identity play' online, and the consequences this has for the 'distrust of pseudo-authenticity'. Whilst highlighting the distinctive features of narrative genres within social media, Page's discourse analysis reveals patterns of 'deception through omission', 'concealed identity', and 'impersonation' (Page, 2012, pp. 169–177). What emerges is not only a complex layering of identities with these computer-mediated communications (a differentiation between transportable identities across media, discourse-based roles, and situated identities that individuals inscribe and invoke in their online contributions), but, to Page (2012, p. 166), the very boundaries between the 'fictional' and the 'real' are seen to have been 'complicated by the contemporary practice of self-representation in digital media'.

How should museums respond to such inaccuracies and fictions of the social web? Ought museums to sharply differentiate themselves, emphasizing in contrast their evidence and trustworthiness? Or should they instead adapt and tune (a little more) into some of the performative discourses of online culture? Is it the case that museums are more comfortable with the illusory when it is framed (and controllable) on-site, rather than online? Is it the case that museums are more willing to explore the artificial in the physical venue, yet more likely to revert to a more dominant information mode (of databases, evidence and linked data) on the web—and if so, why? This chapter considers the context of these questions, specifically the relationship between museums and the fictive dimension of the web. Drawing from philosophy, sociology, economics and media studies, my approach here will maintain the multidisciplinary perspective of this volume as a whole, and, in doing so, it will attest to museums studies' enduring profile as a subject characterized by its freedom of movement across traditional academic boundaries. The chapter underscores the volume's attempts to understand (and show the value of) the historical contexts of the web and social media alongside those of policy and technology. More specifically, the aim here is to contribute further to the efforts of other chapters to theorize and reflect more deeply on the idea of 'participation' (particularly through social

media) and its intellectual and practical consequences for museums and museum studies.

My discussion works from an assumption that the web's anomic quality (reformulating equations of trustworthiness, testing distinctions between professional and amateur, and relativizing what might be deemed authentic) still remains problematic for the museum. The consequence, it is suggested here, is that museums have remained mostly cautious on the web, reverting more often to traditional functions—predicated on their store of empirical evidence, and their academic credentials. Yet, this chapter will propose that, in doing so, museums have tended to resist a fictive tradition that has been a strong part of their (pre-web) history. This is a fictive tradition of using artifice (alongside the original), the illusory (amidst the evidenced), and make-believe (betwixt the authenticated). These are the well-established curatorial techniques of imitation (showing and using copies), illustration (conveying ideas without objects), immersion (framing concepts in theatrical and performative ways), and irony (speaking figuratively, or even presenting something knowingly wrong for effect). My discussion, therefore, will consider some of the consequences of museums reclaiming these approaches online. In particular, it is through proposing evolved notions of the authentic, the value of mimesis and the place of trust that my aim here is to set the terms of reference through which museums can become complicit with (rather than counter to) the performative aspects of the web, and how they can reconnect with the illusions that (off-line) have been such a defining part of museums' identity and role.

TRUST AND ACCURACY ON THE ANOMIC WEB

The web is still problematic, not just for museums, but for any traditional and established provider of rich content within the knowledge economy. Indeed, Drotner and Schrøder (2010, pp. 5–6) attest to the 'tensions' and 'dilemmas', the 'oppositions' and 'complexities' that still characterize our use and study of the web in these domains. It is evident that after two decades, the case may have been made for the museum online (Parry, 2010), yet the culture sector—like others around it—is still working through the consequences of being 'dramatically connected' (Shirky, 2008, p. 11). On a practical level, the museum today still wrestles with the managerial and design challenges of embedding and sustaining an online presence (De Niet, Heijmans & Verwayen, 2010; Ellis, 2011), as well as how to measure the extent and value of this provision (Finnis, Chan & Clements, 2011).

Yet, beneath these strategic challenges and policy choices, sits (according to some theses) a web medium that is, if not anomic (or normless) then at least in a state of fluidity where some essential principles for the museum related to trust, accuracy and artifice, all remain difficult to fix. An articulation of this sense of normlessness can be found in the work of Russell Hardin. Writing from an American moral and political philosophy perspective,

Hardin (2008, p. 106) leaves us doubting whether 'standard vocabulary for describing and explaining human relationships' fits our behavior online. It is a reading of the web as something 'lawless' and 'normless'. From a vantage point in cultural sociology, writers such as Martin Hand (2008), likewise, have highlighted the anxieties that flow from an atomized and citizen-consumer world online of 'unparalleled but ultimately meaningless choice' (p. 18). And it is here that we see Shirky (2008) describing social organizations and relationships 'radically altered' (p. 21) by the web. In a book focused upon 'new kinds of group-forming', and built around a ladder of action, enabled by social media tools ('sharing', 'co-operation' and 'collective action'), the language of Shirky's thesis might be unsettling for established institutions such as museums (Shirky, 2008, pp. 17, 49). His is a web in which barriers to collective action have 'collapsed', and in which the work of noninstitutional groups consequently presents 'a profound challenge to the status quo' (Shirky, 2008, pp. 22, 48).

With this absence and ambiguity around norms (this anomic quality) on the web, equations around 'trust' are particularly vulnerable to renegotiation and reformulation. The web (particularly within its most recent participatory, aggregated, syndicated formation) poses museums and museum users alike with a series of problems about how trust works and what is trustworthy online. When all users of the web are essentially authors and creators (collectors and exhibitors), the indices for trustworthiness need revisiting. 'When we are all authors', British commentator Andrew Keen (2011, p. 65) challenges, if somewhat mischievously, 'and some of us are writing fiction, whom can we trust?' The web, in short, has become a 'peculiarly extreme context' for developing trust (Hardin, 2008, p. 98). In more general terms, 'trust' is a notoriously difficult concept to engage with and to discuss, and the academic literature around it has thought to be 'confused'—even by some of its own scholars (Hardin, 2008, p. 17). Writing, for instance, from the perspective of management studies, McKnight and Chervany (2001) have acknowledged how researchers have 'remarked and recoiled' (p. 27) at the confusion that sits within the literature within trust. They see this in part as a consequence of 'narrow intra-disciplinary research definitions' of trust and the multiple meanings that the word carries (McKnight & Chervany, 2001, p. 27). Despite these conflations, 'trust research' does, nonetheless, alert us usefully to the critical role of trust for the success of a computer-supported society (Falcone and Castelfranchi, 2001, p. 55). Specifically, Falcone and Castelfranchi identify 'people's trust in the computational infrastructure; people's trust in potential partners, information sources, data, mediating agents [. . .]; and agents' trust in other agents and processes' (pp. 55–56), as some of the key sites at which trust is important within digital and network settings. More crucially, trust research tells us that the 'new scenarios' for trusting online will transfigure our older frames of reference (Falcone, Singh & Tan, 2001, p. 1). For museums, this can mean entering into what (some) trust researchers would call new 'trust-based behaviour',

such as cooperation, information sharing, informal agreement (McKnight & Chervany, 2001, pp. 34–35). Some of the more recent considerations within digital heritage of museums building relationships within network settings, whether on the ethics of social media (Parry, 2011) or the dynamics of participation and cooperation (Simon, 2010), are representative of this need to confront new trust-based behavior online. And as much as they might (excitingly) be indicative of a new wave of user-focused—rather than technology-focused—digital heritage writing, so they might also alert us to where a site of tension for the museum online remains.

Alongside this transfiguration of trust-based behavior online comes a series of other challenges related to accuracy on the web. Specifically, this is the issue of differentiating (and preserving) the accurate online. One of the consequences of 'mass self-communication' (Castells, 2009, p. 4), is what the British commentator Andrew Keen (2011) has—not uncontroversially—described as the web 'shattering the world into a billion personalised truths, each seemingly equally valid and worthwhile' (p. 17). Keen's diatribe is against what he sees as a 'shamelessness' in our 'filter-free Web 2.0 world' (Keen, 2011, pp. 3, 81). Keen (2011, p. 27) protests that 'the cult of the amateur has made it increasingly difficult to determine the difference between reader and writer, between artists and spin doctor, between art and advertisement, between amateur and expert'. The suggestion is that in such a situation (the situation of the empowered Web 2.0 prosumer), the quality and reliability of the information we receive declines, and that 'amateurism, rather than expertise, is celebrated, even revered' (Keen, 2011, p. 37). In later editions of his work, Keen is obliging in presenting to his readers some of the criticisms (including his own self-criticism) of this thesis, namely: favoring traditional mainstream media; overlooking the shortcomings of some broadcasters' output; not acknowledging the high quality that can be found in the blogosphere; and neglecting the positive catalytic effect that user-generated content has had on mainstream media. Nonetheless, confrontationally, Keen (2011) concludes that, 'the real consequence of the Web 2.0 revolution is less culture, less reliable news, and a chaos of useless information' (p. 16). Whether we agree with these shortcomings or not (and whether we may go even further, as some have, in suggesting that Keen's thesis is 'error ridden, simplistic' and 'inaccurate'), his work at least turns our head to the question of what happens to accuracy in the era of Web 2.0 (Keen, 2011, p. xvi). This issue of an increasing quantity of (not always verifiable) information online (Hand 2008, p. 3), demands museums to ask themselves, as Shirky (2008) puts it, '[w]hat happens when there's nothing unique about publishing anymore, because users can do it for themselves' (pp. 60–61). In short, what happens to institutions such as the museum when there is an information surfeit, and the act of publication is no longer special?

These issues of trust and accuracy have, therefore, remained troublesome for the museum online. The idea of a virtual museum may now be orthodox, and the affiliation between the museum and the web far from remarkable.

And yet, as these debates (and their inevitable associated discussions regarding the visit event) have matured and subsided, the rise of the social web and the machine-processable web has brought questions on trustworthiness and accuracy to the fore. There is, however, a third troublesome characteristic of the web (regarding authenticity) that for museums, again, appears to persist. The web still vexes the academy on how (if at all) it can harbor something called the authentic—a nontrivial point for an institution such as the museum for which the framing of authenticity has been quintessential. British museologist David Phillips (1997) expresses this eloquently as the 'relentless material momentum' of the apparatus of display ('the cases and plinths, the hanging systems and practices, the lack of cash to change it all when it comes to installation'), that contrive a tradition of what the culture of the authentic is, and how it is allowed to perpetuate in museums (p. 201). Debates on this subject have extended from whether authenticity on the web is almost impossible to verify (Keen, 2011, p. 25), to whether even the concept of originality itself is anachronistic in the digital age (Hand, 2008, p. 3). In this regard, these 'unresolved issues of [. . .] authenticity' (Hand, 2008, p. 1) within digital culture have still not shaken free from earlier generations of critical thinking about new media. Preoccupations and entanglements over an opposition between 'real' and 'artificial' are testimony to a discourse of media theory still affected by writings from the pre-web era such as that by French cultural theorist Jean Baudrillard. Web content can all too reflexively be viewed through Baudrillard's prism, the pessimistic implication of which is the online object becoming viewed as a 'simulation' and the user confronted with hyperreality—'a world of self-referential signs' (Poster, 1988, p. 6). This version of media theory does not allow the online to represent a physical reality. Instead, the digital museum, the digital object and the digital record, all become 'perfect simulacra forever radiant with their own fascination' (Baudrillard, 1988, p. 169). Mark Poster (1988) helps us to see how at this point we lose both artifice and realness online, how the simulation is 'different from a fiction or lie in that it not only presents an absence as a presence, the imaginary as the real, it also undermines any contrast to the real, absorbing the real within itself' (p. 6). In other words, when the web is viewed from a Baudrillardian perspective, the online cannot be imagery, as the hyperreal is not a representation of the 'real'—the 'Illusion is no longer possible', Baudrillard (1988) tells us, 'because the real is no longer possible' (p. 177). But, likewise, the online hyperreal is not part of the real, as there is no real. Characteristically, Baudrillard (1988) bleakly refers to how 'none of our societies know how to manage their mourning of the real' (p. 181). In short, it is as if he does not allow our museums online to be images of the on-site museum, nor valid realities in their own right. Though perhaps in its most pessimistic form, and, of course, only one possible reading of new media, the Baudrillardian thesis, nonetheless, typifies the austerity readings of the digital that still have currency today.

Thirty years on, we are still dealing with the fallout from Baudrillard's essay on 'Simulacra and Simulations', and the terms of reference and rules

of engagement it appeared to set for commentators (including those on digital heritage) to follow (Thomas & Mintz, 1998; Witcomb, 2003, p. 140). If seen from within this discourse, the web, consequently, still presents itself as troublesome for the museum—an institution whose central business has been negotiating realness.

THE INFORMATIONAL MUSEUM AS RESPONSE
TO THE ANOMIC WEB

The proposition made here, therefore, is that despite a maturing of digital heritage discussions around museums online, and having traversed the initial debates around the function and value of the museum online, the web (especially the social web) is still not unproblematic for museums. Specifically, it is suggested here that ambiguities around the norms of the web, confusions around the equations of trust and trustworthiness, and struggles around the place (or even the relevance) of authenticity, all remain for the museum. The response of the museum sector to a web landscape (characterized by its disputed expertise, contested veracity and prevalent artifice) has been on the whole cautious. Comparative to the rest of the fictive, ironic, illusory web, museums online have (performatively speaking) been relatively conservative. At both a national and international level, the default mode for museums (particularly with high-profile strategies online) has in the main, been informational, emphasizing their veracity. Landmark global projects, such as the Google 'Art Project', have been at pains to position the museum as a trustworthy provider of what is trailed as 'expert information'. The centerpiece of the collaborative project is the realism of the 'virtual tour' of the physical gallery spaces within the participating institutions. In each case, the user is reassured by the producers of the attentive accuracy of the art objects on display down to a 'brushstroke level detail' (Scott, 2011; Google, 2012). Likewise, in major projects such as 'Europeana', the strategic emphasis has been on the aggregation and distribution of trusted heritage information. Its strategic plan tells us that 'Europeana will become the trusted source of Europe's collective memory' (European, 2011, p. 4). Back in its original proposal documentation, we see a primary business case predicated upon users gaining 'integrated access to cultural heritage digital items via the Internet' (EDLnet, 2007, p. 4). Aiming to overcome what was then considered a landscape of 'complexity and fragmentation' in the digital heritage information provision, where collaboration between member states had been 'ad hoc', the project's initial focus was on building solutions to the interoperability of the cultural content (EDLnet, 2007, p. 2). Europeana was a practical response to the European Commission's plan (in 2006) to promote digital access to Europe's heritage through the creation of a 'single access point to cultural content' (EDLnet, 2007, p. 2). What we see today in Europeana (self-styled as 'a vast resource of organised and trustworthy

knowledge'), though outstanding in its scale and rigor, is an encapsulation of museums' default setting online—the emphasis on being positioned as a trusted and information-orientated service (Europeana, 2011, p. 4). To take a national level example, in a project such as the high-profile 'National Museums Online Learning Project' (NMOLP) in the UK (which ran 2006–2009), we note a creative vision for an online presence compromised by a caution (from the institutions themselves and the learning partners they were serving) as they strove to develop innovative online learning environments for school children ('WebQuests') and lifelong learners ('Creative Spaces') (Bayne, Martin, Ross & Williamson, 2009, p. 4). Undoubtedly impressive in its achievement in bringing nine national museums together on one substantial piece of work (opening the way, promisingly, for future permeability across institutions and collections management systems), in its final self-evaluation, the NMOLP nonetheless was seen to have presented users with an 'inflexibility', 'constraint' and 'closure' in its structure (Bayne, Martin, Ross & Williamson, 2009, p. 4).

Owing to their scale, scope and levels of funding, the Google 'Art Project', 'Europeana' and the 'NMOLP' are in some respects atypical digital heritage projects. Yet they are some of the most visible. Moreover, they exemplify the way in which museums have set themselves as the trusted source of online heritage information. In these most conspicuous (and most abundantly endowed) of digital heritage projects online, the museum consolidates its position as database—whether of object records, gallery images or learning resources. In this way, the museum online typically creates what trust theory would see as 'Institution-based Trust' (McKnight & Chervany, 2001, p. 37). This is a construct from a sociological view that 'people can rely on others because of structures, situations, or rules that provide assurances that things will go well' (McKnight & Chervany, 2001, p. 37). In their quality assurance, ethical awareness, rigor and emphasis on the credentials and expertise of the participating organizations, the Art Project, Europeana and NMOLP—like so much of museums' online provision—foreground these 'protective structures' (McKnight & Chervany, 2001, p. 37). Together these academic credentials, ethical frameworks, social responsibility, and empirical evidence create a matrix of trust, in which museums online are habitually located. To be a 'museum' online is to be accurate, fair and evidenced—to be a bastion of the authentic and the genuine. The result is that museums strive to be accurate and authoritative on the web. It is through this highly evidenced, informational and controlled presence that museums have traditionally sought to be both trusted and differentiated online.

BRINGING THE FICTIVE TRADITION TO THE MUSEUM ONLINE

And yet, there is something curious (an irony even) about this posture that museums have typically taken online when confronted with the ambiguities

of trust and accuracy that are seen to pervade the anomic web. In adopting this heavily information-orientated approach, replete with its protective and trust-ensuring structures, the museum might be seen to be denying what has historically been such a central part of its identity and approach—namely, its fictive tradition. After all, back in the space of the gallery, the museum has long enjoyed traditions of using artifice, the illusory and the techniques of make-believe. The museum on-site has never been a purely information-orientated medium. Its authenticated collections, corroborated evidence, and its expert theses have all, of course, always been fundamental to what a museum is (Knell, 2000; Taquet, 2007). But just as critical to its interpretive approaches and visitor experiences has been its ability to convey concepts metaphorically, theatrically and illustratively. Since the museum's inception, it has been commonplace for a replica and reconstruction to hold value, without prejudice (Pearce, 2007, pp. 19–22). It is conventional for an exhibition to simulate a historic, removed or imagined space, where a visitor is expected to suspend disbelief (Crawley, 2012; Lord, 2005). It is orthodox for a concept or theory to be communicated through illustration, demonstration and 'simulation' rather than primary material evidence (Toon, 2005). And it is routine for narratives to be expressed through fictional persona, figurative language or even as a 'pastiche' of reality (Knell, 2007, p. 26). These illusory techniques of imitation, immersion, illustration and irony have all been just as vital to the identity and role of the museum. The metaphorical, theatrical and the fictional have been as complementary (and not necessarily oppositional) to the museum as the academic, accurate and the evidential. This fictive tradition is (and perhaps has always been) reconciled within and instrumental to the discourse of trust and authenticity in the museum. And yet, significantly, it is these very same traditions that we so frequently see the museum resisting online. It is as if when confronted with the fictions and anomic qualities of the web, the museum chooses to resist its own fictive traditions—choosing instead to emphasize the parts of its curatorial and interpretive tradition that speaks more directly to a discourse of certainty.

In practical terms, therefore, what would it take to help the museum develop online this confidence with the fictive? What are some of the ways of thinking that can help the museum to reconcile its (at present) unbalanced use of the fictive on and off the web?

NEW REALISM

There are two concepts that appear particularly useful here when reasoning the use of the fictive online: Evolved notions of the authentic within a discourse of 'new realism'; and a reclaiming of the value of mimetic representation. Let us first consider, then, this idea of authenticity and 'new realism'—specifically as a framework for museums embracing the fictive online.

Contemporary museology is providing us with new definitions of the 'authentic' that shift its definition away from an emphasis on the genuine and the original, and more toward terms such as *honesty* and *humanity* (Golding, 2009; Nightingale & Sandell, 2012). In this frame of reference, authenticity becomes much more to do with intent and impact, and much less to do with provenance and authorship alone. At first sight, ideas of the 'authentic' might seem anachronistic. Phillips indeed helps us to historicize notions of the 'authentic', revealing what he calls some of the 'transient social contrivances' that have formed it, elements that may now appear as 'anachronistic leftovers in the modern world' (Phillips, 1997, p. 2). And yet, just as the notion of the authentic might from some vantage points have been heavily criticized (Fleming, 2009), considered 'a relic of a bygone age' and 'a naiveté' (Hand, 2008, p. 140), and something the museum ought to 'escape' (Phillips, 1997, p. 4), the concept still, evidently, has traction and weight. Canadian philosopher Charles Taylor (1999), for instance, reassures us that the different 'branches' (philosophical, artistic) that have created our culture of 'authenticity' are many—and 'some strain within the very idea of authenticity', and they 'pull us in more than one direction' (Taylor, 1999, p. 25). But in doing so, Taylor allows us to be troubled—whilst not averse to—the contradictory complexity of 'authenticity'. Similarly, writing as a professor of political science, American Marshall Berman (1980) provides a Marxist reading of contemporary culture and society in which the authentic is used, essentially, as the concept of 'being and knowing oneself'. Like Taylor, Berman (1980) locates 'authenticity' historically, as 'one of the deepest and most pervasive themes of the Romantic Age' (p. ix), connecting it, as Fleming (2009) does, to neo-romantic concepts of the individual as 'the unique site of immediate experience' (p. 27). Once understood in this wider meaning and deeper historical context, Taylor and Berman both give us cause to hold on to a notion of the authentic. In theses such as these (and perhaps more it seems within philosophy and political thought, rather than museology), 'authenticity' is considered much more as an ideal, and not just a proved accuracy. In contrast to the traditional parlance of curatorship, from these perspectives we are reminded of a definition of authenticity that is much more about being true to oneself (one's own moral choices), and about an ideal of human potential. Therefore, to synonymize the authentic simply with 'original' or 'accurate' is to limit the term to just one of its many layers and meanings, and in doing so askew and inhibit where authenticity may reside and how it might manifest itself. We might say, therefore, that with a more circumspect usage of the term, an authentic museum object is not just the original, but an instantiation of a thing (physical or digital or otherwise) that can evoke in the user or visitor a deeper sense of human experience and potentiality. Authenticity may at times be about provenance, but it is not dependent upon it. Sometimes the authenticity of the object for the user–visitor may come from the origins or the originality of the thing being encountered. But equally, it may be the idea of these origins, if not

even another quality or referent of the thing that carries its authenticity for the user–visitor. Consider, for instance, the visitor who confronts Cetiosaurus axoniensis (at New Walk Museum and Art Gallery, in Leiceseter, in the UK), who is presented with a full-size modeled reconstruction—rather than a complete original skeleton of this sauropod dinosaur. The authenticity might be seen to be not only in the knowledge that a small number of the bones are original, and that others (up to 40%) do exist but are elsewhere (in the museum stores) and not displayed, but also in the physical encounter of this resemblance of an animal no longer extant that fills the gallery space dwarfing the visitor. Likewise, the authenticity of Brunel's SS Great Britain (in Bristol, in the UK) is in the visitor occupying the space where the ship was made (and returned at the end of its eventful life) and where a large part of its iron hull still survives—even though the majority of what is seen and experienced by the visitor is but a set, a staged (although meticulously evidenced) representation of a possible interior of the ship. In both cases—with the ship and the dinosaur—the visitor, we might say, has an authentic experience even though what he or she sees is substantially artificial.

From this perspective (unlike being anchored to notions of provenance and 'originality'), the notion of authenticity might seem, as Taylor (1999) puts it, 'an ideal worth espousing' (p. 73). Indeed, Taylor gives us a way of seeing the relevance of authenticity to modern cultural and sociological discourse. Showing it as a multilayered, contested and historically dependent concept, he gives us a way to see the authentic not just as that which is technocratically certain and verifiable, nor just that which is personally valid, but—a third way—an authenticity that is about ideals. Taylor concedes the fragility of this concept of authenticity within modern society, and he may in many respects be retrieving the notion of the authentic as an idea more for sociological debate. But to him the authentic may be a problem—but a problem worth remembering. In this regard, Taylor's apology for authenticity connects with the writing around what might be called 'new realism'. It is a line of thought that suggests the authentic becomes more valuable within the 'flattened world' of postmodernism, where, as Taylor (1999) puts it, 'the horizons of meaning become fainter' (p. 69); 'We face a continuing struggle', he concludes, 'to realise higher and fuller modes of authenticity against the resistance of the flatter and shallower forms' (Taylor, 1999, p. 94). This stance, of 'new realism', has been considered a pioneering route ('rooted in a larger reality') out of the 'paralysis' of postmodernism (Boyle, 2003, p. 294). David Boyle's perspective, from new economics, provides the rallying call for what authenticity can mean within the discourse and practice of the 'new realists':

> We have lived with postmodernism for so long now that it's hard to imagine any other attitude to the world beyond the clever, cynical, clip way we see it these days—where everything from history to physics is relative, where everything gives rise at best to a world weary smirk. Yet

I believe the New Realists and their demand for authenticity are the first glimpse of what comes after the demise of postmodernism, and how the next generation will live their lives'. (Boyle, 2003, p. 292)

Boyle shines a light on what, from a museological perspective, has elsewhere been exposed as postmodernism's 'doubting subjectivity' and 'penetratingly cynical mode of thinking' (Knell, 2007, p. 3). What writers such as these begin to give us is a way of reclaiming a notion of the authentic after postmodernity. It is a shift away from the primacy of *authentic object* (the object that is original, accurate, part of an empirical paradigm of verification), to the primacy of *authentic experience* (an object that is still present and vital but which catalyzes a revealing of human potential). This is authenticity as 'the truth of oneself' (Fleming, 2009, p. 1), what Phillips encapsulates as 'not the authenticity of objects, but the kind of personal authenticity' (Phillips, 1997, p. 215). This new realist perspective (after postmodernism), provides a means by which the museum might reconcile authenticity with the anomic web—as it is experienced through instantiations of things (rather than the physical presence of singular objects) that becomes central. From this new realist perspective, the museum can creatively explore the web as a medium for *authentic experience*—and, in doing so, more confidently draw upon the fictive tradition and culture of make-believe that has served it so well in the physical venue.

MIMESIS

The second (and related) concept that might help the museum in its reevaluation of its informational stance on the web, is mimesis. If 'new realism' and the notion of *authentic experience* might give the museum the permission to be fictive on the web, so mimesis (and a reappraisal of the virtual) might offer the museum the framework to trust in images and representations online. From this perspective, rather than distrusting the illusions and representations of the web, the illusory and fictive online can be valuable (cathartic even) for the very reason that they are understood and recognized as representations. However, such a perspective requires a challenge to some entrenched orthodoxies within some (particularly Western) philosophical traditions. Particularly, after Plato, there can still be an implicit hierarchy of ways of seeing and ways of knowing, if not a mistrust of images. In Part VII of *The Republic*, the 'Simile of the Cave' serves as a powerful means to illustrate an aspect of Plato's greater argumentation to describe (and justify) the role of the Philosopher Ruler (Plato, 1987, p. 326). In the dialogue, one of Plato's interlocutors asks us to

Imagine an underground chamber like a cave, with a long entrance open to the daylight and as wide as the cave. In this chamber are men

who have been prisoners there since they were children, their legs and necks being so fastened that they can only look straight ahead of them and cannot turn their heads. Some way off, behind and higher up, a fire is burning, and between the fire and the prisoners and above them runs a road, in front of which a curtain-wall has been built, like the screen at puppet shows between the operators and their audience, above which they show their puppets. (Plato, 1987, p. 317)

In this allegory, the tied prisoner in the cave represents 'illusion' (*eikasia*) confronted as he or she is with what Plato calls 'secondhand impressions and opinions'. The freed prisoner who can begin to comprehend the projection at play in the cave represents the commonsense belief (*pistis*) of the natural sciences. Those that can see the shadows in the world outside the cave represent 'reason' (*diamoia*) and deduction of mathematics. Whilst, finally, those that are able to see the whole construct, including the world outside of the cave represent the intelligence (*noēsis*) of dialectic philosophy (Plato, 1987, p. 311). Plato's allegory reminds us vividly of the hierarchy implicit within Western traditions of thought, a hierarchy that can place representation lowest of all, as the (misleading) interpretation of a shadow of a higher thing, and in contrast to the 'real'. It is a distinction and a hierarchy that Plato returns to in his illustration of 'The Divided Line' (again in Part VII of *The Republic*), where he distinguishes sharply between 'objects' that are physical things ('originals' that are 'genuine') and 'illusions' that are 'shadows' and 'images' (Plato, 1987: 312–313). The consequence of this Platonic legacy runs deep in traditions of museology. It has meant that however rich the role play, however imaginative the live interpretation, however the interactive, it is the object (the genuine, original, actual accessioned thing) that has tended to be located higher in the hierarchy (Jackson and Kidd, 2010). The modern curatorial tradition is one that has continued to accommodate the distinctions of Plato's 'cave'—especially its unease with image and illusion.

Challenging this mistrust of the image are the traditions such as 'mimesis' (that which is edifyingly imitative) and 'the virtual' (that which is ideally real). These are both traditions that view simulations and resemblances as valid—if not vital—dimensions of human culture. In each case, the viewer can imagine the real, whilst acknowledging the fictive nature of what is being presented. Rob Shields is particularly helpful in extracting this history of virtuality and the mimetic. Alerting us to its pre-digital significance, his work allows us to see memories and dreams as part of 'the virtual', with rituals as one way in which cultures have managed 'virtualities', integrating them, as he explains, into life 'as carnivals, sacred times and places, and mysteries' (Shields, 2003, pp. 43–44). Yet as well as allowing us to historicize the virtual (and to decouple it from exclusively digital meanings and connotations), Shields also helps us to acknowledge the idea's enduring purpose and value. This is a conception of the virtual as 'another register or manifestation of the real', and not just 'an incomplete imitation of the

real' (Shields, 2003, p. 25). He builds a typography that persuades us to differentiate the virtual from the material, the mathematical and the abstract (Shields, 2003, p. 32). The virtual, therefore, is not necessarily a digital place (although it may be), nor is it just a surrogate of a higher reality. Instead, 'the virtual', Shields suggests, 'is ideal but not abstract, real but not actual' (Shields, 2003, p. 43). It is not the actually real, the ideal possible (the abstract), or the actual possible (the probable). It is the place in our cultures for the 'ideal-real' (Shields, 2003, p. 29). Crucially, neither the 'virtual' (the 'ideal-real', neither abstract nor actual), and the 'mimetic' (the knowingly and edifyingly representational), are deferential to a 'sovereign reality' (Shields, 2003, p. 48). To inhabit the virtual and to represent mimetically is not to be alternative or subordinate to 'the real'. The virtual and the mimetic are part of 'the real'.

It is in this way that virtuality and mimesis can contribute to the museum's reasoning in accommodating (and appreciating) the illusory and fictive qualities of the web. When the web is viewed as 'virtual' and its content 'mimetic', then the museum has the rationale for occupying that space, and the reassurance for producing content that is knowingly artificial. Conceiving the web as the virtual, and the museum's web-based content as mimetic, frees the museum from the need to continually defer to an absent 'real'. When it can confidently view and understand its web presence as 'virtual' (with all that is encompassed by that term, historically and philosophically), and when it can have confidence in the mimetic value of the content it places online (however representational that content may be), then the museum will not need to view its web presence in constant deference to the real. For, at that point, the museum online will be part of the real.

RECONNECTING WITH THE MUSEUM'S FICTIVE TRADITION ONLINE

Mindful of this volume's wider concern with social media and user engagement, my attempt here has been to highlight how some of the qualities of the web, specifically around trust and accuracy, have elicited from museums an online presence (compensatingly and heavily) orientated around expertise and information. It has been suggested here that this emphasis on information-rich, trusted databases of expert content, has been somewhat at odds with the multifarious ways that museums have, in fact, back in their galleries in the physical venue, enjoyed using the techniques of make-believe and illusion—through imitation, illustration, immersion and irony. My proposition here, consequently, was to allow notions of the 'virtual' and 'mimesis' to give reasoning for the museum not only to occupy web space with digital content that is meaningful and real, but to empower the museum to migrate more confidently and more often its techniques of make-believe (its fictive tradition) on to the web. This is certainly not a call for the museum online

to mirror the museum on-site; the two, after all, are profoundly different in their propositions. This is not about equating the physical and the web-based experiences and idioms of culture. Rather, the opportunity I see here simply relates to how the museum might reclaim the fictive and illusory on the web, as creatively as it has in gallery, yet in a way that is appropriate to the medium. And as it does, the museum might also migrate a new set of interpretive frames: A shift from belief to a suspension of disbelief; the reemphasis from evidence to the evidenced; and a reblending of the actually real and the ideally real. In doing so, the web and social media can be a means not just to consult and include, to share and extend the museum's accurate archive, and to garner more information for collections records. But, additionally, the social web can also come to be a highly conducive place to reconnect with the playful, illustrative, fictive and theatrical qualities that have come to define the museum.

My points of discussion here on make-believe and media, accuracy and authenticity, will have wider relevance to this book's broader themes—not least to the new participatory roles for users in the social web, and to how online communities are being built by (around and with) museums. As museums enter new contracts of coauthorship and ownership, and as their users continue to reinvent social media (as well as themselves in social media), so these questions of trust will be ever present and unavoidable, and will continue to demand our respect and attention.

ACKNOWLEDGMENTS

The research behind this paper has been made possible, thanks to the generous support of the Arts and Humanities Research Council and the Engineering and Physical Sciences Research Council (supported by Research Councils UK) within the national 'Science and Heritage' program. The work forms part of a three-year project entitled 'Representing Re-Formation', led by Dr. Phillip Lindley of the University of Leicester (on which the author is co-investigator), in partnership with English Heritage, Norfolk Museums and Archaeology Service, The Yale Center For British Art and Oxford University. The author is particularly grateful to the School of Education (Oxford University) and the British Museum (specifically its conference 'Museums and Participation') for allowing earlier versions of this paper to be aired and rehearsed at such supportive and thoughtful events. Likewise, I am also grateful to Nick Poole for his comments on an earlier draft of this chapter.

REFERENCES

Baudrillard, J. (1988). Simulacra and simulations. In M. Poster (Ed.), *Jean Baudrillard: Selected writings* (pp. 166–183). Cambridge, MA: Polity Press.

Bayne, S., Martin, B., Ross, J., & Williamson, Z. (2009). *National museums online learning project: Final report*. Edinburgh: University of Edinburgh. Retrieved from www.education.ed.ac.uk/dice/nmolp/pdfs/finalreport.pdf

Berman, M. (1980). *The politics of authenticity: Radical individualism and the emergence of the modern society*. New York, NY: Atheneum.

Boyle, D. (2003). *Authenticity: Brands, fakes, spin and the lust for real life*. London: Flamingo.

Castells, M. (2009). *Communication power*. Oxford: Oxford University Press.

Crawley, G. (2012). Staging exhibitions: Atmospheres of imagination. In S. MacLeod, L.H. Hanks, & J. Hale (Eds.), *Museum making: Narratives, architecture and exhibitions* (pp. 12–20). London: Routledge.

De Niet, M., Heijmans, L., & Verwayen, H. (Eds.). (2010). *Business model innovation: Cultural Heritage*. Amsterdam: The Den Foundation.

Drotner, K., & Schrøder, K. (2010). Introduction: Digital content creation: Perceptions, practices, and perspectives. In K. Drotner & K. Schrøder (Eds.), *Digital content creation: Perceptions, practices and perspectives* (pp. 1–13). New York, NY: Peter Lang.

EDLnet (European Digital Library Network). (2007). *Description of works: Thematic networks: Grant agreement number 52001: Annex 1*. eContentplus. Retrieved from http://www.theeuropeanlibrary.org/portal/organisation/footer/Appendix_1_4_Description_of_Work_EDLnet_v9.pdf

Ellis, M. (2011). *Managing and growing a cultural heritage Web presence: A strategic guide*. London: Facet Publishing.

Europeana. (2011). *Europeana Strategic Plan 2011–2015*. Retrieved from http://pro.europeana.eu/c/document_library/

Falcone, R., & Castelfranchi, C. (2001). The socio-cognitive dynamics of trust: Does trust create trust? In R. Falcone, M. Singh, & Y. Tan (Eds.), *Trust in cyber-societies: Integrating the human and artificial perspectives* (pp. 54–72). Berlin: Springer.

Falcone, R., Singh, M., & Tan, Y. (2001). Introduction: Bringing together humans and artificial agents in cyber-societies: A new field of trust research. In R. Falcone, M. Singh, & Y. Tan (Eds.), *Trust in cyber-societies: Integrating the human and artificial perspectives* (pp. 1–7). Berlin: Springer.

Finnis, J., Chan S., & Clements, R. (2011). *Let's get real: How to evaluate online success?* Brighton: Culture 24.

Fleming, P. (2009). *Authenticity and the cultural politics of work: New forms of informal control*. Oxford: Oxford University Press.

Golding, V. (2009). *Learning at the museum frontiers: Identity, race and power*. Farnham: Ashgate.

Google. (2012). FAQs—Google Art Project. Retrieved from http://www.googleartproject.com/faqs/

Hand, M. (2008). *Making digital cultures: Access, interactivity and authenticity*. Aldershot: Ashgate.

Hardin, R. (2008). *Trust*. Cambridge, MA: Polity.

Jackson, A., & Kidd, K. (2011). *Performing heritage: Research, practice and innovation in museum theatre and live interpretation*. Manchester, NY: Manchester University Press.

Keen, A. (2011). *The cult of the amateur*. London: Penguin.

Knell, S.J. (2000). *The culture of English geology 1815–1851: A science revealed through its collecting*. Aldershot: Ashgate.

Knell, S.J. (2007). Museums, reality and the material world. In S.J. Knell (Ed.), *Museums in the material world* (pp. 1–28). London: Routledge.

Lord, B. (2005). Representing enlightenment space. In S. Macleod (Ed.), *Reshaping museum space: Architecture, design, exhibitions* (pp. 146–57). London: Routledge.

McKnight, D. H., & Chervany, N. L. (2001). Trust and distrust definitions: One bite at a time. In R. Falcone, M. Singh, & Y. Tan (Eds.), *Trust in cyber-societies: Integrating the human and artificial perspectives* (pp. 27–54). Berlin: Springer.

Nightingale, E., & Sandell, R. (2012). Introduction. In R. Sandell & E. Nightingale (Eds.), *Museums, equality and social justice* (pp. 1–9). London: Routledge.

Page, R. (2012). *Stories and social media: Identities and interaction.* New York, NY: Routledge.

Parry, R. (2010). The Internet and audience development as a serious challenge in the twenty-first century. Proceedings from *Audience development in museums and cultural sites in difficult times* (pp. 25–31). Dublin: National Gallery of Ireland.

Parry, R. (2011). Transfer protocols: Museum codes and ethics in the new digital environment. In J. Marstine (Ed.), *Routledge companion to museum ethics: Redefining ethics for the twenty-first century* (pp. 316–331). London: Routledge.

Pearce, S. (2007). William Bullock: Inventing a visual language of objects. In S. J. Knell, S. MacLeod, & S. Watson (Eds.), *Museum revolutions: How museums change and are changed* (pp. 15–27). London: Routledge.

Phillips, D. (1997). *Exhibiting authenticity.* Manchester, NY: Manchester University Press.

Plato. (1987). *The republic.* H.D.P. Lee (Ed.). London: Penguin Classics.

Poster, M. (1988). Introduction. In M. Poster (Ed.), *Jean Baudrillard: Selected writings* (pp. 1–9). Cambridge, MA: Polity Press.

Scott, L. (2011). Working and benefiting with the commercial sector (unpublished conference panel session). *Go collaborate: Museums computer group conference.* Brighton, June 17, 2011.

Shields, R. (2003). *The virtual.* London: Routledge.

Shirky, C. (2008). *Here comes everybody: How change happens when people come together.* London: Penguin.

Taquet, P. (2007). Establishing the paradigmatic museum: George Cuvier's Cabinet d'anatomie compare in Paris. In S. J. Knell, S. MacLeod, & S. Watson (Eds.), *Museum revolutions: How museums change and are changed* (pp. 3–14). London: Routledge.

Taylor, C. (1999). *The ethics of authenticity.* Cambridge, MA: Harvard University Press.

Thomas, S., & Mintz, A. (1998). *The virtual and the real: Media in the museum.* Washington DC: American Association of Museums.

Toon, R. (2005). Black box science in black box science centres. In S. Macleod (Ed.), *Reshaping museum space: Architecture, design, exhibitions* (pp. 26–38). London: Routledge.

Witcomb, A. (2003). *Re-Imagining the museum: Beyond the mausoleum.* London: Routledge.

2 Social Work
Museums, Technology, and Material Culture

Pam Meecham

In the self-reflexive new museum, digital technologies have the potential to broker fluid identities at the same time as transforming the visitor experience by facilitating user-generated knowledge and creative opportunities. Such possibilities speak of a shift in power relationships between the established authority of the museum and the visiting public. The latter elevated from the subaltern position established under Enlightenment philosophy at the birth of the public museum in the 18th century to, at best, active participants, co-curators, and interpreters of collections. The transition from the physical domain of the museum to the social spaces of digital networks, however, is not a seamless triumph of technological progress. This chapter draws together some of the issues at stake when organizations with a historic commitment to tangible material culture develop modes of communication that represent the 'authentic' artwork in a multitude of intangible ways often mediating between the viewer and 'the real thing'. The chapter also discusses examples of effective and affective transformations in museum practices that have contributed to a current global imperative to rethink what a museum might be and crucially what relationship it has to its communities. The implications of such shifts in thinking are not only for diasporic or source communities currently reimagining, with or without museums, the representation of their own cultures. The restructuring and relabeling of collections amassed under the taxonomies of Empire require an unsettling: a rummaging in the basement of a naturalized, if fictive, order. Interventions into spaces that historically validated material culture as signifiers of national identity (Bennett, 1995) have resulted in a reassessment of the museum's role as merely a benign dusty lumber room with little but nostalgia for former glories to contribute to contemporary global society. The use of digital technologies has been at the forefront of transformations, enabling greater access to archival information and collections resulting in community building and the widespread dissemination of hidden and repressed histories.

Transformations in the art gallery, in particular, are contested. Perceived as under threat, traditional cultural and aesthetic values are, it has been argued, undermined by the social role of the new art gallery. Analysts suggest

some participatory strategies such as 'social bookmarking', together with more interactive information tagging, emphasizes that the museum is now part of a broader folksonomy, and therefore its unique claims to legitimacy and authority are being eroded. The term " 'folksonomy', in fact, might be placed in deliberate tension with the word 'taxonomy' being a way of arranging and collecting information that is anti-hierarchical and horizontal" (de Groot, 2010, p. 97). It is the claim to uniqueness and authenticity and the counterclaim to democratization that is the most telling area of dissonance discussed in this chapter.

The transition to a more democratic post-museum is largely the result of two forces: One theoretical, the other pragmatic. First, the self-reflexive museum was alert to criticism stemming from Pierre Bourdieu's identification of the power of *distinction* through theories of 'cultural capital'. Moreover, empirically researched knowledge held that at least in France of the 1960s and '70s, visiting the museum was class and education based (Bourdieu, 1984). Further, Foucault's reckoning of the universalizing tendencies of museums and Tony Bennett's Marxist interpretation of the civilizing agendas of 19th century-museum politics in influential studies such as the *Birth of the Museum* bore down on the museum. The second arena not unconnected to the theories of the first has been the recent expansion in education. Funding imperatives across many cultures in the last decade have demanded more socially accountable regimes: In the UK, New Labour's expansion of the museum sector went hand in hand with an instrumental culture that saw the museum as an apparatus for social change: As one route to a more inclusive public cultural sector. The hard-won battle for wider social engagement in museums has largely been waged by educationalists once confined to basement activity. Following David Anderson's 1997, *A Common Wealth: Museums in the learning age*, a report to the Department for Culture, Media and Sport (DCMS) England, there has been a rapid growth in museum education that although currently threatened by recession has reestablished a prominent place in many national museums. Funding via *Renaissance in the Regions*, and the creation of regional museum Hubs and the establishment of a national learning framework, *Inspiring Learning For All* resulted in a positive community-oriented ethos often decentering the hold of collections and conservation, that since the 1920s, was given priority at the expense of education and, at times, the visiting public. The publication *Renaissance in the Regions: A new vision for England's museums* cited above identified technology's role in social change, stating "ICT (Information and Communication Technology) has an important role to play in widening access, beyond the walls of museums for those who are prevented from visiting in person, whether by disability or geography" and that, crucially, technology would help in the development of "wider audiences—more representative of each region's population" (DCMS, 2002, p. 7). This was not however the first call to order: To demands that the museum change its social relationship with its audience. Echoing the legendary American museum director

John Cotton Dana's democratic idealism of the 1920s *re*:source stated: "New audiences will use museums in ways which will dissolve traditional barriers between different organizations, placing the emphasis on the user rather than the institution" (*re*:source, 2001, p. 62). During the last decade, rapid and continuous change in museum identities, purpose, and educative ambitions have been radically recalibrated as they were coerced, through accountability regimes and social change, to reevaluate and transform their traditional, hierarchical relationship with audiences. The visitor as active agent rather than passive recipient of received wisdom is echoed in another shift away from the material object to the viewer, witnessed in the increase of visitor rather than object-centered research.

Given the fast pace of change, the above (2001/2) has an already outdated ring. In some respects, however, the linking of technology and the future is unsurprising and has historic precedents. If we heed Raymond Williams's cautionary tales that new technological developments such as television merely replicated the existing social order, doing little to dismantle it (Williams, 1974), we would do well to stand back and look at the fast-changing scenario to assess the impact of digital technology on the repositories for material culture, the things themselves and their audiences. For Martin Heidegger, like Williams, also writing in the 1950s, technology was a concern, not necessarily a problem. However the ways that we can be enframed should give us pause for thought if, regarding the new as always necessarily progressive, invalidates earlier technologies and ways of being. If we take as central to Heidegger's thinking that there is a truth in our relationship with things, then technological rationality needs to be tempered, handled with care lest order and logic through technology become a way of framing our thinking. Nonetheless, the perception that the future is a technological one and that for museums that means *online* rather than *inside* a technologically enhanced museum space is indicative of a deep divide in the utopian aspiration to modify the traditional relationship between museum and audience.

Technology has been used with uneven results to broker relationships between the custodians of culture and audiences unfamiliar with museum rituals and protocols. *Culture Online* (DCMS, 2002) set up with a budget of £13 million increased to £16 million by 2005 (although closed down in 2007), created numerous award-winning projects. The initiative's strap-line of "a digital bridge between culture and learning" was an indication of New Labour's democratic cultural aspirations (see www.cultureonline.gov. uk) (Earle, 2012). A rush to digitize collections sees most museums with online, copyright-free collections. Faced with the impossibility of tracking the misuse of images, many museums and galleries have relinquished copyright except for blatantly commercial purposes. The Walters Art Museum in Baltimore in 2012 removed copyright restrictions for more than 10,000 images. Moreover, The Walters enhanced web access also allows the creation of online exhibitions with, crucially, access to research conservation records and exhibition histories moving "make your own exhibition" initiatives beyond

the whimsical into scholarly, research-based activity. Unprecedented changes in the museum's relationship to its publics is acknowledged in the loss of control over images previously jealously guarded by copyright laws against all-comers, not just those who would profit financially from collections. Digital, downloadable images if not yet the norm, are commonplace. See, in particular, the UK's Arts and Humanities Research Council (AHRC) funded National Inventory Research Project (2002–7), http://nicepaintings.org that researched over 8,000 paintings in UK collections and is accessible on the Visual Arts Data Service (VADS) website. NICE the National Inventory of Continental European Paintings includes all pre-1900 Continental European oil paintings in UK public collections.

Initially, it was largely the education and marketing departments that made greatest use of enhanced social networking and information dissemination provided by digital media creating new social networks and communities in the museum. Digital technologies optimistically paved the way to improved audience engagement, dialogic exchange and a participatory ethos. In tandem, an overhaul of the univocal interpretation of art and artifacts (often a search for one authoritative answer) has resulted in multivocalism and plurality: A democratization of museum collections still sometimes perceived as historically elitist and apologists for class difference. Technological innovations across museums, archives and libraries have also enabled greater interdisciplinarity access, collaborations and user-generated knowledge previously confined to the 'legitimate' scholar. For instance, in 2011, the Victoria & Albert Museum, London, used visitors to enhance their "Search the Collections" website. Using skills such as zoom and compare to obtain the best image crop, visitors have reassessed over 120,000 photographic images of objects from the museum's collections. Although offered a limited curatorial role, the project is exemplary of others that give audiences limited power over how and what is displayed. Curators in the above scenarios are given some respite from their traditional gatekeeping role, but if this amounts to a democratization of national resources remains to be seen.

Coupling the museum with citizenship and technology, museum directors Neil MacGregor (British Museum, London (BM)) and Nicholas Serota (Tate) in 'The Museum of the 21st Century', July 7, 2009, debate at the London School of Economics (LSE) acknowledged contemporary social change. In the history of the museum in the West, it is often difficult to disentangle the innovatory from the merely novel and to recognize a paradigm shift when it happens. While reminding us that the museum was the first Open University, a seismic shift is predicted by MacGregor who stated, "The future has to be, without question, the museum as a publisher and broadcaster". Serota followed, "The challenge is to what extent do we remain authors, and in what sense do we become publishers providing a platform for international conversations? . . . I am certain that in the next 10 to 15 years, there will be a limited number of people working in galleries, and *more* effectively working as commissioning editors working on material online" (*The Guardian*,

Our future lies on the web, say museum heads, July 8, 2009). Co-curating and using the public through crowdsourcing (a form of outsourcing that goes to undifferentiated people rather than a specific group of employees) have been used by museums to learn from those outside the sector. Active audiences are particularly enabled by Web 2.0 technology. 'Steve: The Museum Social Tagging Project', a virtual gallery space is a further example. The Institute of Museum and Library Studies (IMLS) 'Researching Social Tagging and Folksonomy in the Art Museum' talks of the development of open-source tagging tools that are part of a commitment by "museum professionals and others who believe that social tagging may provide profound new ways to describe and access cultural heritage collections and encourage visitor engagement with collection objects" (www.steve.museum). From Tate Britain's 'Write Your Own Label', online visitor submissions to public co-curating at the Museum of London and Tate Liverpool's Young Tate organized 'Alternative Turner Prize' (2007) with virtual public participation, there has been change in the distance (physical and social) between public and authorial collections. However, even if the future of the museum's democratic purpose is now foregrounded in museum debates, it is firmly placed in the lap of online activity with its promise of digital democracy. The two directors above pointed toward virtual multiplatforms and increased dialogue between a range of diverse peoples, collections online and virtual exhibitions for those unable to travel and free downloads that have (in the case of the British Museum's collection) transformed, for instance, the study of drawing worldwide. MacGregor cited the online virtual tour of *Word into Art*, part of the *Middle East Now* celebrations in 2008, where the calligraphy exhibition was given an online tour requested by Arab people unable to leave, for instance, Ramallah in Palestine, when the tangible exhibition visited Dubai.

EXPRESSING DOUBTS

Nevertheless, questions remain, and the utopian digital embrace undertaken by many museums has not been uniformly welcomed. Questions have arisen concerning the purpose and effectiveness of technological applications in the physical museum building. Kept at a technology distance from the actual exhibition space, much is possible but within the boundaries of buildings, there is uncertainty. Many museum professionals and the visiting public remain skeptical, even hostile, to digital applications in the museum, concerned about issues of authenticity, authority, ownership, and truthfulness of representation. Mediation between 'the thing itself' and the viewer is still a vexed issue: Particularly in the art gallery. Empowerment is less easily achieved within the historic gallery where traditionally curators have collected, displayed, and interpreted collections, and audiences have received them. To reconceptualize the relationship between the newly enfranchised

public and increasingly beleaguered curators requires rethinking: Again, Serota stating, "In the past, there has been an imperfect communication between curators and visitors that is the challenge now" (*The Guardian*, July 2009). In part, the issues turn on a passionate attachment to the real thing. While in some galleries there have been changes to the language used that speaks of a new dialogic relationship: For instance, in The National Gallery, London's 'Close Examination: Fakes, Mistakes and Discoveries' that used electromagnetic radiation to "reveal the misconceptions of the past to visitors in a way not previously possible" (National Gallery, 2010), for many it's business as usual.

HIGH AND LOW CULTURE

Changing curating practices in some galleries seeking to diminish the distinction between high and low art demonstrates how uneven the ground is. Rethinking exclusive attachment to avant-garde culture, some art galleries have introduced 'inauthentic' popular print culture into spaces that validated the unique, signature style of the artist through the 'aura' of the masterpiece. In 2002, the Guggenheim Museum in New York showed 'Norman Rockwell: Pictures for the American People', a traveling exhibition seen by more than a million people. The exhibition consisted of over 400 works of mostly magazine covers. Rockwell (1839–1978) was a blatant populist whose sentimental 'American way of life' images of small-town USA were familiar to millions through cover illustrations on the *Saturday Evening Post*. A lifetime of derision by serious art critics did nothing to dispel Rockwell's popularity. He did paint images of lynching and of segregated schooling, but such images are rarely reproduced. Inevitably, critics were deeply divided by the Rockwell show, with some casting doubts on his rehabilitation as "an artistic Benjamin Franklin" (Meecham & Sheldon, 2009). It is noteworthy that the epithets 'illustrator' and 'storyteller' that dogged Rockwell have also been subject to patchy revision. The critic Kimmelman was concerned that "the Guggenheim . . . [is] trashing the reputation won for it by generations of artists, and [the exhibition] only underlines Rockwell's reputation as merely the maker of what he himself called 'feel-good' 'story-pictures'" ' (2001). The appearance of Rockwell's reproducible and illustrative art in a bastion of high art such as the Guggenheim also allowed a space for critics and theorists to reinforce their commitment to quality, and reaffirm the modernist critics' defense of the 'hard-won image' while railing against the newly discovered populism of erstwhile champions of 'elitist' culture. The hostility toward print culture is not a deviation from issues at stake in this chapter. I want to explore what is sustained, gained, and lost in translation when embodied communication becomes digital and divested of the physical social interaction that occurs in the gallery space that hosts the unique artifact. For instance, arguably while the digital enables, through search

engines, access to all of an artist's work across the globe rather like the whole music album experience, what is lost in random play is the relationship of one painting to another, one gallery to another.

THE SOCIAL AT WORK

Given that, for some, a sense of place or home is cyberspace, and given the rhetoric of social networking, what currently constitutes social and social networking needs definition. According to the *Oxford English Dictionary*, the term 'social-networking' was first coined by the English temperance reformer John B. Gough in his autobiography of 1845 when he wrote, "I again became involved in a dissipated social network". Few terms are more loaded in contemporary culture than 'social'. In the same way that we were not conscious of being analogue until digital required that we understand our history (do you remember mono to stereo?), the entry of 'social' into the everyday language of culture has two often-conflated meanings in museums. The move to *social work* in museums has its advocates and detractors: Broadly speaking, those who see the job of the museum as developing strategies to promote social cohesion and the opening up of collections to audiences that are 'hard to reach'; and those who see the *real* job of the museum as scholarship and conservation. Riding roughshod over history, the latter advocates of ivory tower museums rarely acknowledge that the core historic role of the museum was education. Access and inclusion are no newcomers ushered in by Britain's New Labour mandate to shoe-horn culture into its agenda of social reform (Smith, 1998). Currently coupled with networking, the term again suggests something new taking place: A different kind of *social* to that which took place previously. Social is also used in conjunction with design in Bitgood's study of visitor psychology: *Social Design in Museums* (2011). Research tells us that visitors are more likely to read a text panel if questions are used as headers (Hirshi & Screven, 1988), and that subject matter that relates to the visitor in a more meaningful way is more likely to be read (Bitgood, Benefield & Patterson, 1989). Bitgood et al. (1990) also found that placing of text panels was important, and visitors were more likely to read if they could simultaneously look at the object. Visitors' enjoyment is also more likely if the distance between them and the exhibition is minimized, or even removed, in the creation of an interactive or immersive experience, in what Bitgood et al. term the penetration of the exhibition space. Walking through exhibits may be particularly effective in creating a feeling of 'time and place' (Bitgood et al., 1990). We also know that many people visit exhibitions as a social activity and that we learn and remember more through discussion rather than solitary communion. In terms of children learning in the gallery, we know that working with peers is a hugely motivating factor (Carnell & Meecham, 2003). While there is little difference in cognitive learning between museum and classroom, there appears to be a difference

in affective outcomes (Borun, Flexer, Casey & Baum, 1983). By this, I take the research to be differentiating between cognitive processing activities that refer to the functions that pertain to information processing and task execution (e.g., relating, structuring, analyzing, and memorizing) and affective processing activities that relate to the motivational and emotional aspects of learning (for example, expecting, generating emotions, appraising, and memorizing) (Haanstra, 2003, p. 35). This is an important point as research indicates that affective experiences are remembered more easily: A point to which I will return.

SOCIAL SPACERS

Researchers looking at visitors beyond the social scientists' traditional categorizations have created, for instance, at England's Tate eight audience 'segments'. When researching visitor behavior, consumption, and attitudes to art, new categories of visitors were created: Aficionados, actualizers, sensualists, researchers, self-improvers, social spacers, site seers, and families (Morris, Hargreaves & McIntyre, 2007, p. 67). What interests me here is the growing body of knowledge around the importance of the gallery as a social space. Research that demonstrates the social benefits of visiting the museum often points to the positive nature of social communication. Research currently is moving away from the 19th century-civilizing agendas of social reformers to investigate the individualized well-being, life-style agendas of the 21st century, and the importance of the gallery visit with others. According to the report *Audience Knowledge Digest: Why People Visit Museums and Galleries, and What can be Done to Attract Them* (2007) based on extensive research, there are four key drivers in motivations for visits: The first is social followed by intellectual, emotional, and spiritual. The researchers differentiated between galleries and museums, maintaining that in museums 48% of visits are driven by social motivation while in art galleries this is just 30% with many gallery visitors being motivated by secular spiritual motives such as escapism, contemplation or creativity: Just 3% in museums while 15% in galleries. Morris et al. found that families, in particular, were more likely to be motivated by social and intellectual drivers. What is important here is the amount of emphasis placed on the social role of the museum or gallery. Morris et al. quoted Alan Brown's research that indicated a third of visits to museums were motivated by social activity. Nonetheless, what we can see from even a cursory glance at recent statistics is that web visiting is increasing disproportionately to footfall. For instance, the number of footfall visitors to the British Museum, London, increased by 10% (0.4m) over three years: From 5.5m in 2008/09 to 5.9m in 2010/11. In stark contrast, the number of unique website visits almost doubled in the same period: From 10.7m in 2008/09 to 21.5m in 2010/11. The National Gallery received just over 5 million actual visits in 2010–11. But during the

Jan Gossaert exhibition in 2011 that lasted 3 months (February to May), nearly 15 million page views and catalogue entries were recorded on related Gossaert painting sites. The figures confirm the tacit sense that a new model army of citizen archivists and researchers is emerging as a result of the web. Likewise, the assumption that the only social activity is the actual gallery visit may need to be expanded to include social networking (rather than create a binary between actual and virtual). In June 2012, the Design Museum, London, launched a collection app. Within a short time, it had 81,000 downloads, 540,000 followers on Twitter and 157,000 fans on Facebook. The figures are significant for a small museum that punches above its weight.

Tim Berners-Lee's World Wide Web (1991) potentially transformed power relations where the possibility of new social forms of engagement would overturn our relationship to knowledge and (if we can maintain net neutrality) knowledge creation. Presided over by a benign shared sense of community, even universality, the web initially offered enhanced forms of social communication and empowerment that could evade the regulatory strictures of traditional publishing and schooling with its insistent hierarchy of certification and validation. Moreover, the web could potentially evade corporate culture's marketing strategies (that saw users as consumers) and remain in the realm of the critical citizen (Gunkel & Gournelos, 2012; Lovink, 2011 & 2002). Participatory democracy in the museum (for good or bad, one of the most conservative of organizations) cannot be achieved by just introducing social networking. It requires what Raymond Williams advocated back in the late twentieth century: Wresting culture from its seemingly exclusive attachment to middle-class values. This would require a dismantling of the distinction between high and low culture and a move away from a fictive, detached objectively to reinvestment in the museum experience to rival or blur the distinction between the theme park and the gallery. We saw above that putting low art into a high-art space can cause consternation. Moreover, the now freely available copy, print or digital surrogate can also put into sharp relief our relationship to the original.

If social networks have transformed visitors' research possibilities in recent years, the proliferation of digital images has also affected our experience of art works. It can be argued that our relationship with surrogate images has also changed. The Toledo Picture Study of 2001 looked at visitors' emotional (or affective) responses to original artworks and a range of surrogates: In particular asking about the effect of surrogation on viewer responses to the expressional qualities in works of art. Taylor concluded, "the most interesting qualitative data directly addresses differences between original works of art and surrogates in terms of emotional response. These responses, in particular . . . mentioned the effect of the gallery's parquet floors and deep-hued walls, the presence of others in the gallery, or those who share stories of past experiences at the museum as children, with their families, or as volunteers" (2001, p. 22). The importance of the gallery visit was stressed in the research, but over a decade later it would seem timely to review aspects

of the findings. In the original study that ranked different types of surrogates, the digital was found wanting in relation to the original paintings. In terms of "intensity of emotion experienced, the original scored highest with slides following in front of digital image and photograph and the book page coming last" (Taylor, 2001, p. 18). However, in 12 years, there have been huge technological innovations and improvements in the quality of reproduction that Taylor identified, "while technologists have been able to refine some of the physical limitations of digital surrogates (that is, relative lack of density of the image, colour fidelity), a short fall in other critical physical considerations persists (lack of dimensionality, limited sense of scale, a restriction to the single sense of sight) and most important, little progress has been made in capturing the affective response individuals are likely to experience when faced, for instance with a Rubens painting" (Taylor, 2010, p. 175). Not alone, Taylor suggests we refocus attention on the viewer rather than the object to better understand the complexities of the viewer experience: One challenge for digital technology is creating models that better understand experiencing museum content online and better understand the gap between original and reproduction.

Another more recent study also sought to better understand the relationship between experiencing the authentic and surrogates. Although a small-scale study, research by Quiroga, Dudley and Binnie (2011) at Leicester's School of Museum Studies is telling. The researchers compared looking at an original oil painting, Millais's (1851–1852) *Ophelia*, in Tate Britain, to looking at a digital counterpart under laboratory conditions. An eye tracking study looked at the fixation patterns of participants shown the original *Ophelia* hanging in the gallery or in digital form in a booth where the image was surrounded by black cloth. Timed for a one-minute duration, the two groups of viewers' responses were significantly different. In both groups, what was visually focused on and bodily behavior was noted. "The lab study focused on the smaller area of Ophelia, those in the Tate study explored more thoroughly the original artwork, exploring the larger area surrounding Ophelia" (Quiroga, Dudley & Binnie, 2011, p. 15). Speculatively it could be that the painting was read as a whole work and the digital image treated as a photographic portrait with the classic concentration on the face and hands. It may be that context was a contributing factor here as it was noted that visitor behavior was also marked by difference, with Tate visitors more physically active, speculatively that the embodied experience is part of the gallery visit while the viewers of the digital Ophelia was seated and moved less. One issue may have been the quality of image "if we zoom into details in the museum, we see the brushstrokes and texture of the paint, whereas if we do the same in the lab, we just see pixels" (Quiroga et al., 2011). However, technology moves quickly, and the technical issue of qualitative difference may have been overcome with *Art Authority* claiming to be better than the original and with a close-up facility that uncovers details not visible to the naked eye in the often poor lighting in the gallery (the distance from

the object removed by the digital image). However, Quiroga, Dudley and Binnie conclude that even given the increasing use of digital media, "seeing the genuine piece of art really makes a difference to the experience. . . that through the experience of the original the viewers are looking for more valiant features. While the digital image can capture increasingly high details [beyond] the naked eye. . . they often lack the propensity to encourage the curiosity of the viewer" (2011, p. 17).

IMMERSE YOURSELF

The organizers of *Van Gogh Alive: The Exhibition* state: "Immerse yourself in the work of Vincent Van Gogh through an artistically choreographed sequence of sights and sounds in this unique production that fuses art and audio-visual technology (Figure 2.1 and Figure 2.2). "Showcasing the artist's work during his most prolific period of painting between 1880 and 1890, the dynamic display unfolds across the inside of a distinctly designed gallery interior. Explore the space, and discover new viewing angles and ever-changing perspectives on this giant moving canvas" (Grande Exhibitions of Australia, ArtSci website).

The publicity in Singapore for the immersive exhibition further suggested the experience of seeing an actual Van Gogh could be 'underwhelming'. The immersive experience was conceptualized as more physical and technologically exciting through the use of scaled-up fragments of reproductions of

Figure 2.1 Van Gogh Alive: The Exhibition. © Grande Exhibitions.

Figure 2.2 Van Gogh Alive: The Exhibition. © Grande Exhibitions.

Van Gogh's paintings. Indeed, Laura *Expat adventures Singapore*, May 11, 2011, blogged on the ArtSci website: "We took a look at Van Gogh Alive—the exhibition. I'm so glad we did though because it was so good. This was not an exhibition of the actual original paintings by Van Gogh but rather a display of his art projected on to walls and the floor and accompanied by pieces of classical music. The paintings are far bigger than in real life (and in most cases cover the whole wall) and you simply walk in amongst them absorbing them. As you walk amongst them the paintings change in keeping with the music and other than a few seats for you to simply sit and watch the art show, if you wish, there is nothing in the room to distract you but his paintings. In a small room off the main exhibition hall there are copies of a few of his most famous works together with a brief description of what the painting conveys, his inspiration for it and so on. The main part though is the artwork display in the next rooms. It is hard to convey here how much walking through these paintings as if I were a part of them totally amazed me, but I lost track of time here whilst appreciating the art and the music". The distinction between the real, authentic and the immersive experience is a complex one and not easily dismissed as populism, dumbing-down: Or the misguided complicity of a subaltern failing to recognize 'distinction'. Or is it an example of the high-low cultural dichotomy that New Labour rather confusingly set out to dismantle?

PAY ATTENTION

Chris Whitehead posits a problem in the use of digital technologies and the imperative to produce multivocal interpretation of artworks fueled by knowledge of visitors' entrance narratives. Whitehead urges a reconsideration: While the technologies allow for multiple framings and higher levels of visitor choice in navigating interpretive paths in the introduction of, say, film footage, music and other visual and auditory information, there may be a point at which ancillary objects become the focal ones disrupting the traditional scopic regime of the museum. Moreover, the demands of competing interpretational material may impede visitor attention (Whitehead, 2012, p. 177). Taking *Van Gogh Alive: The Exhibition* as an extreme example, the argument becomes blurred. While for some a walkthrough of fragmented Van Gogh paintings may not be 'authentic', it does throw into question the relationship between digital technologies' reproductive capacity and the direct apprehension of, say, *Wheatfield with Crows* (1890) at the Van Gogh Museum in Amsterdam. Not before time, some may suggest, that the attachment to value via the original artwork is dismantled, offering greater democratic potential in translation between media. Others may feel the disruption of communion with 'the real thing' through the introduction of new media is to ask questions about new forms of attention that play rough with the silent aesthetic responses that call attention to the painting as a thing in its self. Whitehead questions Kesner's assumption that access to new media and visual technologies have altered our perceptual skills, making art less rather than more accessible (Whitehead, 2012, p. 178). Optimistically Whitehead suggests rather than art rendered less accessible, we should look at, "how they [new forms of attention] may. . . enable new, hitherto unimagined, forms of access" (2012, p. 178). There is here a fundamental question at the heart of interpretation: Where does authority lie? Do we continue with unmediated looking (leaving aside for now the mediation of the gallery space and its lack of neutrality)? Moreover, Laura (*Expat adventures Singapore*) did not find the distinction between the real thing and the digital a problem, and her willingness to share her experience with others is a testament to the social engagement offered by the Internet. She felt the addition of music, rather than disrupting, enhanced her experience. Is the digital with its lack of original the logical outcome put in motion by the Guttenberg press? At a basic level, did those who hand scripted the manuscript in the 16th century utter dire warnings about the original versus the printing press's reproductive capacity, or is much more at stake. Western culture values the original in monetary terms (*The Scream* by Munch auctioned at £74 million in 2012), but does the direct experience of the painting matter to those who never own it? The gallery then is poised between elitism and democracy: between being both "democratic and oppressive", Cinta Esmel-Pamies, (2009); between user-generated knowledge and the traditional authority of the curator between setting up false binaries

or accepting a blurring of categories and distinctions. Do we accept that
the proliferation of images may fundamentally alter our perceptions of the
original or that digital imagery can exist cheerfully side by side with the
original with no damage done?

Goggle's *Art Project* (Figure 2.3) launched in 2011 uses Street View tech-
nology familiar through Google Maps with Street View. While its reproduc-
tion values may not reach the gold standard set by the *Art Authority* app, the
project seeks to replicate the gallery visit with its astonishing 360-degree vir-
tual tours of art galleries. It allows virtual access initially to international art
museums and galleries, including The Frick Collection, New York City, that
through covenants cannot not travel; Uffizi, Florence; The State Hermitage
Museum, St Petersburg, Rijksmuseum Amsterdam. Users can zoom in and
study details of paintings in high resolution. They can also navigate around
the museum and see the context within which artworks are viewed. In 2012,
the global project (from Brazil to Australia to Delhi and Liverpool) added 10
more galleries to the first 17. The high-resolution images pass muster with
curatorial demands, and the close-up possibilities can lay claim to being bet-
ter than the real thing (and ecologically sound in dispensing with the need to
travel to view). The earlier charges against the surrogate images' quality dis-
missed and the possibility of building the users' own gallery that is then dis-
played online adds an incentive bonus. Certainly the large-scale images and
extraordinary detail available via a big screen are impressive. Reviewing the
Art Authority app for iPad (An Incredible Virtual Art Museum), Patrick Jor-
dan (writing in 2010) while conceding that nothing can match seeing great
art live and close up, details the benefits of *Art Authority* that contains works
from over 1,000 artists and over 40,000 paintings and sculptures. The app
takes away time constraints and a lot of walking and "is easier to get around

Figures 2.3 Google's Art Project. The Frick Collection. © Google.

Figure 2.4 Thomas Struth, 'Stanze di Raffaello 2, Rome 1990', size: 171 x 217 cm. Material: Chromogenic Color Print. © Thomas Struth.

than any museum" (Jordan, 2012). "Art Authority provides a stunningly displayed, carefully selected, well-organised view of the western art world. It's part world-class art museum, part academic reference library and part digital coffee-table book. It's also part magic. An art museum like no other!" (Art Authority website). However, while Thomas Struth's Stanze di Raffaello 2, Rome 1990 (Figure 2.4); and Peter Thomas's, View of the British Museum (2012; Figure 2.5) may deter the fainthearted from a visit to the gallery, a visit to the galleries of *Google Art Project* with its rare fuzzy-faced figures in the distance is curiously lonely. Beyond the benefits of convenience, where do the new apps and virtual museums leave us with the search for authenticity?

THE AUTHENTIC AND THE AFFECTIVE

This is complex territory given the claims for a digitally enabled democratic culture. One of the claims made by Rudolf Arnheim, Taylor and more recently by researchers publishing findings in the United States is that while cognitive development seems to be realizable with or without the original or authentic, in the realm of the *affective*, access to the authentic and the associated gallery visit is important. According to *Reinvesting in Arts Education: Winning America's Future Through Creative Schools* (an American

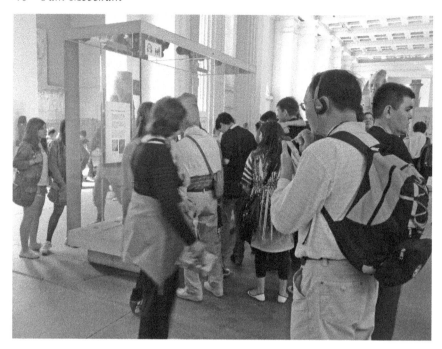

Figure 2.5 Peter Thomas (2012) View of the British Museum. © Peter Thomas.

survey of 25,000 high school pupils across 25 years), outcomes from arts in-tegration in particular have intrigued neuroscientists in addressing the ques-tion of transfer of learning in the arts to other subjects. Neuro-Educational Initiative researchers at Baltimore's Johns Hopkins University hypothesize that arts integration, which emphasizes repetition of information in multiple ways, provides the advantage of embedding knowledge in long-term mem-ory. Furthermore, the brain appears to prioritize emotionally tinged infor-mation for conversion to long-term memory. The rehearsal and repetition of information embedded in multiple domains may cause an actual change in the physical structure of neurons (Rudacliffe in President's Committee on the Arts and the Humanities, 2011, p. 23). The initiative is one of sev-eral research projects looking systematically at how arts instruction supports learning transfer. Such scientific research, although presently inconclusive, may uncover the reasons for many teacher observations that students learn differently: Some seem to learn best kinesthetically, others respond best to visual or aural approaches (President's Committee on the Arts and the Hu-manities, 2011). Taylor also states that psychologist and art theoreticians alike tell us that cognitive recognition and affective responses are processed in different parts of the brain, with affective response being processed fastest *and having primacy over cognitive response* (Taylor, 2010, p. 181).

There is an irony here. At the same time that we witness a proliferation of access to images across so many media, we see a trend by many scholars

and museums to reinvest in reconstructing the original, authentic viewing conditions of artworks (from altarpieces to whole historic exhibitions). Part of the art historian Michael Baxandall's purpose, articulated in 1985, was to "discuss how far we can think, to *critical purpose*, about the relations between the visual interest of pictures and . . . the systematic thought, science or philosophy, of the culture they came from" (1985, p. 74). From a perspective of almost 30 years, Baxandall's concerns around the then-pressing issue of the affinity between pictures and forms of thoughts was prescient. Ideas that hardened into a notion of 'period eye' and by 2003 'words for pictures' have unresolved resonance that recourse to the surrogate via the digital has rendered even more complex. Making connections between ideas and pictures 'properly complex' or better not evoked at all, Baxandall infers that pictures created in other cultures and periods are difficult to access: The act of perception determined by the original social circumstances. Therefore, different visual experiences, skills and conceptual structures marked out the intentionality of the original maker. While Baxandall, rightly, did not consider viewing within the original context, values, and belief systems of the people for whom images were originally made as possible, nonetheless the reinvestment of museums in the reconstruction of the original lighting, framing, and placement of works down to the wall color and augmented reality reconstructions is an interesting, almost antediluvian moment, given that digital technology often dispenses with the physical context of the gallery to sole concentration on the decontexualized artwork. There is a second irony here. In the 1990s, when the social history of art still had apologists, it was precisely the historical recontexualization of artworks often deracinated from their original contexts in art galleries that required urgent attention. It can be argued that the return to the original context for the display in museums is about enhancing the visitor experience: The challenge for the digital is how to create new viewing experiences that do not negate the museum visit but work in tandem. However, this assumes that access to such a proliferation of images in so many forms does not modify or fundamentally alter our relationship to the original. Official cultural display through museums and galleries sanction aura: That is the specialness of the unique object.

These are complex times for the new museum conceptually, actually, and technologically: A place where new social relationships are being forged on several fronts that perhaps inadvertently question our relationship with the artwork. Artists themselves are often part of a resistance to gallery orthodoxy with institutional critique being key to their work. Mobile technologies in the last decade have been useful for artist activists in mobilizing resistance under the banner of individualism via flash mobs, etc. We have also witnessed a rash of new signature-style landmark buildings where "Audiences might see the new buildings as being emancipated from the art exhibited inside" (Greub & Greub, 2006). In such places, art can look awkward and misplaced, the art coming second to visiting the building. Or the museum building is replaced altogether by a virtual tour without people present. The

museum's attempts to court populism in exhibitions, dissolving some of the distinction between high and low cultures is also inviting displeasure and approval in about equal measure.

CONCLUSION

There is currently no mutually understood position around interpretation: Some galleries remove interpretive panels to return to minimal texts, others task visitors with writing their own online or on Post-it notes. This is, in part, due to the collapse of the relative certainty of modernism's defense of quality and its apologists' emphasis on direct, unmediated apprehension of the artwork. The continual adaptations and reforming demanded by technologies exacerbates the situation in museums that traditionally move slowly. In the museum, the multilevel convergent media world where modes of communication have proliferated have and are still changing the way we consume material culture. Our relationship to the original artwork remains unresolved: Cheerful diversification or a collapse of the distinction between media? If we take the view that aesthetic judgment is not a product of birth or education but a subjective experience from which no one is excluded, the gallery needs to embrace greater forms of democracy, but the digital bridge is not value free and not the only vehicle for democratizing culture. Is the experience of a Van Gogh painting via a fractured immersive digital image another contribution to the "disenchantment of the world" (Max Weber): The loss of aura part of the necessity of losing attachment to romantic ideas of artist as genius? Or are such exhibitions extraordinary ways of accessing and crucially contributing to museum communities? Is the dissemination of much-loved pictures via the smartphone like owning the humble postcard: The digitized print on canvas a gesture to cultural democratization or tourist kitsch? In part, this depends on cultural value and if we can move beyond the historical explanation of pictures and the deconstruction of images (O'Sullivan, 2001).

AUTHENTICITY IN USAGE: FROM OBJECT TO VIEWER

The art installation is often a multisensory experience and has been closely associated with affect theory. The *Van Gogh Alive* exhibition while playing hard and loose with orthodox notions of authenticity also offers an immediate sensory experience. Siân Jones maintains that an attachment to authenticity through a prevailing materialist approach is a product of modernity in the West (2010). Writing in relation to art and aesthetics after the mashup, David Gunkel goes further back to Plato's *Republic*. Gunkel questions the dichotomy between the original and the copy that posits the latter as always doomed to the derivative charge laid against the artist's replication of the perfect form of the divinely created world. We have inherited in the West

a tradition from 'The Allegory of the Cave' that suggests the further away from the original the less authentic the outcome. Like its mashup counterpart in music, *Van Gogh Alive* is probably better understood without recourse to traditional categories or frameworks of aesthetics but should make use of an Emersonian term and proceed 'otherwise' by reconsidering long-standing assumptions about art, artistry and aesthetic judgment (Gunkel, 2012, p. 54).

Jones argues that authenticity debates around material culture are polarized /dichotomized between Western constructivist and materialist perspectives. Unsatisfied with this position, she argues for a reevaluation maintaining that it is the network between people, objects, and places that underpins the "ineffable, almost magical, power of authenticity" (Jones, 2010, p. 181). She argues that people employ authenticity as a means of negotiating their place in a world characterized by displacement and fragmentation. She examines the relationship of local communities to the original and replica Hilton of Cadboll, cross-slab at Easter Ross, Scotland. Pitting the institutionally validated historic cross against the recent replica carving, she concludes that rather than a search for the authentic, scientifically, culturally validated original that seeks the essence of things, it can be argued "that authenticity . . . is bound up in some of modernity's defining practices of categorization and purification". She states "it is also paradoxically involved in recognizing and negotiating networks of inalienable relationships between objects, people, and places. In respect to objects, it is their relationships embodied by their cultural biographies . . . which inform the experience of authenticity and its powerful impact on people's lives" (Jones, 2010, p. 198). Jones further argues that in a contemporary world marked by heightened forms of dislocation and displacement, authenticity is used to work out "genuine or truthful relationships between objects, people and places" (p. 198). To push this further, the use of the replica and surrogate in the multiplicity of forms that original artworks now inhabit contribute to our sense of self, and their very familiarity across forms gives us a sense of place and authenticity.

Nicholas Bourriaud's (2002 and 2005) call for relational aesthetics and participatory art practices and, latterly, a process he terms 'creolisation' are important here. "What matters today [he states] is to translate the cultural values of cultural groups and to connect them to world networks". While restating the call for cultural autonomy, the creolisation of cultures has democratic purpose. It may, however, mean relinquishing cherished ideas about authenticity and our relationship to material culture and embrace more discursive models of images and their tangible and intangible locations.

REFERENCES

Anderson, D. (1997). *A common wealth: Museums in the learning age*. London: Department for Culture, Media and Sport (DCMS).

Baxandall, M. (1985). *Patterns of intention: On the historical explanation of pictures*. New Haven, CT: Yale University Press.

Bennett, T. (1995). *Birth of the museum*. London: Routledge.

Bennett, T., Savage, M., Silva, E., Warde, A., Gayo-Cal, M., & Wright, D. (2009). *Culture, class distinction*. London: Routledge

Bitgood, S. (1990). *The role of simulated immersion in exhibition, Technical Report No. 90–20*. Jacksonville, AL: Centre for Social Design.

Bitgood, S. (2011). Social design in museums: The psychology of visitor studies, *Collected Essays Volume One*. Edinburgh: MuseumsEtc.

Bitgood, S., Benefield, A., & Patterson, D. (1989). The importance of label placement: A neglected factor in exhibition design, *Current Trends in Audience Research* (Vol. 3). Washington, DC: AAM Visitor Research and Evaluation Committee.

Bitgood, S., Benefield, A., & Patterson, D. (1990). *Visitor studies: Theory, research, and practice* (Vol. 3). Jacksonville, AL: Centre for Social Design.

Borun, M., Flexer, B., Casey, A., & Baum, L. (1983). *Plants and pulleys: Studies of class visits to a science museum*. Philadelphia, PA: Franklin Institute.

Bourdieu, P. (1984). *Distinction: A social critique of the judgement of taste*. Cambridge, MA: Harvard University Press.

Bourriaud, N. (2002). *Relational aesthetics*. Paris: Presse du Réel.

Bourriaud, N. (2005). *Altermodern and its discontents*. Keynote lecture from Art Association of Australia and New Zealand Conference.

Carnell, E., & Meecham, P. (2003). *Visual paths to literacy: Research project final report*. London: Institute of Education, University of London.

Dana, J.C. (1999). *The new museum: Selected writings by John Cotton Dana*. Washington, DC: American Association of Museums.

De Groot, J. (2010). Historiography and virtuality. In E. Waterton, & S. Watson (Eds.), *Culture, heritage and representation: Perspectives on visuality and the past* (pp. 91–103). London: Ashgate Publishing.

Dudley, S.H. (Ed.). (2010). *Museum materialities: Objects, engagements, interpretations*. London: Routledge.

Earle, W. (2012). *Museums, technology and cultural policy: Tensions and contradictions in the development and delivery of cultural learning online*. Unpublished PhD, London: Institute of Education, University of London.

Esmel-Pamies, C. (2009). *Into the politics of museum Audience research* [E]dition 5, *Tate Encounters*. London: Tate Publishing.

Gournelos, T., & Gunkel, D.J. (Eds.). (2012). *Transgression 2.0 Media, culture, and the politics of a digital age*. London: Continuum.

Greub, S., & Greub, T. (2006). *Museums of the twenty-first century: Concepts, projects, buildings*. Munich: Prestel.

Gunkel, D.J. (2012). Audible transgressions: Art and aesthetics after the mashup. In T. Gournelos & D.J. Gunkel (Eds.), *Transgression 2.0 Media, culture, and the politics of a digital age* (pp. 42–56). London: Continuum.

Haanstra, F. (2003). Visitors' learning experiences in Dutch museums. In M. Xanthoudaki, L. Tickle, & V. Sekules (Eds.), *Researching visual arts education in museums and galleries: An international reader*. Amsterdam: Kluwer Academic Publishers.

Heidegger, M. (1954). *The question concerning technology*. New York, NY: Harper-Collins Publisher.

Higgins, C. (2009, July 8). "Our future lies on the web, say museum heads'. *The Guardian*.

Hirshi, K., & Screven, C. (1988). Effects of questions on visitor reading behaviour. *ILVS Review, 1*(1), 50–61.

Jenkins, H. (2006). *Convergence culture: Where old and new media converge*. New York, NY: New York University Press.

Jones, S. (2010). Negotiating authentic objects and authentic selves: Beyond the deconstruction of authenticity. *Journal of Material Culture*, http://mcu.sagepub.com

Jordan, P. (2010). *Art authority* [Review of the app for iPad *An Incredible Virtual Art Museum*]. Available from http://ipadinsight.com/ipad-app-reviews/review-art-authority-for-ipad-an-incredible-virtual-art-museum/

Lovink, G. (2002). *Dark fibre: Tracking critical internet culture*. Cambridge, MA: MIT Press.

Lovink, G. (2011). *Networks without a cause: A critique of social media*. Cambridge, MA: Polity Press.

MacGregor, N., & Serota, N. (2009). The museum of the 21st century. Available from http://www.lse.ac.uk/events

Meecham P., and Sheldon J. (2009) Making American Art London and New York: Routledge.

Morris, Hargreaves & McIntyre (2007). *Audience knowledge digest: Why people visit museums and galleries, and what can be done to attract them*. MHM and Renaissance North East.

Museums Libraries Archives Council (MLA) (2008). Inspiring learning For all: An improvement framework for museums, libraries and archives. Available from http://www.inspiringlearningforall.gov.uk

O'Sullivan, S. (2001). The aesthetics of affect: Thinking art beyond representation. *Angelaki Journal of Theoretical Humanities, 6*(3), 125–134.

President's Committee on the Arts and the Humanities (2011). *Reinvesting through arts education: Winning America's future through creative schools*. Washington, DC: PCAH.

Quiroga, R.Q., Dudley, S., & Binnie, J. (2011). Looking at Ophelia: A comparison of viewing art in the gallery and the lab. *Neurology in Art, 11*(3), 15–18.

Re:Source: The Council for Museums, Archives and Libraries, later the now defunct Museums Libraries Archives (MLA) Council (October, 2001). *Renaissance in the regions: A new vision for England's museums*. London: MLA.

Rudacliffe (2010). Quoted in President's Committee on the Arts and the Humanities (2011). *Reinvesting through arts education: Winning America's future through creative schools*. Washington, DC: PCAH.

Smith, C. (1998). *The comprehensive spending review: A new approach to investment in culture*. London: DCMS.

Taylor, B.L. (2001). The effect of surrogation on viewer response to expressional qualities in works of art: Preliminary findings from the Toledo picture study. *Museums and the Web*. Available from http//www.museumsandtheweb.com/mw2001/papers/taylor/taylor.html.

Taylor, B.L. (2010). Reconsidering digital surrogates: Toward a viewer-orientated model of the gallery experience. In S.H. Dudley (Ed.), *Museum materialities: Objects, engagements, interpretations* (pp. 175–185). London: Routledge.

Wallach, A. (2003). "Norman Rockwell" at the Guggenheim. In A. McClellan (Ed.), *Art and its publics: Museum studies at the millennium* (pp. 96–115). Oxford: Blackwell.

Waterton, E., & Watson S. (Eds.). (2010). *Culture, heritage and representation: Perspectives on visuality and the past*. London: Ashgate Publishing.

Whitehead, C. (2012). *Interpreting art in museums and galleries*. London: Routledge.

Williams, R. (1974). *Television: Technology and cultural form*. Technosphere Series, London: Collins.

3 The Connected Museum in the World of Social Media

Lynda Kelly

George Brown Goode was an ichthyologist and secretary of the Smithsonian, the world's largest museum and research complex based in the United States. He was renowned as a museum thinker, and his writings are widely read. In the late 1800s, Goode stated that 'the museum must, in order to perform its proper functions, contribute to the advancement of learning through the increase as well as through the diffusion of knowledge' (Goode, 1891/1991, p. 337). Goode identified that the nature of museum work was not only around knowledge creation but knowledge generation and ultimately, learning. In 1999 Stephen Weil, the US-based museum theorist, declared that museums must transform themselves from '. . . being about something to being for somebody' (Weil, 1999, p. 229). In 2012 the ways museums communicate and interact with their audiences has undergone a rapid and profound transformation. This has been especially noticeable over the past five years, due to the rise of the Internet and social media together with the explosion in mobile technologies.

In diffusing the knowledge that Goode referred to, museums now operate across three spheres: Their physical site, the online world (via websites and social media) and in the mobile space. Coupled with this is the reality that audiences are constantly shifting and changing. Access to a raft of information and rich, interactive experiences are now available on most peoples' phones, on-demand. Social media sites such as Facebook, Twitter and Pinterest are becoming the standard places for people to share their experiences and communicate with others, increasingly via a mobile device. Australian research has found that audiences want to interact with museums in a two-way relationship that encourages learning and exchange (Kelly, 2007; Kelly & Groundwater-Smith, 2009; Kelly & Russo, 2010). The rapid spread of social media offers museums the opportunity to redefine relationships with their audiences and now provide platforms for these interactions.

What does this changing relationship between museums and audiences mean for institutional practices? Based on my ongoing research at the Australian Museum in Sydney, I identify the following six themes as being key to answer this question and, on a grander canvas, as instrumental catalysts for the transformative museum now and in the future:

- We are social
- We are mobile
- We are digital learners
- We are participatory and sharing
- Our skills and toolkits are broad, combining both traditional and new ways of working
- We embrace organizational change

This chapter unpacks each of these and discusses what they mean for the transformative museum. Research undertaken by the Australian Museum, Sydney, into visitors' behavior in the online and mobile spaces will be used to illustrate each theme where relevant.

THEME ONE: WE ARE SOCIAL

The Internet, and particularly social media, has fundamentally changed the nature of human communication. According to the US-based literary scholars Davidson and Goldberg (2009), humans are currently in the fourth great information age. Since early times, humans have experienced periods of massive change beginning with the invention of writing; followed by the move from the scroll to codex; then the emergence of the printing press; and now, the Internet and mobile communication. While each of these ages brought with them tremendous change and societal disruption, the Internet has been both the fastest growing, and with the widest geographic spread. There is not one part of the world the Internet has not touched, and the same can now be said of mobile technologies. What does this mean for museums? In speculating about the effect of the Internet on museums, the US-based museum writer and theorist Elaine Heumann Gurian identified that 'the use of the internet will inevitably change museums. How museums respond to multiple sources of information found on the Web and who on staff will be responsible for orchestrating this change is not yet clear. The change when it comes, will not be merely technological but at its core philosophical' (Gurian, 2010, p. 95).

In the past five years one of the biggest innovations on the Internet has been the emergence of social media that enable large social networks to form around common causes and special interests. Social media has been defined as the '. . . term for the tools and platforms people use to publish, converse and share content online. The tools include blogs, wikis, podcasts, and sites to share photos and bookmarks" (Tangient, 2012, n.p.). An important component of social media is the idea of social networking, which refers to '. . . online places where users can create a profile for themselves, and then socialise with others using a range of social media tools including blogs, video, images, tagging, lists of friends, forums and messaging' (Tangient, 2012, n.p.). Twitter, YouTube and Facebook are the most widely used social media sites, with Facebook rapidly becoming the most popular

site across all age groups and on a global scale. The Pew Research Center provides information about how the Internet is shaping and impacting on America and the world across a range of areas including education. Recent research conducted by the center estimated that there are over 500 million Facebook users worldwide, or 1 in every 13 people on Earth, with over 50% logging in each day. The fastest growing use of Facebook across the world is adults over 55 years old (Zickuhr & Madden, 2012, p. 2).

Social media provides platforms that encourage and support participatory communication which, in turn, is transforming the relationships that institutions have with their constituents. This is particularly noticeable in the educational sector, including schools, universities and museums. The ways these platforms can enhance communication are illustrated through two examples—the use of Twitter in university settings and museum visitors' use of social media.

Social Media as an Educational Tool: Twitter in Higher Education

A study of US colleges and universities found that 61% of the respondents in 2007–2008 reported they used at least one form of social media. One year later it was reported that 85% of college admissions offices were using at least one form of social media. However, in 2009–2010 that number rose to 95%, and in the latest research 100% of colleges and universities sampled were using some form of social media in both their communications with students outside of the university, as well as within their face-to-face programs (Barnes & Lescault, 2012).

A good example of how educational institutions can leverage social media is through the use of Twitter. According to a case study reported by the US-based educator Greg Ferenstein (2010), educators are turning to Twitter to increase involvement of students through broadening their participation and creating a community of learners. It was felt that Twitter addressed the problem of little to no participation in classroom discussions, as described by one teacher participant: 'Classroom shyness is like a black hole: Once silence takes over, it never lets go . . . in a class of hundreds, the fraction of students who speak up is small, and a still tinier fraction contribute regularly' (Ferenstein, 2010, n.p.). Experimenting with Twitter resulted in bringing vastly more students into the discussion, with another teacher participant noting that 'it's been really exciting because, in classes like this, you'll have three people who talk about the discussion material, and so to actually have 30 or 40 people at the same time talking about it is really interesting' (Ferenstein, 2010, n.p.).

When trying to establish a community of learners, educators have often found difficulties in encouraging and continuing intellectual discussions outside of the classroom. As Ferenstein also reported, Twitter was found to be the ideal tool to keep conversations going both during and after formal classes, as a teacher participant observed: 'I found that Twitter chatter

during class spilled over into the students' free time. The first thing I noticed when the class started using Twitter was how conversations continued inside and outside of class. Once students started Twittering I think they developed a sense of each other as people beyond the classroom space, rather than just students they saw twice a week for an hour and a half. As a result, classroom conversation became more productive as people were more willing to talk, and [be] more respectful of others' (Ferenstein, 2010).

Museums across the world have been active on Twitter for many years, using it for a variety of purposes such as engaging audiences in discussions, a marketing tool, sharing collections, promoting websites and blogs and across the sector as a professional development sharing tool. However, the ability for institutions to use Twitter for such a range of activities may cause problems regarding the museum's 'voice' and potential diffusion of the brand. In those cases, the strategy needs to be one of integration, ensuring that those responsible for social media across an institution are cognizant of the potential conflicting messages that could eventuate. The capacity for Twitter to be used within museums' physical spaces is also being explored, with the capacity to link Twitter across the three spheres having potential to provide interesting programming opportunities (Bernstein, 2008).

Museums and Social Media

Since 2007 the Australian Museum, Sydney, has been conducting research into both visitors' and non-visitors' use of the Internet generally and social media specifically, with a recent emphasis on mobile technologies. Samples have included a wide range of audience types, with a focus on families, young adults and school students (Groundwater-Smith & Kelly, 2009; Kelly & Groundwater-Smith, 2009; Kelly & Russo, 2008, 2010) and have consistently demonstrated that visitors to museums are using social media in larger numbers than non-visitors.

The first study was conducted in 2007 with an online survey of 2,000 Sydney residents looking at Internet usage and types of websites visited, including a range of social media sites. It was concluded that: '. . . museum/gallery visitors participated at higher levels across all online activities. Apart from using social networking sites, statistical tests revealed that these differences were highly significant across all categories . . . [and] . . . that, not only do those who visit museums participate in more on-line activities, they are engaging in activities that are participatory and two-way' (Kelly & Russo, 2008, p. 90).

This research continued with an increasing emphasis on how visitors and non-visitors were using (or not using) social media. For example, 174 visitors to the museum were surveyed in January 2010 about the types of online activities they had undertaken in the previous six months. As the aim was to see what had changed in the social media landscape and document whether museum visitors were still actively engaged in these spaces, questions largely replicated the 2007 research. This study found that of respondents

- 71% had watched a video on YouTube
- 64% had looked at/added to an online encyclopedia such as Wikipedia
- 57% had used a social networking site like MySpace, Facebook, Bebo
- 53% had read customer ratings/reviews online
- 44% had read a blog
- 40% had listened to a podcast
- 36% had uploaded a photo to a website such as Flickr
- 34% had used a wiki
- 25% had added a rating/review to a website
- 25% had participated in a discussion board/forum
- 16% had added a video or audio they created to a website
- 15% published their own webpage
- 14% had used Twitter
- 13% made a comment on a blog

Comparing the 2007 and 2010 studies demonstrated that, not only had participation in social media increased generally, but visitors to the museum still had a propensity to be engaged in social media sites, reading and commenting on blogs, as well as watching videos. To continue to unpack these findings, instead of merely asking had they used these tools, our further research examined how audiences actually used these tools. Two studies were undertaken in April and May 2010: One sampling visitors to a range of museum exhibitions and programs, and the second consisting of an online survey of 1,000 Sydney residents.

In the first study, 169 visitors completed a survey asking about use of social networking sites, whether they had seen or were members of the museum's social media sites and how comfortable they felt with technology. Results showed that Facebook was by far the most popular site used regularly by museum visitors: 71% had a Facebook account and 45% used it every day, with the primary use for personal interactions. Interestingly, visitors still used Wikipedia (70%) and of those, 20% had added, edited or deleted a wiki page. YouTube remained popular with 62% reporting that they had watched a movie on this channel and 7% adding their own movie. The use of blogs and blogging also increased substantially since 2007, with 37% having read a blog and 31% with their own blog. However, Twitter usage was low, with only 7% having read a tweet, although it is worth noting that of these 67% had a Twitter account.

To compare visitors' and the broader communities' use of social media 1,000 Sydney residents completed an online survey during May 2010. A range of questions were asked including general interests and lifestyle, museum visiting habits, as well as uses of social media. Results showed that social media usage across this broader sample was almost identical to museum visitors. For example, 71% had a Facebook account, although usage tended to be lower with 34% reporting using Facebook every day. Wikipedia usage was the same as visitors—70% had visited Wikipedia and 13% added, edited

or deleted a wiki page. YouTube watching also remained popular with 72% watching a movie on YouTube and 7% having added their own movie. Blog usage across this sample was noticeably higher than museum visitors: 52% had read a blog, and 23% had their own blog. The use of Twitter was also higher with 23% stating they had read a tweet, with 69% of these having a Twitter account.

Participants were also asked whether they had visited the Australian Museum in the previous 12 months. As in the 2007 research, the data from this subsample of visitors showed that significantly more people who had visited the museum had accessed YouTube, read blogs and tweets, had a Facebook account and visited and added to Wikipedia. These again show that visitors to the Australian Museum tend to be more actively engaged in social networking and using social media tools than non-visitors.

Surveys continued in 2012, with an added focus on mobile technologies. In March 2012, 100 visitors to *Jurassic Lounge*, a museum evening program primarily targeted to and attended by those aged 18–30, were asked about their social media participation. Even though this sample is skewed toward young audiences who typically use social media, the findings are worth noting especially for institutions targeting this audience. The reported use of Facebook was substantial with 91% having a Facebook account and of these 78% using it for personal communication and 13% professionally. Other findings included that 80% had read a blog; 21% having own blog and 34% having read or written a blog in the previous month. Wikipedia is still widely used: 92% had read a wiki page, with 34% the previous month and 12% having added to a wiki page. Twitter results also increased with 55% of respondents having read a tweet; 26% having a Twitter account and 22% using Twitter in the previous month. Interestingly, when asked which *one* mobile application they could keep on their smartphone the application they would most keep was Facebook, at 31%, significantly more than the next most mentioned application (mapping at 16%).

Respondents were also asked about Pinterest, a relatively new social network that is becoming increasingly popular (see Cabalona, 2012; Rydholm, 2012). Pinterest is rapidly becoming '. . . the third most-used social media platform in the United States. It ranks in after Facebook and Twitter, and before LinkedIn . . .' (Dilenschneider, 2012, n.p.). This site is '. . . a pin board-style social photo sharing website that allows users to create and manage theme-based image collections such as events, interests, hobbies and more. Users can browse other pin boards for inspiration, 're-pin' images to their own collections, and 'like' photos' (Danielle, 2012, n.p.). The biggest advantage of Pinterest is that it directly links to users' Facebook and Twitter accounts, thus becoming instantly accessible to an individual's already established networks, without having to form new ones. Interestingly, the museum study found that 45% of respondents had heard of Pinterest; 14% had viewed images on Pinterest; 6% had added images to their own account

and 12% used/seen Pinterest in the last month. While this result may be explained by the demographic, a survey of Australian Museum members conducted in May 2012 found that 28% had heard of Pinterest, and 11% viewed images on this site.

Taken together, this body of work over six years consistently demonstrates that those who visit museums generally, and the Australian Museum specifically, use social media tools in greater numbers than non-visitors. The Pinterest example also demonstrates that museum visitors adopt new social media sites in greater numbers than expected. These results mean that, not only should museums continually monitor online and social trends and regularly ask their physical visitors about their online networking activities, museums need to also think about the types of physical experiences provided to visitors who are increasingly used to engaging in participatory activities in their everyday lives.

THEME TWO: WE ARE MOBILE

There is no doubt that mobile technologies and smartphones are changing the very ways humans communicate and access information, becoming more accessible and ubiquitous. According to Google's latest research on smartphone ownership, 'Six countries have the highest smartphone adoption: Australia, UK, Sweden, Norway, Saudi Arabia and the United Arab Emirates all have more than 50% of their population on smartphones. An additional seven countries—the United States, New Zealand, Denmark, Ireland, Netherlands, Spain and Switzerland—now have more than 40% smartphone penetration. These numbers show that a global mobile movement is happening as smartphone adoption moves mainstream. Mobile devices have become indispensable to people's lives and are driving massive changes in consumer behavior' (Pham, 2012, n.p.), as well as how people now access information and learn, which, in turn, raises new sets of challenges in terms of information literacies such as searching, accessing and referencing.

Museums are rapidly recognizing both the potential application of mobiles in their programming (Burnette, Cherry, Proctor & Samis, 2011) and the impacts of mobiles on visitor learning and engagement (Kelly, 2011a). However, to date, there has been little research into visitors' use of mobile technologies. Dowden and Sayre, US-based museum technologists noted that 'just as the world wide web has redefined the public role of museums, hybrid mobile devices promise to improve by allowing museums to focus on content and strategy rather than hardware, while taking full advantage of the tools and technologies of a multi-networked world' (Dowden & Sayre, 2007, p. 35). They identified that museums needed to seize the opportunity to take advantage of mobile technologies as they provide ubiquitous access to content, across multiple channels and multiple devices, allow for personalization and geospatial applications.

For museums, mobile technologies can provide deeper, richer and more interesting ways for visitors to interact with collections and research, either within the physical museum site or elsewhere. Layered information and rich media (audio, video, images and text) are typical ways to extend the museum experience to a mobile device. However, the main advantage of mobile is that it enables opportunities for visitors to participate and contribute wherever they happen to be and whenever they choose to do so which, in itself, presents a significant challenge for museums in determining the best ways to provide these.

Surveys conducted at the Australian Museum since May 2011 have continually demonstrated that smartphone ownership among visitors is high, yet more recently the types of smartphone ownership is diversifying. For example in May 2011, 72% of those surveyed had an iPhone, and in November 2011, 60% had an iPhone. However, even though in March 2012 this remained relatively stable at 59%, a much broader range of phone types were recorded. The Android platform, while relatively slow to take off in Australia, is continuing to rise and it has been predicted that this will be the worldwide standard in a few years (Frommer, 2011).

One mobile technology increasingly being used by museums are QR codes (Kelly, 2011b). QR (or quick response) codes are similar to barcodes, in that the user scans an image and is taken (usually) to a website with further information, rich content or even special offers and discounts. However, the museum's research found that these have been slow to take off, with the most recent visitor survey (March 2012) finding that of those sampled, 64% did not know what a QR code was; 19% knew about them but had not used them; with only 13% having scanned and used QR codes. Despite these findings, QR codes have the potential to extend the visitor experience in a fairly easy and cost-effective way, although how they are practically applied and placed requires careful attention.

Given the increasing attention to developing mobile applications by museums, how people learn in the mobile space has not yet been widely researched or recognized as an area of investigation by museums, as they are often focused on developing stand-alone mobile applications based around orientation to their physical sites.[1] For museums that establish their educational programs on constructivist principles (Hein, 1998; Kelly, 2011a), mobile learning is an ideal platform to meet this mode of learning, being described as accessible from anywhere, providing access to a wide range of learning materials, collaborative and providing instant feedback. The features that mobiles allow for include the ability to access rich media, enabling personalization, being always available and providing a social experience with high levels of interactivity and engagement (Dowden & Sayre, 2007). The Digital Youth Project (Ito, 2008), a study of how young people are engaging with technology in the United States, found mobile technologies provide opportunities to rethink social norms, develop technical skills, experiment with new forms of social expression, share—extend social worlds, engage in self-directed learning—explore interests, and encourage independence.

In their physical form, museums are sites where learning is expected, as well as where learning happens (Kelly, 2007). In the mobile sphere, further research needs to be undertaken to understand both the potential for mobile applications to be linked back to the museum's physical and online offerings, and as a rich, deep learning experience for users. Mobile technologies have the unique capacity to connect people wherever they happen to be, thus advancing social networking and the ability for collaboration and cocreation (for example, in sourcing and sharing information about a particular object a museum knows little about, or through using a voting function to gauge opinions about a particular issue or topic the museum may be considering an exhibition about).

For the connected museum, the rise of mobiles also demands new processes and new ways of working under a process that may be called "agile development". However, museums are often locked into ways of working based on how exhibitions are developed, that is, with long timelines and (sometimes) big budgets, large project teams and not responsive to change. These processes have resulted in a mindset of museum staff that is not attuned to working in an agile way, which relies on an iterative process and may result in releasing a product that may only be "half-finished" (Kelly, 2011c). This approach can be difficult for museum practitioners who are more familiar working under more traditional modes of operation, and specific ways of thinking about authority and power (these issues are further unpacked in theme four below).

THEME THREE: LEARNING IN 140 CHARACTERS

We are all digital learners, and there is increasing attention being paid in the literature to learning in the digital age (see, for example, Davidson & Goldberg, 2007; Drotner, Jensen & Schrøder, 2008). The Horizons Project, established in the United States in 2002 by the New Media Consortium, looks at emerging technologies and what these mean for teaching, learning and education. In the 2010 report (Johnson, Levine, Smith & Stone, 2010) a number of key trends were highlighted with five in particular having implications for museum practice.

The first trend was the idea that 'people expect to be able to work, learn, and study whenever and wherever they want to' (Johnson et al., 2010, p. 4). This implies that visitors will learn not only in the museum's physical space even while they are actually in the physical space. Visitors are now able to access whatever content they like from wherever they happen to be. A second trend identified was that 'it does not matter where our work is stored; what matters is that our information is accessible no matter where we are or what device we choose to use' (Johnson et al., 2010, p. 4). This raises several questions for the connected museum, such as how are they enabling their collections and other scientific data to be accessed remotely? How are museums relating the physical objects on display with

deep, rich information available across a range of online platforms, including mobile?

The third trend revolves around collaboration: 'The work of students is increasingly seen as collaborative by nature' (Johnson et al., 2010, p. 4). Museums will need to recognize that the boundaries between their audiences and the institution is breaking down. How are museums encouraging social learning and collaboration between the physical, online and mobile spaces? The fourth trend concerns the role of educational institutions and training students for future learning: 'It is incumbent on the academy to adapt teaching and learning practices to meet the needs of today's learners; to emphasise critical enquiry and mental flexibility . . . to connect learners to broad social issues through civic engagement; and to encourage them to apply their learning to solve large-scale complex problems' (Johnson et al., 2010, p. 4) Museums have always been about engaging audiences with big issues. According to worldwide studies on museums and controversy led by Australian museum researchers Cameron and Kelly (2010), visitors have constantly expressed an interest in being challenged and having their say on controversial topics. What better way than using online tools to harness the power of citizens?

The final trend impacting on museums concerns digital literacy: 'Digital media literacy continues its rise in importance as a key skill in every discipline and profession' (Johnson et al., 2010, p. 5). How are museums setting themselves up to keep abreast of these skills? How are they changing the types of skill sets and types of employees the institution recruits? How are museums changing the ways they work to meet the requirements of the digital world? The report also states that '. . . digital literacy must necessarily be less about tools and more about ways of thinking and seeing, and of crafting narrative' (Johnson et al., 2010, p. 5). Museums are ideal places where stories can be told that encourage visitors to make their own meanings. The US-based museum consultant Leslie Bedford notes that 'stories are the most fundamental way we learn. They have a beginning, a middle, and an end. They teach without preaching, encouraging both personal reflection and public discussion. Stories inspire wonder and awe; they allow a listener to imagine another time and place, to find the universal in the particular, and to feel empathy for others. They preserve individual and collective memory and speak to both the adult and the child' (Bedford, 2001, p. 33). Kathleen McLean (2003), a prominent museum consultant in the United States, describes the ways visitor experiences may be constructed in different types of learning environments, using the analogy of campfires, caves and wells: in other words, places that humans have gathered for centuries. It will be interesting to see how the use of narratives can be developed and linked to digital learning. To take McLean's metaphor further, the next gathering spaces for humans could be around some type of screen—whether that be via a mobile device or a social networking site such as Facebook, where the sharing of narratives are not only encouraged, but actively supported through Facebook's timeline and wall-posting capabilities.

Digital Learners and Museums

Museum educator Deborah Howes notes that 'the Internet is an ideal platform for achieving all of the educational goals while also enabling visitors to experience the joy of learning in a self-directed environment—like they do in a museum' (Howes, 2007, p. 77). However, how can this be achieved? In November 2009 the Australian Museum held a series of workshops with primary and secondary teachers to find out how they use the Internet in their classrooms and how the museum could best leverage their online resources in working more closely with them and their students.

Participants identified a number of issues that they felt would impact museums and on educational audiences in future. These included:

- widespread prevalence of smartphones for students (and teachers) so mobile web will become important
- wireless schools—no longer are students/teachers tied to a classroom or even their own school environment
- students value their social networks and peers' opinions and information rather than "experts"
- teachers are no longer "repositories of information" but are facilitators of students' learning—the relationship is more two-way and equal
- there is a move toward digital books primarily to reduce bag weight but also to save costs
- students expect instant feedback as they are used to this in their lives
- we are now dealing with "digital learners"—kids in the future will never not have had their hands on something that does not plug in
- kids are now totally multitasked—where in the past this would be seen as a negative, we now need to see this as a normal part of learning
- social and collaborative learning is now the way we all learn
- childrens' brains are changing to accommodate the ways they now learn and engage
- they do not need to retain/remember information as they can just go back and access it again
- we have moved from a one-to-many form of teaching to a many-to-many approach and a more equal arrangement and a more empowered one
- the beauty of sharing online is that students can see each others' work and learn from that

THEME FOUR: SHARED AUTHORITY AND THE PARTICIPATORY MUSEUM

Now, and in the future, social networking will increasingly be the ways citizens will come together under a participatory framework to find innovative solutions on a mass scale utilizing the opportunities for collaboration

provided by social media and mobile technologies. Beth Noveck, who worked as an advisor on the Obama Open Government initiative, outlined how the idea of openness and "wiki-government" underpinned the way the government wised to engage citizens: 'By soliciting expertise (in which expertise is defined broadly to include both scientific knowledge and popular experience) from self-selected peers working together in groups via the Internet, it is possible to augment the know-how of full-time professionals. . . . Collaboration catalyses new problem-solving strategies, in which public and private sector organizations and individual solve social problems collectively' (Noveck, 2009, p. xii).

Regarding citizen input to environmental issues and social media, Australian cultural researcher Juan Salazar speculates that '. . . citizen's media can provide a relevant platform to rethink how museums and science centers present scientific knowledge and encourage civic action' (Salazar, 2010, p. 277) by becoming '. . . relevant cultural brokers that contest current understandings of the complex interfaces and intersections between science, media and citizenship. Perhaps there is a role for participatory citizens' media models to inform how museums and science centers can engage with local communities' (Salazar, 2010, p. 276).

The notion of the participatory museum has been widely reported and discussed (see, for example, Simon, 2010), yet the issues surrounding what this means for the connected museum are still under some debate. In discussing how this idea challenges museums, Rob Stein, deputy director of the Indianapolis Museum of Art, has remarked that 'Participatory Culture is driven by the rise of ubiquitous access to information and media' (Stein, 2011, n.p.). In the same conversation, Shelley Bernstein of the Brooklyn Museum raised the issue of sustaining audience participation:

> How do we create engaging experiences consistently, so that visitors feel participation is part of the overall culture of the institution? I've seen a lot of one-offs, where there's a burst of activity around one single project, but the challenge is creating a consistency so that valued participation is always part of the museum experience. In addition, these projects too often just exist online and not within the walls of the institution when people visit. The challenge is creating an overall experience that works both online and off and one that consistently allows visitors to participate in meaningful ways. (Bernstein, 2011, n.p.)

When discussing visitor-centered participation and participatory design, Dan Spock, director of the History Center Museum, Minnesota, notes that 'if you invite people to really participate in the making of a museum, the process must change the museum' (Spock, 2009, p. 7).

So, now rather than any time in history the Internet, through social media, and mobile technologies enables museums to join together with citizens to solve big problems that museums can take a position on: for example,

climate change, biodiversity, social justice. However, how will museums meet these challenges as they are traditionally slow to embrace change and wish to hold on to their authority and voice? Some clues come from thinking about museum visitors as active members of what has been called "Generation C", citizens who are in control of their own experiences; choose what they will pay attention to, as well as when and how; seek challenges; work and learn collaboratively and are widely connected, operating under the ethos of "I share, therefore I am". The next generation has been called the post-Google generation, being children who will never have known a world without being connected to an electronic device, and most commonly, one that is mobile. In both generations, participation is not only embraced, it is expected, 24/7. However, although there has been some debate surrounding the notion of the digital divide and access, it may be argued that as this technology is becoming more widespread and affordable, participation and connectivity will be even more ubiquitous.

THEME FIVE: MUSEUM 101: WHAT IS OUR TOOLKIT?

A discussion in late 2011 on the *Museum 2.0* blog around the question, "What are the most important problems in our field?" identified three areas for consideration across the sector (Simon, 2011):

1. How can we make cultural knowledge—content, context and experience—as widely, freely and equitably accessible as possible?
2. How can our institutions and programs improve quality of life for individuals and communities?
3. How should we structure our institutions and funding programs to do 1 and 2?

Although these are interesting and timely questions, museums will need to look beyond a focus on institutional structures to the skills and abilities required in the transformative museum. What will be in our toolkits in a future working environment defined by mobility, shared authority and audience participation? I would argue that museum staff now and in the future will be required to be

- content producers across a range of platforms, not just technological ones
- experts in their field, but not the sole experts
- facilitators, not teachers
- storytellers, using the tools of narrative to weave a range of stories around content from a range of perspectives
- sharing policies and practices online
- writing for Twitter, wikis, blogs and Facebook

- navigating content differently
- continually researching and collaborating with an audience using a range of tools to understand and connect with our many and varied audiences
- nimble and flexible, while being rigorous

How can these requirements be integrated into everyday museum practice? US-based museum researchers Herminia Din and Phyllis Hecht (2007), writing about how museum studies needs to embrace digital literacy, note that 'preparing for a career in the museum field today requires a convergence of academic and technical skill training, formal and informal learning, internships, fellowships, membership in professional organizations, networking with peers and colleagues and seeking out mentors. It requires an innovative multilevel approach in order to keep up with the museums' changing landscape. The integration of technology into all aspects of today's training is critical to the future success of the next generation of museum professionals and to the survival of the twenty-first century museum' (Din & Hecht, 2007, p.16).

THEME SIX: ORGANIZATIONAL CHANGE

As Goode said, 'The people's museum should be much more than a house full of specimens in glass cases. It should be a house full of ideas' (1891/1991, p. 306). Channeling the three spheres of operation mentioned in the beginning of this chapter (that is, physical, online and mobile) will make it possible for museums to be places of ideas where audiences and museum staff can work together to create and disseminate knowledge and engage with ideas. To achieve this, museums will need to go back to basics, as Heumann Gurian stated: 'My fundamental assumption is that museums will soon need to shift from being a singular authority to a participants and encourager of intellectual and social engagement among its visitors. In doing so museums will have to look at the administrative assignments and responsibilities of staff in order to become this more responsive institution' (2010, p.108). In an interview with James Turner of O'Reilly Radar concerning museum authority and accountability for museums in a digital world, Mike Edson of the Smithsonian has observed that 'in the last epoch, we were measured by the success of our internal experts. And in this coming epoch, we're going to be measured by the success of our networks at large: Our social networks, our professional networks. People are going to be connected. Ideas will be sharable and portable' (Turner, 2010).

To manage this change organizationally and across the three operational spheres, the connected museum will need to be prepared to let go of authority and take risks through trying new approaches to program development based on audience interests and needs, not on the museums'. It will give staff

permission to fail and learn from these. The museum will encourage and fa-cilitate a broad range of connections and networks, as well as provide scaf-folding and support for others to innovate using their content and material. It will acknowledge that a healthy community will self-monitor and self-correct and be more relaxed about control, keeping in mind the principle of "listen first, act later". Finally, the connected museum will be required to train and support current and future employees for jobs that have not been invented yet, and find new ways to navigate complex issues surrounding pri-vacy, intellectual property and copyright without being held back by them.

CONCLUSION: THE CONNECTED MUSEUM

The Internet and social media, coupled with mobile technologies, are fun-damentally challenging the very nature of institutions. As Noveck noted: 'Social technologies make it possible to join groups online for shared work and play. As a result, there has been much public discussion and scholar-ship about the impact of the Internet on *me*, namely how individuals are responding to life online. Now we are beginning to tackle the question of how it affects *us*, namely how society organises and manages itself through institutions. At this political juncture, the future of governance in the digital age is not simply a descriptive inquiry but also a normative opportunity to change these institutions' (2009, pp. xv–xvi). In observing the effects of Web 2.0 and social media on museums, the British museum researchers Mike Ellis and Brian Kelly, in a Museums and the Web conference presentation, states that Web 2.0 '. . . puts users and not the organization at the center of the equation. This is threatening, but also exciting in that it has the potential to lead to richer content, a more personal experience' (Ellis & Kelly, 2007, n.p.). Taking Weil's notion of museums being for people, social media pro-vides the perfect vehicle to take these ideas further with the transformative museum enabling learners, users, visitors to become participants wherever they are and however they choose. Yet, how willing are museums to imple-ment cross-organizational change and conduct meaningful two-way interac-tions and dialogue with their audiences using tools offered by social media and mobile technologies?

In an early text published by the American Association of Museums and edited by Katherine Jones-Garmil in 1997 looking at museums and their digital activities, a museum technologist stated that 'users need to be taught about new technologies gradually, consistently and persistently' (Hermann, 1997, p. 90). Reflecting on this notion, Din and Hecht remark that 'this is still true; however as technology's effect on museums' business processes and strategic planning grows, staff need to understand the role of tech-nology even more urgently. The training in specific technical skills is still important, but the focus should now be on understanding the conceptual underpinnings of technology in the museum' (Din & Hecht, 2007, p. 16).

In 2012, this need is still urgent and an appreciation of technology still required, however the focus must now shift to creating strong synergies between the physical, online and mobile experiences, while understanding how audiences are interacting and behaving across these three spheres.

Twenty-first-century museum audiences will be better connected, more informed, more engaged, older, more culturally diverse, more interested in ideas and architects of their own learning. They will be mobile, accessing information wherever they are and at whatever time of their choosing, active participants, rather than passive receivers of content and information. Given the opportunities provided across the physical, online and mobile spaces, the connected museum must be flexible, mobile, vibrant and changing and "houses full of ideas". The question still remains, however, is whether museums are really ready to meet these challenges and become truly transformative in a world that is increasingly connected.

NOTE

1. There are exceptions to this, however. See the Twitter hashtag #mtogo for examples.

REFERENCES

Bedford, L. (2001). Storytelling: The real work of museums. *Curator, 44*(1), 27–34.
Bernstein, S. (2008). Where do we go from here? Continuing with Web 2.0 at the Brooklyn Museum. In J. Trant & D. Bearman (Eds.), *Museums and the web 2008: Selected papers from an international conference* (pp. 37–48). Toronto: Archives and Museum Informatics.
Bernstein, S. (2011, October 11). Comment. In Stein, R. Please chime in: The challenges and opportunities of participatory culture (n.p.). *Indianapolis Museum of Art Blog.* Retrieved from http://www.imamuseum.org/blog/2011/10/11/please-chime-in-the-challenges-and-opportunities-of-participatory-culture/
Burnette, A., Cherry, R., Proctor, N., & Samis, P. (2011). Getting on (not under) the mobile 2.0 bus: Emerging issues in the mobile business model. In J. Trant & D. Bearman (Eds.), *Museums and the web 2011: Proceedings.* Toronto: Archives & Museum Informatics. Retrieved from http://conference.archimuse.com/mw2011/papers/getting_on_not_under_the_mobile_20_bus
Cabalona, J. (2012, March 18). How Pinterest can turn your brand red-hot (n.p.). *Mashable Business.* Retrieved from http://mashable.com/2012/03/18/pinterest-brand-attention/
Cameron, F., & Kelly, L. (2010). *Hot topics, public culture, museums.* Newcastle: Cambridge Scholars Publishing.
Danielle, A. (2012, May 18). What on earth is Pinterest? (n.p.). *Agent 99.* Retrieved from http://agent99pr.com/what-on-earth-is-pinterest/
Davidson, C., & Goldberg, D. (2009). *The future of learning institutions in a digital age.* Cambridge, MA: MIT Press.
Dilenschneider, C. (2012, April 9). The early adopter phase on Pinterest is coming to an end (or, 5 reasons for museums to get on Pinterest right now) (n.p.). *Know your own bone.* Retrieved from http://colleendilen.com/2012/04/09/

the-early-adopter-phase-on-pinterest-is-coming-to-an-end-or-5-reasons-for-museums-to-get-on-pinterest-right-now/

Din, H., & Hecht, P. (2007). Preparing the next generation of museum professionals. In H. Din & P. Hecht (Eds.), *The digital museum: A think guide* (pp. 9–18). Washington, DC: American Association of Museums.

Dowden, R., & Sayre, S. (2007). The whole world in their hands: The promise and peril of visitor-provided mobile devices. In H. Din & P. Hecht (Eds.), *The digital museum: A think guide* (pp. 35–44). Washington, DC: American Association of Museums.

Drotner, K., Jensen, H. S., & Schrøder, K. C. (2008). *Informal learning and digital media.* Newcastle: Cambridge Scholars Publishing.

Ellis, M., & Kelly, B. (2007). Web 2.0: How to stop thinking and start doing: Addressing organizational barriers. *Museums and the web 2007: Proceedings.* Toronto: Archives & Museum Informatics. Retrieved from http://www.museumsandtheweb.com/mw2007/papers/ellis/ellis.html

Ferenstein, G. (2009, March 1). How twitter in the classroom is boosting student engagement. *Mashable social media* (n.p.). Retrieved from http://mashable.com/2010/03/01/twitter-classroom/

Frommer, D. (2011, December 1). Why the iPhone market share war with Android actually matters. *Business Insider* (n.p.). Retrieved from http://articles.businessinsider.com/2011-12-01/tech/30462095_1_tablet-market-apps-smartphone-market

Goode, G. B. (1991). *The origins of natural science in America.* S. G. Kohlstedt (Ed.). Washington: Smithsonian Institution Press. (Original work published 1891).

Groundwater-Smith, S., & Kelly, L. (2009). Learning outside the classroom: A partnership with a difference. In A. Campbell & S. Groundwater-Smith (Eds.), *Connecting inquiry and professional learning in education* (pp. 179–191). London: Routledge.

Gurian, E. H. (2010). Curator: From soloist to impresario. In F. Cameron & L. Kelly (Eds.), *Hot topics, public culture, museums* (pp. 95–111). Newcastle: Cambridge Scholars Publishing.

Hein, G. (1998). *Learning in the Museum.* London: Routledge.

Hermann, G. (2007). Shortcuts to Oz: Strategies and tactics for getting museums to the Emerald City. In K. Jones-Garmil (Ed.), *The wired museum* (pp. 65–91). Washington, DC: American Association of Museums.

Howes, D. S. (2007). Why the Internet matters: A museum educator's perspective. In H. Din & P. Hecht (Eds.), *The digital museum: A think guide* (pp. 67–78). Washington, DC: American Association of Museums.

Ito, M. (2008, November 19). Living and learning with new media: Summary of findings from the digital youth project. *Mimi Ito* (n.p.). Retrieved from http://www.itofisher.com/mito/weblog/2008/11/living_and_learning_with_new_m.html

Jensen, B., & Kelly, L. (2009). Exploring social media for front-end evaluation. *Exhibitionist, 28*(2), 19–25.

Johnson, L., Levine, A., Smith, R., & Stone, S. (2010). *The 2010 horizon report.* Austin, TX: The New Media Consortium. Retrieved from http://wp.nmc.org/horizon2010/

Jones-Garmil, K. (1997). *The wired museum.* Washington, DC: American Association of Museums.

Kelly, L. (2007). *Visitors and learners: Adult museum visitors' learning identities.* (Unpublished doctoral dissertation). University of Technology, Sydney.

Kelly, L. (2011a). Learning in the twenty-first century museum: The museum without walls. Paper given at the Learning Museum Network Conference, Tampere, Finland.

Kelly, L. (2011b, September 4). QR codes in 2011. *Web 2U* (n.p.). Retrieved from http://australianmuseum.net.au/BlogPost/Web-2U/QR-Codes-in-2011

Kelly, L. (2011c, April 20). Agile development for museums. *Web 2 U* (n.p.). Retrieved from http://australianmuseum.net.au/BlogPost/Web-2U/Agile-development-for-museums

Kelly, L., & Groundwater-Smith, S. (2009). Revisioning the physical and on-line museum: A partnership with the coalition of knowledge building schools. *Journal of Museum Education, 34*(4), 55–68.

Kelly, L., & Russo, A. (2008). From ladders of participation to networks of participation: Social media and museum audiences. In J. Trant & D. Bearman (Eds.), *Museums and the web 2008: Selected papers from an international conference* (pp. 83–92). Toronto: Archives and Museum Informatics.

Kelly L., & Russo, A. (2010). From communities of practice to value networks: Engaging museums in Web 2.0. In F. Cameron & L. Kelly (Eds.), *Hot topics, public culture, museums* (pp. 281–298). Newcastle: Cambridge Scholars Publishing.

MacArthur, M. (2007). Can museums allow online users to become participants? In H. Din & P. Hecht (Eds.), *The digital museum: A think guide.* (pp. 57–65). Washington, DC: American Association of Museums.

McLean, K. (2003). In the cave, around the campfire, and at the well. Paper presented at the International Councils of Museums-CECA Annual Conference, Oaxaca, Mexico.

Noveck, B. (2009). *Wiki government: How technology can make government better, democracy stronger and citizens more purposeful.* Washington, DC: Brookings Institution Press.

Pham, D. (2012, May 15). New research shows 6 countries are the clear leaders in smart-phone adoption: Do you know which ones? *Google mobile ads blog,* (n.p.). Retrieved from http://googlemobileads.blogspot.com.au/2012/05/new-research-shows-6-countries-are.html

Rydholm, J. (2012, February 24). A Pinterest primer. *Quirk's marketing research media.* Retrieved from http://quirksblog.com/blog/2012/02/24/a-pinterest-primer/

Salazar, J. (2010). "MyMuseum": Social media and the engagement of the environmental citizen. In F. Cameron & L. Kelly (Eds.), *Hot topics, public culture, museums* (pp. 265–280). Newcastle: Cambridge Scholars Publishing.

Simon, N. (2010). *The participatory museum.* Santa Cruz, CA: Museum 2.0. Retrieved from http://www.participatorymuseum.org/

Simon, N. (2011, October 3). What are the most important problems in our field? *Museum 2.0* (n.p.). Retrieved from http://museumtwo.blogspot.dk/2011/10/what-are-most-important-problems-in-our.html

Spock, D. (2009). Museum authority up for grabs: The latest thing or following a long trend line? *Exhibitionist, 28*(2), 6–10.

Stein, R. (2011, October 11). Please chime in: The challenges and opportunities of participatory culture. *Indianapolis Museum of Art Blog* (n.p.). Retrieved from http://www.imamuseum.org/blog/2011/10/11/please-chime-in-the-challenges-and-opportunities-of-participatory-culture/

Tangient (2012). Short AZ. *Social media* (n.p.). Retrieved from http://socialmedia.wikispaces.com/ShortAZ

Turner, J. (2010). When it comes to new media, the Smithsonian is all in. *O'Reilly radar* (n.p.). Retrieved from http://radar.oreilly.com/2010/05/how-the-smithsonian-keeps-up-w.html

Weil, S. (1999). From being *about* something to being *for* somebody: The ongoing transformation of the American museum. *Daedalus, 128*(3), 229–258.

Zickuhr, K., & Madden, M. (2012). *Older adults and Internet use.* Washington, DC: Pew Research Center's Internet & American Life Project. Retrieved from http://www.pewinternet.org/~/media//Files/Reports/2012/PIP_Older_adults_and_internet_use.pdf

Part II

Researching the Dilemmas
The Iterative Design/Research Process

4 'One Way to Holland'
Migrant Heritage and Social Media

Randi Marselis and Laura Maria Schütze

Museums in many parts of the world are challenged by increased diversity within the populations that make up their potential audiences, and many museums of cultural history now acknowledge the culture of ethnic minority groups as an important subject in multiethnic societies. A central issue in these museum practices is the question of how to collaborate with source communities, understood as "groups in the past when artifacts were collected, as well as their descendants today" (Peers & Brown, 2003, p. 2). Collaboration with source communities does not adhere only to "old" collections in ethnographic museums, but is also relevant to ongoing collection practices. An important theme in relation to source communities is ownership and repatriation of cultural objects. Furthermore, working with source communities implies a two-way information process through which groups are given access to memory materials and the expertise of museum staff but are at the same time recognized as able to contribute with valuable perspectives on their own culture (Peers & Brown, 2003, p. 1). This chapter examines how the Tropenmuseum in the Netherlands, one of Europe's largest ethnographic museums, has used Facebook, Twitter, Flickr as well as the museum's blog to reach migrant communities in order to collect and share information and stories related to photographs of postcolonial migrants. Through combining these different social media with promotion of the related off-line photo exhibition in print media, the museum connected to individuals within the relevant source communities, who were able to help unfold the stories behind the photographs.

MUSEUMS AND SOCIAL MEDIA

Since the emergence of the Internet in the mid-1990s, museums have been quick to engage this new platform for communicating with the audience. The Internet "became just another of the multiple channels that museums were already building" (Parry, 2007, p. 97) and have been building since the first outreach projects by museums in the beginning of the 1960s, according to the British museologist Ross Parry (2007, p. 96). The dynamics of this first

generation of the web were such that the audiences had "the means (through digital network hypermedia) to initiate and create, collect, and interpret in their own time and space, on their own terms" (Parry, 2007, p. 102). Yet in order to initiate the online "visit", the museum had to draw users to the museum website, which was not always that easy. In contrast, social network media have the great advantage of engaging people where they actually are (Kalfatovic, Kapsalis, Spiess, Camp & Edson, 2008, p. 270). As the web has developed toward a more participatory culture often referred to as Web 2.0, social networking sites like Wikipedia, Facebook, Twitter, Flickr, and YouTube have emerged, and many museums have also become familiar with incorporating social networking sites as part of their outreach and communication strategies. According to the American exhibition designer Nina Simon, Web 2.0 can be used by cultural institutions to reach audiences that normally do not visit the onsite museum, and can thereby "reconnect with the public and demonstrate their value and relevance in contemporary life" (Simon, 2010, p. i). This point is also stressed by the production coordinator at the United States Holocaust Memorial Museum, Amelia Wong, who uses the term *social media outreach* to describe the potential for expanding and diversifying audiences, as well as for making "traditional-seeming institutions less intimidating and more regularly present in everyday life" (Wong, 2012, p. 281). One of the opportunities created by social media is that museums can use them as "a form of open storage or open exhibition space" (Wong, 2012, p. 285). Making objects that are part of the cultural heritage of specific groups visible through social media may be one way to further the outreach programs and community collaboration already taking place off-line within many museums.

This potential has been realized by many museums on both small and large scales. On the large scale, the Flickr Commons was launched in January 2008 "to increase access to publicly held photography collections [. . .and. . .] to provide a way for the general public to contribute information and knowledge" (Flickr, n.d.). By June 2012, 56 cultural institutions such as NASA, Brooklyn Museum, and Stockholm Transport Museum had joined the Commons. The Smithsonian, USA, joined in 2008 because they wanted "to go where visitors are and not requiring them to come to us" (Kalfatovic et al., 2009, p. 270). The British senior lecturer in information studies Andrew Flinn has described a number of projects like Your Archives, The National Archives, UK, and The Polar Bear Expedition Digital Collections, Michigan University, USA, where museums and archives use social software and participatory software for "harnessing and sharing community knowledge" (Flinn, 2010, p. 43; see also Wong, 2012). The use of social media is not attractive just for large museums but indeed also for small museums that do not have the resources to build large web exhibitions. The Danish Immigration Museum uses Facebook to communicate about immigration issues and collect personal stories about immigration for the museum database (F. G. Børsting, personal communication, April 11, 2012). We also see this

incorporation of Facebook in source community collection strategies in many other museums' use of Facebook and Twitter, for example, Medical Museion, Denmark; and Lower East Side Tenement Museum, New York.

The minority museum Museum Maluku, the Netherlands, which is of special relevance for the present chapter, has been very successful in using Facebook to collaborate with source communities in the Netherlands as well as in Indonesia. The museum's Facebook profile performs an important role in relation to the source community. It is used to communicate with the Dutch-Moluccan community and acknowledge cultural events and memories of this group. But Facebook postings are also used to articulate ongoing relations to the Moluccan Islands (today part of Indonesia), and it has the potential to connect the museum to Moluccans living outside of the Netherlands. Small museums' presence in social media might seem less spectacular than large institutions' elaborate web initiatives. However, as we hope to demonstrate below, it is important to base studies of museum engagement strategies through social media not on the size of an institution but rather on the depth of the relation to the source communities. It is this depth, we argue, that is important for this kind of communication to be successful.

THE TROPENMUSEUM

The Tropenmuseum opened in 1926 and was built as a colonial museum. The museum was given its present name in 1950, after the Dutch had been forced to acknowledge Indonesia's independence in 1949. According to the Australian historian Robert Aldrich (2010), colonial history was "largely erased" from the exhibitions for many years, but today the museum takes a "thorough and thoughtful" approach to this part of Dutch history (2010, pp. 24–25). The museum has a large website, and parts of the museum's collection are accessible through a variety of web-based databases, that is, the museum's own database, the Virtual Collection of Masterpieces, and Wikimedia Commons (de Rijcke & Beaulieu, 2011). When it comes to social networking sites, the museum is present on YouTube, Flick, Facebook, and Twitter. Furthermore, curators have been blogging about their work. Since the museum has a broad ethnographic profile and is focusing not only on migration and minority groups in the Netherlands, the museum could potentially connect with a wide variety of source communities both in the Netherlands and beyond.

In this chapter, we focus on the use of social media in relation to one specific exhibition at the Tropenmuseum. In 2010, the museum held an exhibition of photographs by Leonard Freed (1929–2006), an acclaimed American photographer. The special exhibition showed photographs from the period 1958–1962 that portray postcolonial migrants arriving from the former colony of Dutch East India, which is now Indonesia. The museum's exhibition of these early Freed photographs may be said to have an element of visual repatriation, since the photographs are shown in the context in which they

were originally taken, and is thereby reinserted into contemporary Dutch discourses on postcolonial cultural memory work. In order to collect information about persons in the photographs, curators at the museums experimented with using blog posts, Flickr, Facebook, Twitter, and the Dutch social networking site Hyves in order to reach source communities.[1] Our examination of this project is based on observations of the interaction between museum staff and users taking place on the social network sites as well as on background information obtained through a collective interview with the curator of the culture and history of Southeast Asia, Pim Westerkamp; and the producer of digital media, Susanne Ton.[2]

POSTCOLONIAL MIGRATION TO THE NETHERLANDS

In 1945, Indonesia declared its independence from the Netherlands, but the war of independence went on until 1949 when the Netherlands acknowledged Indonesian sovereignty. Postcolonial migration from Indonesia started immediately after the Second World War and continued until the early sixties. While all the groups arriving had been closely connected to the colonial system, their status within the colony had also been quite diverse. Freed photographed two groups of postcolonial immigrants, *Indische Nederlanders* and Moluccans, and these postcolonial migrants as well as their descendants may be considered to be the source communities of the photo exhibition 'One way to Holland'.

The Indische Nederlanders were Eurasians, descendants of "mixed" families created through interracial marriages, and they held Dutch citizenship. By 1942, this group comprised approximately 175,000 people (Ostindie, 2010, p. 25). Most of these would later become "repatriates," which, although most of them had never before been to the Netherlands, was the common term applied to Dutch citizens arriving from Indonesia. They had experienced discrimination in the colonial system, and after the Second World War, the Dutch government discouraged their coming to the Netherlands (Oostindie, 2010, p. 87; van Leeuwen, 2009, p. 18). However, the Indische Nederlanders were seen by many Indonesians as traitors, and their life in the new republic became increasingly difficult (van Leeuwen, 2009, p. 18). From about 1952, Indische Nederlanders began to immigrate to the Netherlands, and during the New Guinea crisis in 1957, President Sukarno ordered all Dutch citizens to leave immediately, so the last big group of Indische Nederlanders arrived in 1958. Many of the people portrayed by Leonard Freed were amongst these latest repatriates, and as it says in the introduction to the photo exhibition at the Tropenmuseum's website: "Freed follows them from the boat, to temporary camps, with relatives, on the street, in their work, and in school" (the Tropenmuseum, 2010a).

The second group of postcolonial migrants that Freed photographed, the Moluccans, had in colonial time the status of natives, and did not have

Dutch citizenship. The Moluccans were soldier families originating from the Moluccan Islands in the eastern part of the colony, and the men had served in the Dutch colonial army (Smeets & Steilen, 2006). These Moluccan soldiers had fought on the Dutch side during the Second World War and during the following war between Indonesia and the Dutch colonial power over Indonesian independence. When the Netherlands finally acknowledged Indonesian independence, the colonial army was to be demobilized, and the soldier families wished to settle in the Moluccas. However, most of these Moluccan soldiers supported the fight for an independent Republic of South Moluccas, *Republic Maluku Selatan*, which was proclaimed in April 1950. Subsequently, however, they were now banned from returning to the islands and had become pariahs in the new Indonesia (Oostindie, 2010, p. 27). In 1951, the Dutch government decided to ship the Moluccan families (around 12,500 people) to the Netherlands. The Moluccans were placed in camps, and a policy of segregation was maintained for many years since both the Dutch government and the Moluccans themselves awaited a possibility for the families to return to the islands. Their stay in the Netherlands was supposed to be temporary and, according to the Dutch cultural anthropologist Lizzy van Leeuwen, it was "in fact an emergency measure" (2007, p. 12). When Leonard Freed photographed in a Moluccan camp, this group had already been in the Netherlands for nearly a decade, but most Moluccans were still living in camps.

CONTEXT OF THE EXHIBITION

When Freed photographed Indische Nederlanders and Moluccans, their presence in Dutch society was very much a current social issue and some of his photographs were published at the time, but eventually they all entered the private archive of Freed as a series, which he named *Indonesians in Holland*. A few of the pictures were included in a 2007 retrospective exhibition, *Worldview*, and in the photo book that was published on the occasion of the exhibition (Freed, Ewing, Herschdorfer & Sinderen, 2007).[3] The Dutch museologist Lisa van Beek worked as a trainee at this exhibition and had the opportunity to work in Freed's archive. In 2009, she collected the photo book, *Indonesiers in Holland—1958–1962*, which brought together 34 photographs from Freed's series of postcolonial immigrant portrays (Freed & van Beek, 2009). This book formed the background for the exhibition at the Tropenmuseum. The beautiful photo book is an interesting photo-historical document. The front and back of each photograph is reproduced, with the front of the photograph on the right page, and the back of the photograph with Freed's signature and original captions on the back of that same page. The book furthermore includes a typed list describing the content of all 56 rolls of film in the series, and a short text by Freed in which he, in line with the public opinion at the time, foresaw a new generation of Dutch youth

"without racial feelings" (Freed & van Beek, 2009, p. 29). In her introductory essay, van Beek points out that this idyllic picture of the arrival and integration of postcolonial migrants in Dutch society has since been revised (see also Oostindie, 2010). The choice of giving the book the title *Indonesians in Holland 1958–1962*, which was originally used for the photo series by Freed himself, is in line with the design choices of the book and makes good sense from a photo-historical sense of view, but nevertheless it was a controversial choice. Most of the postcolonial immigrants explicitly did not see themselves as Indonesian, and neither do their descendants. Furthermore, people of *Indisch* background in the Netherlands are often frustrated with the majority population's tendency to confuse the categorizations Indisch and Indonesian (Oostindie, 2010, p. 118). The use of the original title could create distance in relations to the migrant groups portrayed, and the title did indeed elicit some critical remarks. One example is a rather harsh comment from an Indische blog, *indisch4ever.nl*.

The comment was made in relation to a blog post about the Tropenmuseum exhibition and is interesting because it explicitly contrasts the title of the photo book with the title chosen by the Tropenmuseum for their exhibition:

> The curators of the exhibition 'One Way to Holland' have understood more than the publisher of the photo book of Leonard Freed about what those photos were actually about; for the Indischen there was in fact no way back. The publisher makes an absolute fool of itself by calling the book "Indonesians in Holland." I bet that the publisher will make a second book, "Round-trip Ticket Holland." Sometimes stupidity is pushing back frontiers. (van Broek, 2010)

This comment emphasizes that these categorizations remain a sensitive issue. Another important issue in relation to the source communities portrayed in the photographs is that Freed's original captions, in only a few instances, named the exact locations and the individuals portrayed. While this might not be seen as a problem in an exhibition at a photographic museum, the ethnographical Tropenmuseum wished to make a more thorough contextualization of the photographs since providing the stories behind objects is part of the museum's curatorial strategy and an important means of acknowledging the heritage of different ethnic groups.

VISUAL ANTHROPOLOGY AND HISTORICAL PHOTOGRAPHS

The Tropenmuseum's use of social media in relation to the photo exhibition 'One Way to Holland' is closely connected to museological practices of collaborating with source communities around historical photographs and visual repatriation. Our approach is inspired by theoretical and methodological developments within visual anthropology that examine the visual

discourses of colonial photographs, which may or may not originally have been created with the intent of producing anthropological information (Edwards, 2001, 2003; Pink, 2003; Sassoon, 2004). This particular tradition within visual anthropology is closely related to the social approach of photo historians (Ruby, 2005). In this context, the works of Elizabeth Edwards, a British historian, which have moved into visual anthropology, are considered central to the development of the field (Edwards 2001, 2003). Edwards has carefully discussed the implications of taking photographs from museum databases and bringing them back to the indigenous groups portrayed (Edwards, 2003). She describes visual repatriation as concerned with "finding a present for historical photographs" (Edwards, 2003, p. 84). In working with collections of historical photographs, Edwards proposes a focus on the social biographies of photographs, which means examining how a photograph is ascribed new meaning as it moves from one context to another: for example, from mission house, to museum, and back to the community (Edwards, 2003, p. 84). This implies not only an interest in how a photograph was framed by the particular vision of the photographer (Edwards, 2003, p. 94), but also how the photograph was subsequently recoded when added and categorized in the museum database or used in publications. The asymmetrical power relations between the "collector and the collected, the photographer and the photographed, the museum and the source community" (Edwards, 2003, p. 84) have privileged some readings of photographs while the stories of the people portrayed have often remained unknown or been actively silenced. Captions and titles used in exhibitions and museum databases often describe photographs in general terms without specifying who the portrayed individuals are, and captions may furthermore be experienced as offensive if they use old-fashioned ethnic terms. Edwards describes photographs in museum databases as public photographs that "remove the subject matter of the image from its contexts, so that meaning becomes free-floating, externally generated, and read in terms of symbol and metaphor" (Edwards, 2003, p. 85). This makes it possible for a portrait of an individual person to become an icon of a historical event or a type, as for instance "The Nuer" (Edwards, 2003, p. 85; see also Sassoon 2004, p. 68). In contrast, Edwards describes private photographs as photographs that are read in context and embedded with local meaning and memories as in the case of family photographs. From this, it follows that the process of visual repatriation may be said to be an act of recontextualizing photographs. We find the terms private and public photographs difficult to work with in cases where visual repatriation is mediated through an exhibition, social media, or for that matter an openly accessible database since the public and private spheres in these arenas often are overlapping and at work simultaneously. The memory work taking place in a publicly accessible space may actually reconnect a photograph to private memories. However, we do appreciate the notion of recontextualized photographs, and this concept is at the core of our analysis of the 'One Way to Holland' exhibition.

Distinguishing between private and public photographs becomes further complicated by the fact that the same photograph may have been used in different contexts and accordingly have been differently framed. Photographs made from the same negative may have been printed as postcards, included in private family albums, used in museum exhibitions, and ended up in one or more archives; and in that sense the same photograph can be said to have had "multiple lives," which complicates the notion of a photograph as an object with a social biography (Sassoon, 2004; Wanhalla, 2008). As pointed out by Australian historian Joanna Sassoon, each new context is likely to imply the writing of a new caption, and an important element in studying historical photographs is examining how the same image is framed differently in different contexts (Sassoon, 2004, p. 71). Our analysis will trace how captions to Leonard Freed's photographs have been rewritten across different contexts including his own archive, the photo book, and in the social media used by the Tropenmuseum.

Drawing on Roland Barthes, Edwards stresses that the power of photographs lies in their indexicality, as a trace of a person, who was once in front of the photographer (Edwards, 2003, p. 84). Thus, she warns against using historical photographs of individuals "iconically, decoratively or unproblematically to 'explain' objects or to evoke a generalized affective tone" (Edwards, 2003, p. 96). A similar position is taken by the American photographer and ethnographer Glenn Jordan (2008), who is engaged in making portraits in contemporary multiethnic societies. Jordan is sympathetic to the inclusive project of the tradition of *social portraiture*, exemplified by such famous photographers as the German Arthur Sander and the American Diana Arbus, who photographed both ordinary and marginalized people. But he warns against their focus on social types and insists on photographing "named individuals, unique personalities, with their own modes of self and group presentation" (Jordan, 2008, p. 156). In the case of historical photographs where the identities of the portrayed are unknown, visual repatriation is thus not only about giving source communities access to these pictures but also about identifying individuals and the context in which the images were taken. Edwards describes this as a "forensic reading" (Edwards, 2003, p. 91) and stresses that such readings are not only facts findings but can be empowering and make room for "radically different articulations" (Edwards, 2003, p. 91). The media strategies of the Tropenmuseum in relation to Freed's photographs may be said to invite source communities to engage in such forensic readings through social network media.

RECONTEXTUALIZING PHOTOGRAPHS THROUGH SOCIAL MEDIA

The title chosen for the Tropenmuseum's exhibition, 'One Way to Holland', strikingly expresses the core experience of the postcolonial migrants and

their descendants. As noted, many had been reluctant to go the Netherlands, and for the majority of these postcolonial migrants there was no way back. In addition to choosing another title than Freed's original title, which was used in the photo book, the museum was careful to distinguish between Moluccans and Indische Nederlanders in the introductory text to the exhibition (the Tropenmuseum, 2010a). Furthermore, the museum went further and used a variety of social media sites to invite the public to engage in forensic readings and thus name persons and localities shown in the pictures. The project included Flickr, Facebook, Twitter, and the Dutch social networking site Hyves as well as blog posts written by the curator on the official blog of the Tropenmuseum. The photo exhibition was also announced through press materials to other media, and this became important in order to reach some users. In relation to the exhibition, the museum bought a collection of Freed's photographs, which was included in the museum database and Dutch metatext was added based on Freed's original captions. The project can be seen as an attempt to recontextualize the photographs (cf. Edwards 2001, 2003), and according to curator Pim Westerkamp, this is in line with general curatorial strategies at the museum, which seek to find the stories behind objects and photographs and use these stories as a means to avoid stereotyping.

In the 'One Way to Holland' project, Flickr can be seen as the main online exhibition site, while Twitter and Facebook were used in a push media strategy to make users aware of the project and create curiosity by posting questions like this one: "The woman in the photo sees after many years apart her family again in Amsterdam. Who knows more about this woman?" (the Tropenmuseum, 2010b). The question is then followed by a link to Flickr.

On Flickr, the museum presented 19 photographs from the exhibition, and each photograph was given a title and a short contextualization based on what the museum assumed to know about the pictures, which in most cases meant rewriting Freed's original captions. Users were invited to post information directly on the Flickr site or send an e-mail to the museum. According to the producer of digital media, Susanne Ton, the e-mail option was added because the museum was eager to reach groups that were not regular users of Flickr but visited just to see these pictures. Furthermore, sending an e-mail may be felt as a more appropriate way of sharing personal stories and memories with museum staff. Our observation of the activity on the Flickr exhibition shows that very few people commented directly on the site. However, after getting permission, the museum chose to repost Facebook comments and fragments of the e-mails they received, so that other people could still follow the process and possibly comment on the gathered information. While the e-mail option was used for purely practical reasons, it may also have had an ethical advantage, since many people feel unsecure about commenting publicly on social media. As pointed out by Wong, "Rather than providing only public opportunities to participate and converse, they [museums] should consider if private and anonymous ways are also (or more) appropriate" (Wong 2012, p. 289).

As mentioned earlier, the Tropenmuseum's broad ethnographic profile means that the museum could potentially connect to a wide variety of source communities, but this can make it difficult to reach specific groups such as Indische Nederlanders and Moluccans. The museum therefore opted for a close collaboration with the small minority museum Museum Maluku, which specializes in the heritage of the Dutch-Moluccan community—a choice that proved instrumental to securing a successful engagement with relevant groups. Museum Maluku has a long tradition of collaborating about photographs with their source community, and Facebook is regularly used to make "followers" aware of newly received photographs and invite them to examine more photos and additional information on the museum website (Marselis, 2011). Followers of Museum Maluku's Facebook postings were thus already used to this way of online collaboration, and this may have made it easier to engage them in the project of the Tropenmuseum. In our interview with the staff at the Tropenmuseum, they described the use of Museum Maluku's Facebook wall as a very successful way of connecting to the Dutch-Moluccan community. They received additional information about 10 of the 12 photos on Flickr that were concerned with Moluccans. Amongst these was a group portrait of seven boys, about which the museum knew only the year (1960), and not whether the boys were Moluccan or *Indische*. In this case, both the location, a specific Moluccan camp, and the names of the individual boys, as well as information that two of them had gone back to Indonesia were sent by e-mail and reposted on Flickr. In the museum's open access database, the photograph is now titled "Group portrait: Moluccan boys in camp Wyldemerck in Friesland." While the Flickr discussion of the photographs is allowed to be speculative, that is, this may be that or that person, information inserted in the museum's open access database needs to be validated. However, the professional research database of the museum may include some of the collected information that has not been validated.

According to the producer of digital media at the museum, Susanne Ton, the museum is still searching for good ways to include information provided by users of social media in the museum's own database. Since the museum is active on several social media networks, a lot of information is provided, and it would require a tremendous effort to validate all of it. Furthermore, much activity, especially on Wikimedia Commons, is taking place in other languages than the two main languages at the museum, Dutch and English, so it would have to be translated. This challenge plays into more general discussions of how museum practices and authorities are transformed by the Internet, and how to acknowledge user interpretations of objects without risking the museum's credibility (Cameron & Robinson, 2007). These discussions were already taking place prior to the fast increase in museums' use of social media, but has been strongly accentuated by the latest developments.

Another example of valuable information came in relation to a photograph that on Flickr was given the title "Moluccan woman with her baby"

and about which the museum did not know people's names or the location of the photograph. A user on Flickr suggested that it is a Mrs. Saëbu, photographed in camp Wyldemerck in Friesland, and in the following post this is confirmed by the baby portrayed:

> The woman above is indeed my mother, Cicu Saga. We are not of Moluccan descent but come from the Southern part of Sulawesi the former Celebes. We belong to the Buginese people. The child in her arms is me, Alwy Saëbu born 16–11–1959 in Wyldemerck. (Ywla, 2010)

This information stresses the complexity of the postcolonial migration process further than introduced in the museum's own introduction to Freed's exhibition. The groups assumed by Freed to be Moluccans were actually also ethnically diverse, and to the persons portrayed, getting these categorizations right is of key importance. As a consequence, the museum's open access database now describes the picture as follows: "The Buginese Cicu Saga Saëbu from Sulawesi with her baby Alwy in the Moluccan camp Wyldemerck in Friesland."

As indicated above, the Tropenmuseum succeeded in connecting with the Dutch-Moluccan community through collaborating with the much smaller Museum Maluku. Because this museum, through sustained collaboration, has built a strong and trustful relationship with their specific source communities, it could relatively easily provide a connection to the source community, a connection that would have required considerable resources for the Tropenmuseum to develop.

THE CURATORIAL BLOG

As is evident, reaching the Indischen community proved more difficult than reaching the Moluccans, and the museum received additional information about only two of the six photographs of Indischen people placed on Flickr. In order to reach this group, curator Westerkamp combined the museum's online search through social media with off-line contacts to photographed individuals or their relatives through private visits and through inviting them to a lecture at the museum. Since Leonard Freed sometimes gave copies of photographs to the people portrayed, some of the pictures in his series *Indonesians in Holland* may be said to have led "multiple lives" (Wanhalla, 2008 p. 48; see also Sassoon, 2004). They were incorporated in his archive, made part of private family stories, and in some cases published in books or magazines. Connecting to source communities around forensic readings of historical photographs has the potential to bring together different interpretations, and the intention should be not to fix the meaning once and for all but to provide room for differing voices. As stated by Sassoon in her work on photographs of Australian Aboriginals: "Cultural institutions have

a particular responsibility to ensure that the meanings contained within and surrounding objects retain their potential fluidity and complexity" (Sassoon, 2004, p. 83). One way to make room for the complexity of objects' stories is to use a curatorial blog to make the search for information and encounters between different interpretations visible to the public. The curatorial blog with its individual blog post by named museum staff may have the additional positive effect of representing the staff "as peers and facilitators in education rather than anonymous purveyors of authority" (Wong, 2012, p. 284).

One of the Indische photographs, to which new information was added on Flickr, shows six persons that are related through the marriage of an Indische man and a Dutch woman (Figure 4.1). The couple is not present in the photograph. The six persons are, from left to right: The son of the couple, the younger sister of the wife, the three sisters of the husband and the aunt of the wife. On Flickr, this photograph was presented as: "Indischen girls from the family Portier."

The photograph was spotted by the family in the newspaper *de Telegraph*, and relatives gave information about the exact location and names of individuals both via e-mail, on Flickr, and as a comment to the introductory

Figure 4.1 Leonard Freed 1960, Caption in open access database of the Tropenmuseum: *Indische girls have fun with their aunt by marriage.* Photo by Leonard Freed/ Magnum Photos Inc.; Collection: The Tropenmuseum open access database, one of the photographs purchased through the 'One Way to Holland' project. With kind permission of the Tropenmuseum, Amsterdam. © Leonard Freed, Magnum Photos Inc., Tropenmuseum Amsterdam col. nr. 60059551.

text about the exhibition on the museum website. However, in one of his blog posts, Westerkamp tells how the family also provided interesting information about the photo shoot (Westerkamp, 2012b). In relation to the exhibition, he had planned to give a lecture on Leonard Freed and on the postcolonial context of the photographs, but having gathered all this new information as well as having received additional photographs, he decided to focus his lecture on the new information. Attending the lecture was also the Dutch woman, whose sisters-in-law were portrayed as the laughing girls in the photograph. In his blog post, the curator describes this picture as challenging the notion of the Netherlands as modern and the former colonies as old-fashioned, since the smart dresses and hair of the girls and the traditional headdress of the peasant aunt reversed these positions. However, the Dutch woman told how Freed had asked her to visit the farm with her in-laws. Furthermore, he had asked the girls to wear their most trendy dresses during this visit. The curator concludes:

> In her own words: the whole visit was staged. It doesn't look like that on the photograph, but this information now colors the picture for me. It shows after all a staged meeting and is far less a registration of the encounter between the Indische repatriates and the Dutch. (Westerkamp, 2012b, para. 3)

Whether staged or not it is a wonderful picture, but this new information gives an insight into the "particular vision of the photographer" (Edwards, 2003, p. 94). Freed might have been eager to show contrasts between modern, postcolonial immigrants and the traditional peasants that he observed in the Netherlands. The picture may also be seen as expressing his earlier-mentioned optimistic view of future relations between postcolonial migrants and the majority population, since his original caption to the picture stressed the interethnic marriage and that the women were now all relatives: "One family, refugees from the former colony now married with Zeeland people. Joking with aunt in Goes Zeeland" (Freed & van Beek, 2009, p. 54).

Another photograph (Figure 4.2) was taken in 1960 and gives a sensitive representation of the bewilderment felt by those who had tried to build up a life in the new Indonesian republic, but were in the end forced to leave. Freed's original caption categorized the man as a repatriant (Freed and van Beek 2009, p. 38), and on Flickr, the museum speculated that he might belong to the so-called regretters, who had initially chosen Indonesian citizenship, but were having a difficult life in Indonesia, and were admitted to the Netherlands after public pressure (Oostindie, 2010 p. 54). That the old man had indeed been in this situation was confirmed by his daughter, an 84-year-old woman, who was shocked to discover a picture of her long-deceased father in the Indische magazine *Moesson*. On Flickr, the museum reposted an e-mail, where she asks for a copy of the photograph, and the museum reported that she had received it. A month later the Tropenmuseum

Figure 4.2 Leonard Freed 1960, Caption in open access database of the Tropen-museum: *Regretter leaves the boat in Amsterdam that he arrived on from Indonesia.* Photo by Leonard Freed/Magnum Photos Inc.; Collection: The Tropenmuseum open access database, one of the photographs purchased through the 'One Way to Holland' project. With kind permission of the Tropenmuseum, Amsterdam. © Leonard Freed, Magnum Photos Inc., Tropenmuseum Amsterdam col. nr. 60059601.

added a link to a blog post by Westerkamp, where he in a personal tone tells how he was deeply moved by his encounters with this woman (Westerkamp, 2012a). In the blog post, he tells how the only photograph she had from her father was from the 1930s, and how she was deeply touched by Freed's photograph of her elderly father. Although she had been given a copy of the photograph, she still, so to speak, revisited her father in the museum a couple of times, overwhelmed by the fact that his portrait was hanging in a major Dutch museum. According to Westerkamp, the elderly woman had taken him into her confidence and told him about her father. Some of these memories were very private and painful, and Westerkamp carefully selected what to tell on the blog. He told about her painful memory of when her father was beaten up by Japanese soldiers during the Second World War, but other stories the curator kept to himself because she told them to him as a person in whom she confided. Some of these stories she had not even told to her own children, and she certainly did not intend them to be made

public. By taking time to listen to her memories and carefully selecting what to publish, Westerkamp may be said to have performed the type of ethically engaged curatorship that Edwards stresses as crucial in relation to visual repatriation (Edwards, 2003, p. 93). Taking the sensibilities of the involved individuals into account made writing the blog posts a time-consuming activity, but the blog posts add valuable depth to the project. The interaction represented through Flickr is mainly focused on sharing information in order to contextualize the photographs, but the blog posts both give a behind-the-scene view of the curator's work and develop the personal aspects of the stories. The process toward regaining the indexicality of the photographs initiated by placing them on Flickr became even more explicit in the blog posts. By developing the stories behind the pictures, these blog posts have the potential to lift the project from being primarily interesting to the source communities portrayed and making it relevant to a broader audience.

CONCLUSIONS

Social media hold promising potentials for strengthening the connection between museums and their source communities. This chapter has examined a social media outreach project by the Tropenmuseum, the Netherlands, which aimed at collaborating with postcolonial migrant groups around historical photographs by Leonard Freed. An important first step in order to succeed with social media outreach may be to use a combination of well-known and popular sites such as Facebook, Twitter, and Flickr to connect to potential new audiences where they already are. However, reaching specific communities through social media proved out to be not that easy. In the case of the Indische Nederlanders, initial contact was established through the promotion of the photo exhibition in print media. This connection was then developed through e-mails, on Flickr, and in off-line encounters between the curator and relatives of the persons portrayed in the photographs. Using social network media to reach the Moluccan community was more successful due to collaboration with the much smaller Museum Maluku and the possibility of posting photographs on their Facebook wall. This exemplifies how a large museum can accumulate new knowledge through collaboration with a smaller, more specialized museum that has established a trustful relationship with a specific source community. More generally, museums could benefit from supporting each other's presence on social media both in order to increase their own visibility and to "combine efforts, expertise, and resources with other museums" (Wong, 2012, p. 291).

In the 'One Way to Holland' project, individuals from the two source communities, Moluccans and Indische Nederlanders, engaged in "forensic readings of photographs" (Edwards, 2003), and as a result, unknown stories unfolded. The project exemplified the importance of remembering the ethical discussions of visual anthropology when historical photographs are brought

to the Internet. Since old photographs often bring up very personal stories, the opportunity of relating one's story in private communication (e.g., through e-mail) remains important, and it may be that only fragments of these stories are suitable for public dissemination. Furthermore, museum staff must make sure to use appropriate language and more generally take into account that memory politics of migrants groups often include highly sensitive issues.

Another issue that is not new but strongly accentuated through the use of social media is how to incorporate user-generated content about specific communities' heritage into museum databases (Nightingale & Green, 2010). The staff at the Tropenmuseum is challenged by a huge amount of user-generated content being produced in different languages on a variety of social media platforms. Within the smaller project examined in this chapter, information provided by users was used to rewrite the captions of photographs in order to make them more appropriate (Edwards, 2003). However, not all the information provided was included in the open access database. Wong predicts that museums are likely to become "more comfortable with the commingling of curatorial and audience voices" (Wong, 2012, p. 285). Nevertheless, the question of how to incorporate information provided by users in museums' databases as well as to make room for a diversity of interpretations of the same objects is in need of further experiments as well as research.

While Facebook and Twitter are effective in order to make users aware of the material, Flickr serves as a user-friendly exhibition site. In the 'One Way to Holland' project, Flickr functioned well as a platform for making the collective "forensic reading" visible, although much information arriving by e-mail had to be reposted by museum staff. Adding a curatorial blog to the communication strategy provided room for more-detailed narratives as well as for behind-the-scene views of the curators' work. Also, it proved fruitful to combine these multiple digital platforms with such off-line activities as lectures and personal visits. It was this differentiated communication strategy that ensured room for different types of dialogue from the concrete, facts-oriented to the deeply personal and emotional encounters. Using social media to connect to source communities thus requires both a critical awareness of the specific affordances of different social networking sites and a commitment to ethically engaged curatorship that takes the memory politics of both communities and the individuals within into account.

ACKNOWLEDGMENTS

The research conducted by Randi Marselis for this chapter was part of the research project Changing Borderlines: Mediatization and Cultural Citizenship, supported by the Danish Council for Independent Research (Culture and Communication) and the University of Southern Denmark. Laura Maria Schütze's research was carried out within the research project Alternative Spaces, Department of Cross-Cultural and Regional Studies, University of

Copenhagen, financed by the Danish Council for Strategic Research. The authors would like to thank staff at the Tropenmuseum for providing information for this chapter. All Dutch citations, comments, and picture titles have been translated into English by Randi Marselis.

NOTES

1. Placing the photographs on the Dutch social networking site Hyves.nl was not successful in terms of collecting information about the photographs, and so this site is excluded from our analysis.
2. This interview was performed by Randi Marselis and took place at the Tropen museum on April 5, 2012.
3. The exhibition was a collaboration of the Musee de L'Elysee, Lausanne, Switzerland; Magnum Photos in Paris, France; and the Photographic Museum in Hague, The Netherlands.

REFERENCES

Aldrich, R. (2010). Colonial museums in a postcolonial Europe. In D. Thomas (Ed.), *Museums in postcolonial Europe* (pp. 113–125). London: Routledge.

Cameron, F., & Robinson, H. (2007). Digital knowledgescapes: Cultural, theoretical, practical, and usage issues facing museum collection databases in a digital epoch. In F. Cameron & S. Kenderdine (Eds.), *Theorizing digital cultural heritage* (pp. 165–191). Cambridge, MA: MIT Press.

De Rijcke, S., & Beaulieu, A. (2011). Image as Interface: Consequences for users of museum knowledge. *Library Trends, 59*, 663–685. doi:10.1353/lib.2011.0020.

Edwards, E. (2001): *Raw histories: Photographs, anthropology and museums*. Oxford: Berg.

Edwards, E. (2003). Talking visual histories: Introduction. In L. Peers & A.K. Brown (Eds.), *Museums and source communities: A Routledge reader* (pp. 84–97). London: Routledge.

Flickr. (n.d.). The Commons: Your opportunity to contribute to describing the world's public photo collections. Retrieved from http://www.flickr.com/commons/#faq

Flinn, A. (2010). Independent community archives and community-generated content: "Writing, saving and sharing our histories." *Convergence: The International Journal of Research into New Media Technologies, 16*, 39–51. doi:10.1177/1354856509347707.

Freed, L., Ewing, W.A., Herschdorfer, N., & van Sinderen, W. (2007). *Worldview*. London: Steidl.

Freed, L., & van Beek, L. (2009). *Indonesiers in Holland 1958–1962* [Indonesians in Holland 1958–1962]. Zwolle: d'Jonge Hond.

Jordan, G. (2008). Photography that cares: Portraits from multi-ethnic Wales. *Journal of Media Practice, 9*, 153–169. doi:10.1386/jmpr.9.2.153/1.

Kalfatovic, M.R., Kapsalis, E., Spiess, K.P., Van Camp, A., & Edson, M. (2008). Smithsonian Team Flickr: A library, archives, and museum collaboration in Web 2.0 space. *Arch Sci, 8*, 267–277. doi:10.1007/s10502–009–9089-y.

Marselis, R. (2011). Digitizing migration heritage: A case study of a minority museum. *MedieKultur, 50*, 84–99. Retrieved from http://ojs.statsbiblioteket.dk/index.php/mediekultur/article/view/3325/4616.

Nightingale, E., & Greene, M. (2010). Religion and material culture at The Victoria & Albert Museum of Art and Design: The perspectives of diverse faith communities. *Material Religion, 6*, 218–235. doi:10.2752/175183410X12731403772959.

Oostindie, G. (2010). *Postkoloniaal Nederland* [Postcolonial Netherlands]. Amsterdam: Uitgeverij Bert Bakker.

Parry, R. (2007). *Recoding the museum: Digital heritage and the technologies of change*. London: Routledge.

Peers, L., & Brown, A.K. (2003). Introduction. In L. Peers & A.K. Brown (Eds.), *Museums and source communities: A Routledge reader* (pp. 1–16). London: Routledge.

Pink, S. (2003). Interdisciplinary agendas in visual research: Re-situating visual anthropology. *Visual Studies, 18*, 179–192. doi:10.1080/14725860310001632029.

Ruby, J. (2005). The last 20 years of visual anthropology: A critical review. *Visual Studies, 20*, 159–170. doi:10.1080/14725860500244027.

Sassoon, J. (2004). Becoming anthropological: A cultural biography of EL Mitchell's photographs of Aboriginal people. *Aboriginal History, 28*, 59–86.

Simon, N. (2010). *The participatory museum*. Santa Cruz, CA: Web 2.0.

Smeets, H., & Steilen, F. (2006). *In Nederland gebleven: De geschiedenis van Molukkers 1951–2006* [Remained in the Netherlands: The history of Moluccans 1951–2006]. Amsterdam/Utrecht: Publisher Bert Bakker/Moluks Historisch Museum.

TheTropenmuseum(2010a).EnkelereisHolland[*One Way to Holland*].Retrievedfrom http://www.tropenmuseum.nl//MUS/45798/Tropenmuseum/Tentoonstellingen/ Tentoonstellingenarchief/Enkele-reis-Holland

The Tropenmuseum (2010b, April 26). De vrouw op de foto ziet naar vele jaren haar familie weer terug in Amsterdam. [The woman in the photo sees after many years apart her family again in Amsterdam] This woman [Twitter post]. Retrieved from http://twitter.com/tropenmuseum

Van Broek, P. (2010). Re: Enkele reis Holland [Re: *One Way to Holland*] [Web log comment]. Retrieved from http://indisch4ever.weblog.nl/geen-categorie/enkele-reis-holland/

Van Leeuwen, L. (2007). Indonesians in Holland: Migration and misunderstanding. In L. Freed (Photographer) and L. van Beek (Ed.), *Indonesiers in Holland 1958–1962* (pp.10–19). Zwolle: d'Jonge Hond.

Wanhalla, A. (2008). In/Visible sight: Māori-European families in urban New Zealand, 1890–1940. *Visual Anthropology, 21*, 39–57. doi:10.1080/08949460701688957.

Westerkamp, P. (2012a, July 21). Een weerzien [A reunion] [Web log post]. Retrieved from http://tropenmuseum.blogspot.dk/2010/07/21-juli-2010.html.

Westerkamp, P. (2012b, September 22). Bijzondere verhalen achter de foto's van Leonard Freed [Unique stories behind the photos of Leonard Freed] [Web log post]. Retrieved from http://tropenmuseum.blogspot.dk/2010/09/bijzondere-verhalen-achter-de-fotos-van.html.

Wong, A. (2012). Social media towards social change: Potential and challenges for museums. In R. Sandell & E. Nightingale (Eds.), *Museums, equality and social justice* (pp. 281–293). London: Routledge.

Ywla (2010). Re: Molukse vrouw met haar baby [Re: Moluccan woman with her baby] [Flickr comment]. Retrieved from http:/www.flickr.com/photos/tropenmuseum/4520967358/in/set-72157623839273646/.

5 Exploring Art and History at the Warhol Museum Using a Timeweb

Karen Knutson

Using a project developed by the Warhol Museum—the Timeweb—this chapter explores some of the key issues that museums, particularly art museums, face as they consider interactive interpretive projects. The Timeweb was designed as a stand-alone digital experience for both in-gallery as well as off-site visitors that allows users to explore historical aspects of Warhol's life, times, and art in a nonlinear way. Institutionally, the Timeweb project team hoped to expand potential audiences and to create a sense of community engagement around Warhol and art historical interpretations of him. Coauthoring tools for user-generated content were envisioned for both the casual user of the site as well as for the community of art experts interested in Warhol and his times. The chapter discusses some of the lessons learned from the design and prototyping process. In particular, the Timeweb project sheds light on the tensions that arise around issues of innovation, institutional voice and interpretation, and didactic vs. user-driven experiences as museums work to embrace Web 2.0.

THE WARHOL MUSEUM

With a long history of experimenting with new approaches to interpretation and curation, the Warhol Museum has become known for innovative museum practice. A quick look at the museum's mission statement helps us to understand the level to which this commitment to being innovative and, more importantly, relevant, to diverse audiences, is central to the museum's operations:

> The Andy Warhol Museum is a vital forum in which diverse audiences of artists, scholars, and the general public are galvanized through creative interactions with the art and life of Andy Warhol. The Warhol is ever-changing, constantly redefining itself in relationship to contemporary life using its unique collections and dynamic interactive programming as tools.

The museum's commitment to its mission is well illustrated by an exhibition mounted in 2002. *Without Sanctuary: Lynching Photography in*

America, was an exhibition that focused on a historical collection of post-cards and photographs that documented lynchings. The museum created a series of informational installations around the historical postcards: installations that provided both a national and local context to the history of race relations. To encourage visitor engagement with the difficult topic, the museum worked with a community advisory committee to plan events around the exhibition. The museum also brought in a social justice organization Animating Democracy to train museum staff to convene dialogue groups in the museum. Video feedback stations allowed visitors to share their reactions to the show. "Postcards for Tolerance" was another feedback option, where visitors were encouraged to write postcards describing their visit to a recipient and mount them on the museum's wall. While the nature of the project—centered around a display of historical postcards—might seem at first glance to be a stretch for a single artist art museum, *Without Sanctuary* offered the museum the chance enact its "museum as forum" mission, using the museum as a platform to generate community dialogue around issues of race and bias.

In addition to creating innovative temporary exhibitions, the museum has also experimented with different interpretive formats throughout the galleries, creating interactives, audio stations, and other mechanisms to encourage visitor response and feedback, as well as utilizing different styles of interpretive labels. Part of the Warhol's approach to innovation involves carefully documenting its practice and impact through evaluation (see Gogan, 2005). Along with my colleagues at the University of Pittsburgh Center for Learning in Out of School Environments (UPCLOSE), I have been collaborating with the Warhol Museum for 10 years, helping the museum to better understand how its work impacts and engages the audiences it serves. We have conducted program evaluations as well as visitor studies that have documented the ways in which visitors experience interpretation within the museum. In the Timeweb project, I would serve as part of the design team. As someone who studies primarily in-museum activities and learning in informal settings, and not technology per se, I was interested to see how the museum was thinking about technology, and how they were thinking about engaging their on-site visitors with a technology interactive.

VISITOR NEEDS AT THE SINGLE ARTIST MUSEUM

There are many different kinds of art museums, and the single artist museum has its own specific institutional challenges. As the then-director of the Warhol Museum once explained, while a survey museum may feature temporary exhibitions that invite repeat visits, single artist museums fear that they may be seen as a one-visit tourist destination (Kino, 2008), and they struggle with finding ways to satisfy the first-time visitor while offering the repeat visitor a different kind of experience. Audiences at the Warhol Museum fit this profile; one study confirmed that over 70% of visitors were seeing the Warhol

Museum for the first time with many of these visitors coming from outside the regional area (UPCLOSE, 2004). The Warhol has been working to create exhibitions and interpretive areas to help raise the visibility of the museum as a constantly changing forum to engage with contemporary art as well as the work of Warhol.

Audiences for single artist museums also put pressure on museums to utilize different display tactics than other kinds of art museums. As art museums, they might like to follow more traditional art display practices, with interpretive text that focuses on aesthetic issues in the artworks, but visitors to a single artist museum tend to want to explore the biography of the signature artist. Andy Warhol is a particularly interesting case since, in many ways, Warhol's biography is almost bigger than his art. Warhol entered the popular culture, cultivated his persona and loved his celebrity status. An UPCLOSE study found that nearly all visitors to the Warhol Museum knew a little about his life and his iconic artworks such as the Campbell's Soup Cans, but 65% had no visual arts background. Visitors' questions instead showed an ongoing fascination with the artist himself, or the times in which he lived and worked, and they found that the museum's interpretive texts were not sufficient to answer their questions (UPCLOSE, 2004). In response to this visitor feedback, staff decided to focus their attention on the creation of an overview gallery that would address common questions about Warhol's life and times. It provided a thematic introduction to Warhol, with sections about his upbringing; family; connections to Pittsburgh; his early work life in commercial advertising; and later, his celebrity circles in New York. Informational text, photos of Warhol, his friends, and family were situated around large quotes and thematic titles as well as reproductions of his works. The room was a lively introduction to the museum with great visual appeal, and the process of pulling it together got museum staff excited about other ways they might engage visitors in a more historical exploration of Warhol and his times.

TIMEWEB PROJECT IDEA EMERGES

The museum wanted to create a place to explore Warhol's life in more depth than could be handled within a single gallery space. They wanted to create a digital project that would allow visitors to have a personally directed and more in-depth experience with Warhol. And finally, they really wanted to provide online visitors, a large and underserved audience, with a novel way to experience Warhol and the museum's resources on Warhol. The Andy Warhol Museum annually sees around 100,000 visitors in its building, but interestingly, the museum sees more than 2.5 million visitors online, of which 20% are from international locations. While their website featured information about exhibitions and curriculum materials for teachers and school-aged children, the needs of many other online audiences were not being met very creatively.

The Timeweb concept emerged to fill all of these needs, and a local web designer was hired, a project team created, and funding was obtained. The team included a project manager, educators (to create content), IT staff (to work on an interface between Timeweb and the museum's image databases), and UPCLOSE (to work on prototyping and evaluation). The web designer had worked with the museum previously, and he had some creative ideas about a potential format for the project.

The Timeweb was envisioned as a means to energize a chronologically based exploration of the life and times of Andy Warhol and his art. It was created to provide a way to explore content-related nodes of information about culture, art, society, history—in a nonlinear and constantly redrawn set of what the designer called, "rhizomatic relationships between nodes." Unlike a chronological timeline, with a two-dimensional and straightforward linear progression from year to year or event to event, the Timeweb utilized a "rhizomatic" approach—where, much like the roots of a plant, links emerged in many directions, and one event could be connected to several others across different periods of time. In this way the Timeweb could suggest the multidimensional intersections of influences and events across time and space. The length of connecting lines between nodes was designed to vary—thus suggesting stronger or weaker ties between events, people, or things. User-generated content would be included by allowing users to add new events, create their own "node maps," or add "connections" between nodes. These could be saved and shared with other users.

Several components were part of the project plan for the Timeweb. The design process required the creation of the interface and the related algorithmic representations. Users would have a dynamic sense of events, people and art interacting within a nonlinear yet chronologically based field, a field that would redraw itself according to the path chosen by the user. The experience would need to be structured so that users would be able to intuitively understand the somewhat complicated nature of links and events in the Timeweb. The project architecture needed to accommodate the needs of users in terms of orientation and way finding. Content would need to be developed and a user community established. While the museum would use material generated for educational curricula to create content nodes, they would also need to create new content nodes, and to grow a community of users who would be willing to seed the database with new content. The database would also need to be integrated with the museum's collection management database, online education resources and the museum website. After this initial work, the resulting prototype would need to be tested both in the museum and online.

INNOVATIVE IDEAS FOR THE TIMEWEB

Unlike content developed for many online museum projects, where content is distilled and summarized in small, layered didactic chunks, the content

for the Timeweb would be based on primary source material, photos, newspaper clippings, artworks, etc. Staff wanted the material to be useful for upper level and college students and scholars who were searching the web for information about Warhol. Another somewhat unusual approach for an "educational" museum project was that while the project was not an educational game, the project was designed to put the experience first. Rather than providing a richly detailed informational website with clearly marked hierarchical sections for family, schooling, influences, etc., instead information would be presented piecemeal in an ever-changing web of possibilities. This was to be a place to encounter information about the life and times of Warhol, but the information would be provided in an unstructured way. Looking at the nodes would be visually interesting, choosing nodes would be somewhat idiosyncratic, and both activities were prioritized over finding the specific facts of Warhol's life and times on a timeline. The content would be primary source material, with both visual images and text-based items, all fully referenced to allow for further study. The digital experience would be visually interesting, engaging and fun.

The Warhol project team wanted to create an innovative product. The rhizomatic Timeweb interface was novel, but the project team also saw the potential for innovation in other ways:

> **Connecting with popular culture:** The Timeweb project created an opportunity for the museum to find new ways to engage the audience in thinking about Warhol and his time period. Most exciting was the way in which this project created a venue for the museum to discuss aspects of popular culture and history.
>
> **Utilizing resources that are not artworks:** Artworks in this project played a secondary role to the exploration of important iconic historical moments in American and international cultural life. The project featured newspaper articles, documents and photos—non-Warhol references. This broader focus highlighted the work of the art historian, or historian, in creating interpretations of art. This focus provided a sense of the rich literary and historical context that should be considered alongside study of the artwork itself.
>
> **Quality of resources:** Many digital projects in art museum contexts are developed with a strong "educational" focus, which tends to mean a focus on school curricula, K–12 students, or a particular reading level. This project is geared toward a college or above audience, an adult audience, and the content is not digested or translated. It is selected and edited, but it has not been summarized or presented to meet certain objectives. Items are primary sources, and they are referenced and quoted verbatim. In this way the project has a certain academic appeal or utility not commonly seen in digital museum projects.
>
> **Interest-driven exploration of content.** The visual and nonlinear project suggests many possible and serendipitous routes through the content. In

this way the web project interrupts typical searching and sorting patterns expected from an educational web project. This aspect of the project in some ways references the free-choice element of wandering through the physical museum, where one encounters things one did not expect to find.

PROTOTYPE OF THE TIMEWEB

Upon opening the Timeweb, a series of small circular pictures or "nodes," with a short descriptive title emerge from a single pile to fill all parts of the screen in a slightly random-looking layout (Figure 5.1). A timeline showing 1920 through 1969 appears at the bottom of the screen, and three navigational icons appear at the top right (home, search, and questions). Some of the nodes include Andrej Warhola dies, May 15, 1942; *Brillo Boxes*, 1964 (an artwork); Race Riot, 1963, Andy Warhol gets shot June 3, 1968; *Jackies*, 1963–64 (artwork series). To give you an idea of how the content was developed, consider the case of Jackie Kennedy Onassis, the wife of US president John F. Kennedy (JFK).

Clicking the Jackies icon opens a detail view that describes how Jackie was the subject of a famous series of portraits by Warhol (Figure 5.2). Warhol was struck by the treatment of JFK's 1963 assassination on television and did a series of portraits of her around the time of the assassination using widely circulated images found in newspapers. Text describes Warhol's process, and photos of Jackie and the artwork in progress are shown as well.

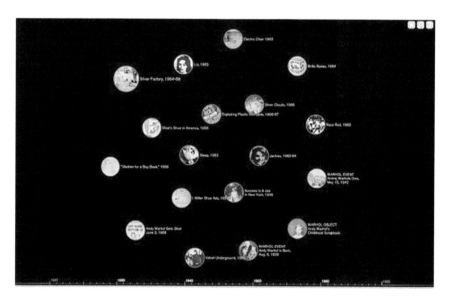

Figure 5.1 First prototype of the Timeweb. Image Courtesy of the Andy Warhol Museum, Pittsburgh.

Figure 5.2 Detail view of Jackie Node. Image Courtesy of the Andy Warhol Museum, Pittsburgh.

Figure 5.3 Jackie Node in redistributed Timeweb. Image Courtesy of the Andy Warhol Museum, Pittsburgh.

Clicking back to the Timeweb front page after looking at the Jackies node, you find that the layout has changed. Now you see the Jackies node with links to a lot of other things—in an unpatterned layout with differing distances and connections to suggest different kinds of relations between nodes (Figure 5.3). For instance, a central node *Jacqueline Kennedy Onassis (1929–1994)*, is linked with *White House-Camelot, Television & the Kennedy Era, Feminism—Betty Friedan's The Feminine Mystique*, etc. These nodes further explore ideas associated with Jackie and the presidency. The White House was called Camelot at this time (as JFK was seen as an idealistic ruler not

unlike King Arthur), John Kennedy was the first president to be regularly on TV, and the book *The Feminine Mystique* came out in 1963 and marked the beginning of the second-wave feminist movement. Some of the nodes have smaller subconnected nodes, like *Jackie Kennedy & Haute Couture*, which has a subsequent link to *Jackie's Pink Chanel Suit*, an iconic fashion look for which she became famous. At this point you begin to see the ways in which you are moving from examining Warhol's work per se, to exploring historical themes and events that occurred during the time of the work. You can also see that the content is not designed to explore the most obvious art-related themes, such as composition, style, or technique.

This second tier into the Timeweb also shows the extent to which content development would be a key driving factor in the completion of the project. Education staff developed content for the nodes, and this process was not trivial. Ideas for nodes were generated and prioritized. Source material needed to be found or written and copyright clearance obtained. The nodes were then hand coded and linked to one another within the interface. In this way connections were posited on a chronological as well as a conceptual basis. The distance between linked nodes was a way to represent the perceived closeness, or directness of links. Staff had to determine potential distances within the node structure.

TESTING THE TIMEWEB WITH VISITORS

In fall 2007, UPCLOSE conducted an evaluation of the overview gallery and the in-gallery *Timeweb*. An online survey was also conducted for users of the online version of the Timeweb. The prototype version of the Timeweb was first set out in the galleries, and during our prototyping, some technical difficulties impacted our ability to fully understand visitor's perspectives. We found ourselves relearning what multimedia designer Scott Sayre had pointed out in his analysis of art museum interactive projects—that technical and usability problems provide some of the greatest frustrations for users (Sayre, 2005). A somewhat unintuitive interface—with inadequate instructional signage combined with some technical glitches, created problems for users. Some of the visitors couldn't use the Timeweb or didn't know what it was to be used for. After solving some of these initial problems, we were able to get a sense of how the Timeweb might function in a gallery setting. Our study included 32 groups of visitors (1 group of 3 visitors, 17 groups of 2, and 7 singletons). Eight of these groups noticed and used the Timeweb station. Three felt that the computer seemed to be broken, while 2 said that they weren't interested in the kind of information presented in the Timeweb. The remaining 3 groups had more sustained interactions with the Timeweb and had comments to share.

The design team saw the Timeweb as a way for users to create an individual path through events, documents, and artifacts. The nodes would

respond and change according to selections made by the user, lending a dynamic air to the exploration of content and disrupting the sense of linearity and lock step connectedness of a typical timeline format. However, the Timeweb user study in the museum showed that the interaction might require a different configuration in order to best suit the needs of the on-site audience, who were not necessarily in a position to spend time navigating through a purposefully meandering exploration of content.

Users thought that the interface was visually appealing. Indeed, the constellation-like changing layout of nodes—so unlike a typical web-based display—was a real draw for users, who were compelled to try and interact with the screen. While they soon figured out how to operate and change the screen, users were somewhat confused by the way in which the system functioned—they didn't really understand that the nodes were connected in any way. And, users felt overwhelmed by the number of nodes as well as the sheer amount of text in the nodes. They also noted that they couldn't find their way back to a place they had previously visited on the Timeweb. They wondered if the Timeweb might be able to include short audio or video clips as they thought that videos might hold their attention better than some of the longer text segments. Ultimately even the most interested groups made it through only a few rounds of exploration within the Timeweb, as they just didn't have the time or patience to really delve deeply into the layers of the Timeweb.

Interestingly, the shortcomings of the Timeweb in the physical space of the museum are some of the great possibilities provided by the interface online. Using a Timeweb in a social context with so many joint decisions to be made is a difficult task. Using an interactive for an extended period of time in museum space is also a challenge. Visitors in the museum tended to be looking for a way to use the Timeweb to help them plan their visit or to learn a specific thing, something that the Timeweb was not designed to support. Online and in-gallery Timeweb interfaces needed to be designed for their distinct setting.

TESTING THE PROTOTYPE WITH ONLINE USERS

As in the in-gallery prototyping, off-site online users experienced similar frustrations with the Timeweb. We added an online survey to the Timeweb and received 230 complete user surveys from users all around the world. The user testing was revealing. While the concept of having a nonlinear timeline representation was exciting, in practice it proved difficult for users to understand. Visitors didn't perceive the weightedness of connections of nodes, though they did understand the first level of connections. Navigation back to the starting point after reading nodes was challenging. There was no way to retrace one's steps as the representation would regenerate, and you might not necessarily wind up back at the same view that you had started with.

On the other hand, online users were more likely to find value in the interactive experience: 70% found the information interesting to read and 74% liked the different images on the site. And 70% were either surprised or somewhat surprised by the information provided on the site. Comments show users responding to the wow factor of the site:

> What a cool, alternative to the usual timeline.
>
> I love the format of the web page. It's like his art work, it's new and hip.

Other users indicate that they are also interested in the actual content of the nodes.

> I'm not an art history buff, but this site could make someone (myself) want to know more about the times of the artists and the events that may have inspired the art.
>
> Well I've only just landed on the site and the Timeweb thingie was the first thing I clicked on. I recently read Victor Bockris's biography of Warhol and was hungering for more info and more images—5 minutes into the site and already you've filled in a few gaps. Nice work.
>
> This was so neat. I am so glad I found this!! I am writing a paper on how the events in Warhol's life connect to his work and this is amazing. I learned so much about my own history. I wish history classes could be this fun!
>
> The connections are obscure—but maybe not vital. I am old enough that I already am familiar with these images and content so the site didn't aid understanding but piqued nostalgia.

Online users clearly spent more time exploring and reading the nodes than our museum visitors. While the content was aimed at adults and contained many primary source materials and references, a potential obstacle in the uptake and use of the site, our survey showed that only 14% of users noted that the text was somewhat or very hard to understand. Comments about content included:

> Very in-depth information offered. I was actually a bit fuzzy on what the Marshall plan was as I had heard news commentators recently talking Marshall plan in regards to Afghanistan. So, thanks for that! The way that the images pop up emerging organically and slowly makes me feel like I am discovering them. I hope to share this part of the Warhol site with my HS Art students!
>
> Wasn't sure of the reason/s why some things were there (like the Soviet SciFi) . . . but interested and interesting!

The design team felt that the prototype was meeting the overall goals for the project when the survey showed that 83% said that the site helped

them to understand the connection between history and art, and 84% that it helped them to understand something about 20th-century history. As we expected some users had difficulty understanding why different events might be connected. But, about 77% felt that they sort of, or really understood, those connections.

Issues noticed in the in-museum prototype about navigation processes also came up in the online version. Twenty-eight percent reported either "kind of," or "really, getting lost" on the site, and 27% reported having trouble figuring out how to navigate the site. Many users commented on issues with navigation:

> I felt that I probably wasn't making the most of the site because I wasn't sure how the navigation worked.
>
> I could not figure out the system as to which image to click next.
>
> I was not looking for anything in particular, so I didn't exactly get lost, however, if I were trying to get "back" to something that I wanted to view more, I'm not sure that I'd be able to as it seems that connections "disappear" and are replaced by new ones depending on what you view.

RETURNING TO THE DESIGN

The prototyping revealed some key interface problems that would need to be corrected, but the design team felt that prototyping was a good proof of concept test for the project—the Timeweb was interesting and compelling for users to explore issues of Warhol and history. The second iteration is ongoing as I write this chapter, and it includes looking into how the Timeweb could connect to the museum's object database so that viewers could ultimately search through the museum's collection to find related works. Designers want to change the front-page interface to improve visitor way finding. Museum staff want to develop more content for the project, and they also want to visitors to be able to tag their route through the Timeweb, to collect images and ideas for future reference or sharing. Museum staff also plan to develop a scholar's area where advanced visitors could add their own content to the broader Timeweb project.

Some of the challenges the team is now grappling with are illustrative of some broader issues that these kinds of digital projects pose for art museums. These issues include coauthoring, dialogue/ participation, and organizational hurdles.

Coauthoring. One of the key goals of the Timeweb was to develop creative coauthoring tools for user-generated content. The idea was that users would be able to curate their own "web" or "my collection" that would be displayed online for other users to see. This coauthored content could appear in two forms—the ability to present their own map or tour through the

Timeweb, altering the algorithms to show user's own interpretations of the importance of relations between existing nodes; and second, users would be able to create their own Timeweb by adding personally significant events, or new nodes. The "my collection" idea was a compelling way of encouraging visitor participation and engagement with the creation of meaningful paths through the time in which Warhol lived and worked. This is a very exciting idea—and one that takes advantage of the digital format.

The team wondered about how, or whether users would like to draw upon the experiences of other users—how could they save and share their personal journeys through the Timeweb? Could they ultimately tag or annotate the Timeweb, could they be allowed to add their own nodes? If they added new nodes, how would the Timeweb distinguish between "sanctioned" interpretations and user-created ones? Would staff need to manage and possibly edit or censor added nodes? The design team also wondered about whether users would be engaged enough to participate in creating their own Timewebs. Would it be a compelling enough activity among all of the other user-focused places on the Internet to be worth the development cost?

The user survey for the initial prototype shed some doubt on the idea of working toward the development of a "my collection" concept. When we asked users if the site would be better if they could make their own node map, only 8% of users said they really wanted that feature. Fifty percent did not want the feature, and 29% were neutral on the issue. And when we asked whether they wanted to be able to comment on how the events were connected, 80% of respondents disagreed or felt neutral about the issue. One participant astutely commented:

> Allowing users to 'make [their] own map of the pictures and text' would certainly increase interactivity, but if one of the goals of the artifact is to foster an understanding of the relationship between Warhol and history, I think the didactic approach you've taken is the way to go.

This feedback added to the preexisting institutional concerns about moving forward with a "my collections/ my nodes" functionality in the site. At the same time, the team still highly valued the idea of having a user-generated aspect to the site, and the ability to have the site represent multiple points of view around the interpretation of Warhol and his work.

While the Timeweb team wanted to allow for user-generated input and collections, there was always a distinction made between the official institutional voice and those of users. This points toward an issue that is seen across digital art museum projects—where the notion of coauthoring and participation is challenging from an institutional perspective (Walsh, 1997). There have been many experiments with tagging and making personal collections by museums, but institutionally, there is still a great concern about editing and content control. In addition to the many challenges of copyright for art museums, the interpretation of objects is the core business for curators and educators (Knutson, 2002). This is professional work, after all, and it is

not taken lightly. As one museum director noted of a recent collections project, it took the museum curatorial staff 18 months to take its records from 5,168 to 12,598 (Brooklyn Museum blog, March 11, 2010). Just agreeing on basic object-level information for each record required an onerous internal vetting process, and the work was just plain slow. While we now have the technology to develop hugely powerful ways to search, use, tag and sort, pieces of our online collections from around the web, the art museum as an institutional form is still not directed to the easy development, release, and sharing of information about artworks.

At the same time that art museums have been protective of the copyright of artworks, they have recognized the need and desire to provide new ways for audiences to engage and participate and to share their perspectives. The Timeweb example reflects a broader point about the difficulty of becoming a participatory museum. It is still a difficult process for museums to understand how to encourage and support feedback. The field is still finding ways to create a place for authentic dialogue to take place between museums and their publics. It is interesting to see how digital projects might help to advance this cause.

Scholar community in the Timeweb. While the notion of having the general public create user-generated content was becoming increasingly difficult to envision, the team was finding traction around the idea of having targeted communities of users seed the Timeweb.

A scholar's advisory committee was created and convened, and participating art historians were asked to test out the site, and each reported out on their assessment of the perceived strengths and weaknesses of the prototype (finding similar results as our other two groups of users). Scholars were paid a stipend for their participation and tasked with generating content for different time periods within the Timeweb.

It was hoped that as this initial group of scholars became involved in the site, eventually the site might become a place where other scholars would share their interpretations of the times and events around Warhol. Perhaps the Timeweb could be used by college classes, and other potential Warhol enthusiasts would be engaged by the additional content and multiple perspectives on the subject? Supporting an academic audience with the Timeweb is a timely endeavor as the humanities field is working to find new ways to conduct and support research in the digital age (Svensson, 2010).

For the design team, coauthoring and user-generated content were some of the most exciting aspects of the digital project, yet ultimately they would pose some of the most challenging problems for the team and the institution. Other similar museum online social projects face similar challenges, since after the first wave of social media development we are now at the place where we need to ask, "How many social networks can one person meaningfully belong to?" What is the real impetus for users to contribute to a project, and what is the payoff for the museum visitor?

The "my collection" aspects of the Timeweb project may have also missed their window of opportunity. In the past couple of years the explosion of

web applications like Pinterest means that visitors have highly sophisticated means to share their opinions, routes, and favorite items—*across projects and platforms*. Pinterest is a site that allows a user to create a pinboard of images from sources across the web. Boards and "pins" can be shared and retagged by other users. These multiplatform ways to tag and share are making it possible for visitors to create a collection that goes beyond the virtual walls of the museum website. Museum websites, many still designing in-site collecting and tagging possibilities, will now need to plan for this ability to interact with other places on the web. There may well be enough users out there (keep in mind the huge numbers of visitors the Warhol's website sees) to support a stand-alone site collection tagging like the "my collection" in Timeweb, but the design of such a service is challenging. The "my collection" part of Timeweb requires a great depth of understanding from users, who would be asked to not just "like" some artwork or event, but to understand, then assimilate, and develop their own interpretation of key events. It is unclear whether users of the Timeweb will be compelled to engage in this level of participation.

Collections management systems. Finally, the Timeweb redesign would also involve a great deal of back-end development. The node structures and algorithms were continuing to be refined, and the node database was being reoriented to draw from the museum's collections database. In this way the Timeweb would be able to easily create new nodes by drawing images and information directly from the collections database. This would allow the Timeweb a greater depth of assets, greater ease in terms of future node development. The process has been challenging and hindered by the fact that the Warhol Museum is institutionally part of a family of museums, the Carnegie Museums (Warhol Museum, Carnegie Museum of Art, Carnegie Museum of Natural History, Carnegie Science Center), which share resources including the collections system and some IT structures. Managing decisions about how the site would be integrated within a broader system of a proprietary collections database would cause many headaches for the team, and while the issue was not solved for the Timeweb project, it did help to further the discussion of how to provide an outward facing collection on the broader museum website.

TIMEWEB 2.0

Drawing from feedback from version 1, and working to include new features from the original design, version 2.0 looks quite different from the first prototype.

In this version the actual Timeweb application is situated within a broader context (Figure 5.4). Above the central Timeweb representation, an ordered series of photos recedes back in focus from a late self-portrait of Warhol, through a photo of JFK, to an earlier photo of Warhol. This series along

Figure 5.4 Timeweb version 2.0. Timeweb design and software by Gradient Labs. Image Courtesy of the Andy Warhol Museum, Pittsburgh.

with the time bar below the Timeweb, suggests the chronological focus of the Timeweb. Small images of Warhol's work below the time bar showcase the variety of media on the site.

Below the middle section of the page, new features round out the site. Realizing that users needed to have more choices and way-finding options

in order to successfully navigate the Timeweb, the Timeweb page now also provides a highlights page, as well as a gallery of images in addition to the Timeweb. These options allow a more structured interaction with the content with or without going into the Timeweb interactive. Below these options are the community features. Featured essays and expanded content are two places where contributions from the scholarly community can be found. These sections are clearly delineated at the top in a new navigation bar provides a home button, as well as highlights, gallery, web and scholarship. At this point the site is still under development to finalize the last bits of work on the connection to the collections management structure, and we have not yet conducted the final wave of prototyping, or an evaluation of the project.

CONCLUSIONS

We sometimes think about digital projects as being somewhat disconnected from our museum work—as something to be outsourced and designed to specifications we choose. What's interesting about the Timeweb project is the way that it provided education staff a means to not only repurpose educational content but also a means to rethink their work; generate new content; and most important, to find a way to engage a new set of stakeholders in a dialogue about Warhol. The project was hard work, and staff and designers were pushing themselves to do something unique.

The repurposing was relatively easy to pull off: they had photographs and ideas established as part of other curricular projects. A big part of the strategy was to recruit content matter specialists who would be asked to come up with key content nodes for different time periods in Warhol's life history. And this piece of the project required a lot of work from museum staff. The art historians, who were involved as coauthors, have not necessarily had the chance to think about their work in this way before. It is unclear how they will ultimately use the site, and whether they will see it as a useful place to house some of their interpretative work on Warhol, or whether they will continue to focus on more traditional sharing venues, like conferences and journal publications. Getting buy-in from this community was work, and it is a risk, but it really helped the Warhol continue its work to engage the community in dialogue about Warhol, art and society.

As you might have expected, working in a digital realm was also a big challenge for staff. The team soon discovered that designing an experience that would be exciting and useful for online visitors was quite different from the kind of interface that museum visitors wanted or needed. The Timeweb design was difficult not only in concept, but also in execution; staff were dependent on the ability of the designer to create a novel piece of software that would integrate into their existing IT system. From this process they gained a new way of thinking about how visitors might interact with content at their museum, but throughout the long design process, they also ran

the risk of designing a product that would be rapidly made obsolete by new software options appearing in the marketplace. At an institutional level, the project helped the team to stretch, grow, and innovate.

On a more theoretical level, the Timeweb project also challenged the status quo. In my mind, one of the most interesting aspects of the Timeweb project is the chosen audience. Many art museum education ventures tend to focus on the non-adult audience. Digital projects are often designed under the education department mantle, and so many interactives have been designed for school-aged children. This is a necessary and valid audience, to be sure. The provision of digital products—games and educational activities is great service, and the digital realm is revolutionizing how we think of museum education. But there is room for so much more. This project is somewhat unabashedly aimed at an adult or college-level audience. The user is asked to do a lot of reading and thinking about broad cultural issues and events.

The selection of content for the Timeweb is interesting. Primary sources, the sense of a variety of possible influences or connections between nodes, and the use of a scholar community puts the emphasis on the work of interpretation. This is key. Museum education has focused increasingly on supporting multiple ways of making meaning in museums. This is a good thing. However, coupled with this desire to empower visitors to make their own interpretations, too often this has led art museums to a point of view that "anything goes," or that "whatever interpretation" is equally valid (Meszaros, 2006). Staff at the Warhol struggled with the tension between wanting to create a place for user-generated content and the need to serve as a community resource and source of knowledge about Warhol—something visitors were expecting the museum to provide—a point of view. The design of the Timeweb does a good job at conveying the message that interpretation is grounded, takes work, but remains open for further reflection and revision. And the content on this site works to advance the field in thinking through the kinds of products that might be desirable for both museum visitors and other art educational objectives.

Interestingly, the content used for the Timeweb project also allows us to think more broadly about the potential audiences and their needs for museum-based information and knowledge on the web. When we consider the casual adult visitor to our digital sites—we need to ask ourselves if the kinds of digital products are we offering capitalize on the assets of the museum—its objects and expertise. The web provides many avenues for an individual to find information about art, artists, etc. What can museums offer that can compete with the almighty Google? While museums continue to struggle over issues of image copyright and proper documentation, other web products may take over as the place to find quality educational information about art and artists. There is a big gap here that requires the careful and extended consideration of curators, educators, IT staff and researchers to develop products that help to advance the museum's mission to provide a unique service relevant to a range of publics.

We should also ask how we might connect our traditional practices in the physical space of the museum (with the art, and our programs) to help the casual adult visitor have a novel experience with art online? Can we help our online visitors experience something of the context of art that lies somewhere outside of object-based learning, or an educationally framed curriculum? What other kinds of things could we do to offer art historical knowledge in a way that is not collection/object driven, but that provides a way to engage in thinking about broader societal issues about art and the creative process? With its focus on generating a content rich experience that is not explicitly didactic, and that includes art images and contextual information, the Timeweb project provides an innovative model for future museum-designed web experiences.

REFERENCES

Bernstein, S. (2010, March 11). Collection online: Opening the floodgates. [Blog post]. Retrieved from http://www.brooklynmuseum.org/community/blogosphere/2010/03/11/collection-online-opening-the-floodgates/

Gogan, J. (2005) The Warhol: Museum as artist: Creative, dialogic, and civic practice. Project case study. Animating Democracy. Retrieved from http://animatingde mocracy.org/resource/without-sanctuary-project-case-study-andy-warhol-museum-pittsburgh-pa

Kino, C. (2008, March 12). Single-artist spaces have their issues, too. *New York Times*. Retrieved from http://www.nytimes.com/interactive/2008/03/12/arts/artsspecial/20080312_SINGLEARTIST_FEATURE.html

Knutson, K. (2002). Creating a space for learning: Curators, educators and the implied audience. (pp. 5–44). In Leinhardt, G., Crowley, K., & Knutson, K. (Eds.). *Learning conversations in museums*. Mahwah, NJ: Lawrence Erlbaum.

Kukulska-Hulme, A., Traxler, J., & Pettit, J. John (2007). Designed and user-generated activity in the mobile age. *Journal of Learning Design, 2*(1), 52–65.

Meszaros, C. (2006). Now THAT is evidence: Tracking down the evil "whatever" interpretation. *Visitor Studies Today, 9*(3), 10–12.

Sayre, S. (2005). Multimedia that matters: Gallery-based technology and the museum visitor, *First Monday, 10*(5). Retrieved from http://www.firstmonday.org/issues/issue10_5/sayre/index.html

Svensson, P. (2010). The *Landscape of Digital Humanities*. *Digital Humanities. 4:1*

UPCLOSE (2004). Summative evaluation study: Overview Gallery Warhol Museum. Unpublished technical report.

Walsh, P. (1997). The *web and the unassailable voice*. *Archives and Museum Informatics: Cultural Heritage Quarterly, 11*(2), 77–85.

6 Informal, Participatory Learning with Interactive Exhibit Settings and Online Services

Monika Hagedorn-Saupe, Lorenz Kampschulte and Annette Noschka-Roos

It is an old dilemma, described by Silverman and O'Neill (2004) in the context of the development of museum knowledge, "that no theory will suffice unless it is grounded in practice, and no practice will sustain itself unless it can be understood and explained" (p. 39). This problem will be illustrated in this chapter on the basis of an interactive on-site installation concerned with gene diagnostics. Based on the results of a visitor research project that has been carried out on this installation, we will discuss strong links and still-open questions of informal and digital learning. The second example is an online service providing access to cultural heritage in Europe with the aim of allowing the widest possible participation, not only by allowing visitors to create a personal space, but also by organizing collection days where personal memorabilia can be digitized and added to the online platform, or by organizing "Hackathon" competitions (http://pro.europeana.eu/web/guest/hackathons) to demonstrate how new services can be developed based on the content available in the *Europeana* initiative.

Russo and Peacock (2009)—concluding their excellent overview of social media spaces and museums—raised a question concerning models and theories related to the development of the participative web. "What are the stated or implicit assumptions about participation in museum Web 2.0 projects?" (p. 33). This is one question amongst others they mention, but one that needs to be settled in order to allow sustainable participation in social media spaces that are regarded "as dynamic systems, not as fixed structures" (p. 33). Developing exhibitions confronts you with some questions concerning participation, even if you have a stated assumption that there will remain unsolved problems in exhibiting or in using the exhibits. Also, when developing online platforms and services, there are still many open issues on how to best allow participation.

As concerns the basic conditions for participation, there are certain intertwined motifs in different areas that have to be taken into account when discussing the growing importance of social media and the meaning of informal learning or digital learning respectively. There are both (1) changing political conditions and (2) changing frameworks in museum research theories with regard to the function of the museum, as well as (3) the role of visitors, and (4) the kind of learning that takes place:

1. First of all there is the political discussion that modern societies need know-how and commitment to scientific issues and other relevant social topics such as migration, urban development et cetera. In Germany, for example, the Federal Ministry of Education and Research (http://www.bmbf.de/en/17858.php) organizes so-called Science Years, with annually changing themes in cooperation with the organization "Science in Dialogue" representing all the important research organizations in Germany (http://www.wissenschaft-im-dialog.de/en/about-wissenschaft-im-dialog/about-us.html). In 2012, for example, there is a call for "Project Earth: Our Future" (http://en.zukunftsprojekt-erde.de/). Also in Europe, museums in particular play an important role in offering exhibitions, programs, discussion sessions, and other attractive events to raise the awareness of the benefits and risks of certain developments in science or technology. Bandelli (2010) states: "In the last decade there has been a growing interest in Europe in the role that science centres and museums play to support public participation in science, and specifically in the governance of science" (p. 2). Consequently, there are several European-funded projects connecting different museums on the European continent dealing with participation issues as a central part or core element, for example: *Nanodialogue* (a dialogue project on the societal and ethical issues raised by Nanotechnology), *SETAC* (Science Education as Tool for Active Citizenship, a project aiming to develop a quality lifelong learning), and *Open Science Resources* (a platform for the European-wide exchange of learning material).

 In Europe, the Council of the European Union in May 2010 stated: "Digitization and online accessibility of European cultural material is essential in order to highlight that heritage, to inspire the creation of content and to encourage new online services to emerge." And the European Parliament too agreed in May 2010 on a resolution that "*Europeana* should become one of the main reference points for education and research purposes, and integrated into education systems."

2. The discussion on the social function of museums and its importance for democratic societies, which started strongly in the 1970s within the International Council of Museums (ICOM) is up and running in many countries and marks the beginning of the idea of museums as institutions for laypeople. (In Germany, for instance, see Auer et al., 1974.) This museological discussion with its different facets (Heumann Gurian, 2007a; Weil, 2002a) has recently been fostered by the museum community itself against the background of rapidly growing global issues such as climate change, immigration and so on.

 For science museums, for instance, it would be interesting to follow and to analyze the assumption of being neutral and impartial and, consequently, to reflect critically the curator's interpretative role in the development of an exhibition (Macdonald, 1998). It is useful to compare here

the Declarations of Toronto (2008) or of Capetown (2011) (http://www. ecsite.eu/sites/default/files/news/CAPE_TOWN_DECLARATION_ FINAL.pdf) with science centers and science museums worldwide. They emphasize the constructive role museums should play in addressing global issues at the interface between science and society: "Globally, science centers and interactive museums have taken the lead in hands-on, inquiry-based learning, and have achieved a high trust rate for the accuracy of the information that they communicate. They focus on promoting dialogue and debate while learning, and on deriving explanations, rather than just providing answers for important scientific discoveries and phenomena. They endeavour to promote social engagement across generations and cultures as well as an ethos of lifelong learning." The aim is set out: "Continue to develop partnerships to promote science awareness and engagement across cultural, political, economic and geographical boundaries." These quotations from the science museum organization do reflect in general the worldwide transformation of museums "from being about something to being for somebody" (Weil, 2002b, p. 28).

3. The frequently cited statement by Weil has been given some new drive in the light of the recent technical possibilities of ICT, with devices not only for delivering or disseminating but also for exchanging information. Firstly, it is becoming even clearer that museums have to manage the problem of "being for somebody" within the growing jungle of information. Secondly, it can be said that development is urgently needed, because there is a growing number of visitors who are so-called digital natives (Prensky, 2001). Thirdly, it is not only the question as to whether these devices would help to build new communities, be they friends, fans, or followers, although this is difficult enough to answer. Just as important is the question of whether it is possible for a cultural institution to communicate with—not to—the public on difficult issues concerning science and society (see the following example).

Some excellent examples presented in the "Museum and the Web" studies (e.g., Kelly & Russo, 2008; Russo & Peacock, 2009) prove the potential of social media to offer a platform, which, however, depends on a competent mode of usage. Unfortunately, little empirical research has been done so far and thus results are only few and incoherent; development is needed, as in the field of mobile technologies (Tallon & Walker, 2008).

"Being for somebody" also includes another communication model, not only online, but also on-site, and vice versa. As an effect of the new media, the relationship with visitors has gotten a qualitatively new facet. From our point of view, whether visitors will be strangers, clients, guests, or partners depends on the museum's collection as well as on its mission statement—and visitors can have each of these roles during one single museum trip. Let us take, for example, the Bavarian

castles of Ludwig II or the Hearst Castle in LA: opened for the public, the valuable interior has to be protected (visitors as strangers), and visitors only can pass through by guided tours (as guests), changing their knowledge during the guided tour (as partners) and feeling comfortable in a café located nearby as clients (Doering, 1999). Posting the real visit experience on social media and finding a virtual community within the web is the qualitatively new step that leads to the open question: Which materials—such as own pictures, experience or knowledge—will be exchanged, and could museums "operate as hubs of a cultural network and engage communities of interest in conversion, collaboration and co-creation?" (Kelly & Russo, 2008, p. 91).

This qualitatively new facet is based on recent ICT and corresponds ideally to the museological position expressed by Hooper-Greenhill (1994; 2000), Heumann Gurian (2007b), Nina Simon (2010), and Black (2012) who all advocate to take visitors seriously. Such an approach forces us to think about the role or the function of the museum (Treinen, 1993) and, as a consequence, results in the necessity to reflect this issue for each museum and for each exhibition, whether on-site or online. Critically and carefully rethinking the relationship between the visitor and the museum also includes the exhibition and its topic as well as the question of the medium that can best support your aims, whether it be a hands-on-installation, a label-object-constellation, a demonstration, a handheld guide, a guided tour, discussions, or workshops. On an equally fundamental level is the question of whom you want to address: whether children or adults, experts or laypeople. Depending on the current situation, you will have to decide whether you use top-down information or a bottom-up dialogue, or both at once and with changing roles. There is no need for polarized thinking, but for knowledge about how human learning works.

4. Taking into account different forms of learning and corresponding theories, Falk and Dierking (1992) established a Contextual Model of Learning with the emphasis on interacting contexts, each defined by a set of personal, sociocultural, and physical variables of importance. It is a dynamic model considering learning—whether free-choice learning or meaning making (Falk 2005; Falk & Dierking, 2000)—as a product and a process individually shaped by the interaction between permanently changing variables over time. From this point of view learning does not emerge solely within the museum, but depends on the visitor's prior knowledge, their interests, their socialization, their friends, further events in the future, et cetera. Regarding this broader context, Falk and Dierking cautiously adjust the role of new media as follows:

This does not mean that digital technologies do not influence visitor learning; there is certainly preliminary evidence that they do. In

particular, we feel that such technologies, when designed well, can have the potential to positively impact visitor meaning making, by (1) enabling visitors to customize their experiences to meet their personal needs and interests; (2) extending the experience beyond the temporal and physical boundaries of the museum visit; and (3) layering multisensory elements within the experience, thereby enriching the quality of the physical context. (Falk & Dierking, 2008, p. 27f)

> The authors stress the importance of their model both for informal learning in museums and for digital learning, and they emphasize the need and the premises, respectively for digital devices to be designed appropriately in order to fulfill their potential (see also Goldmann, 2005).

Criteria for developing well-designed media have been provided by Paris (1997), based on the psychological and educational principles of visitor learning. In the beginning presented primarily for museum educational work, they have recently been applied to social media as well (Kelly, 2011). Paris' principles are based on the assumption that objects within the museum are of central meaning and that their special qualities can be exposed to visitors by constructing personal meaning, choice, challenge, control, collaboration, and consequences (promoting self-efficacy for example). These special qualities are also key criteria for social media and for the construction of new devices; they are of heuristic importance and should be used as guidelines.

In an inspiring contribution (Paris, 2006) delivered in an equally inspiring book on the future of museums (Genoways, 2006), Paris once again stresses the issue of supporting "visitors to engage objects actively and to construct personalized meaning in ways that are motivating and satisfying" (p. 258). Apart from that principle he describes other fundamental issues, regarding them as "heuristic for the future of museums" and adapting further psychological theories important for the museum work such as narrative knowing, communities of practice, and identity development. He advocates deep engagement that "provokes conversations, stories and collaboration; it reinforces positive self-perception and sense of identity in a community. These processes transcend traditional notions of learning facts and concepts, and they are crucial for cultivating life-long museum visitors" (p. 264).

Looking at these four principles from the new media or social media point of view, we can see that they are of heuristic importance as well—although one crucial point is missing, one which is of growing importance for the future of the museum (with or without ICT-possibilities): dealing with conflicts. Since there is a multitude of approaches to face conflicting issues in such environments, we want to give one practical example on how to deal with a specific conflicting topic (genetic tests) in an exhibition. The second example is focused on the emergence of a Europe-wide platform providing a plethora of digitized content. It will also spotlight the difficulties in managing diverse stakeholders.

In both examples, it's the user (or visitor) experience that is greatly enhanced: On the one hand, bringing the person into the midst of the topic and offering the possibility of exploring information on different levels and guided by personal preference allows multiple forms of usage. On the other hand, adding new channels to communicate with peers or professionals adds another dimension, taking us toward a kind of immersive environment.

PRESENTING CONFLICTS ON-SITE IN AN EXHIBITION

The general views outlined above will be demonstrated concretely in a case study of a conflict-prone issue from modern genetic technology. However, this strategy is relevant for nearly every type of museum, whether a city museum covering immigration issues or an archaeological museum in Western countries presenting objects from the Middle East. Dealing with delicate or ethical issues is becoming more and more important, and museums have to know how to handle this.

NEW TECHNOLOGIES AT THE DEUTSCHES MUSEUM

In November 2009 the Deutsches Museum opened a center of new technologies dealing with nano- and biotechnology, and showing recent findings and inventions explored by universities and large research organizations. A central objective of the exhibition is to provide not only information on the results and applications of the new technologies, but also on the actual research process behind them. Nanotechnology and biotechnology are the key technologies of the 21st century. Both share the idea of observing the world at the level of individual atoms and molecules, and thus broadening our knowledge of nature on all scales, from nano to macro. This is a revolutionary change of paradigm because, for the first time, we are actively assembling the world of things from the smallest components of matter—"bottom-up" instead of the previous "top-down" approach. Common to both technologies is the raising of many sociopolitical questions, be it stem cell research or the use of nanoparticles. Frequently there are no unambiguous answers to the sociopolitical questions that are raised here—and that often enough extends through to the application of the technologies. In a democratic society, it is only possible to fathom the opportunities and risks of new technologies if all citizens participate actively. It is therefore in the tradition of the Deutsches Museum to provide a platform for all social groups so they can obtain detailed, knowledge-based information on these topics. The new exhibition at the Deutsches Museum provides an extensive overview of the broad subject of nanotechnology and biotechnology. At certain points, visitors can find more in-depth explanations of particularly interesting topics. The incorporated media stations, for example, strive to present different points of view,

thus providing visitors with arguments for their own answers. In order to impart the research process directly, the exhibition includes various laboratories: a hands-on laboratory, among other things, in which visitors can conduct their own simple (nano) biological experiments with DNA. And a new format was installed at the Deutsches Museum for the first time—the Open Research Laboratory. Here, visitors can actually witness current research as scientists from the university and the Deutsches Museum work live on the latest nanotechnological questions. Engaging in an active dialogue with the scientists allows visitors to not only understand the scientific theory, but also the scientists as people, their motivation and, literally, their daily work (Hix, 2009). The event forum, in addition, provides an interdisciplinary platform for lectures, conferences, discussions, and citizen dialogue days, thus fulfilling the mission of the Deutsches Museum to communicate science to the public.

Apart from many hands-on stations, which allow visitors to inquire into the effects of nanotechnology, audio stations for listening to the pros and cons of the new technology, and other facilities aimed to evoke the interest of the visitors, there is one station that will be described in detail here. This station was the object of a recently finished pedagogical research project. At this moment in time, only a few results can be provided, which nevertheless might be of interest regarding the construction of media dealing with conflicting or delicate issues.

THE GENETIC TEST MEDIA STATION: SOME VISITOR RESEARCH RESULTS

One trend in modern medicine is what is termed personalized medicine, the idea of treating severe diseases not only tailored to the needs of the individual patient, but also to start treatment before signs and symptoms appear. Most of these approaches are based on genetic tests for disease that can be treated effectively. But there are also tests detecting so-called monogenic disorders: diseases that are the result of a single mutated gene. Most diseases resulting from these single gene mutations still cannot be prevented, and often therapies are only available to a limited extent. If a test detects a disease that will inevitably develop later in life, or at least with a certain probability, this will have far-reaching consequences for the person affected, reaching from changes in their sense of self, their life plans, and their career path, right through to the desire to have children and their relationship to potentially also affected family members.

In order to emphasize the complexity of the subject of genetic testing, visitors to the exhibition are confronted with six different situations, in which they take the place of the affected person and can decide in favor of or against a genetic test. Each (fictitious) person tells a two-minute story of his or her situation, briefly describing the background and some consequences for his or her life. At the end, the person asks whether the visitor would choose take

the test in his or her place. After choosing yes or no, the visitor gets a graphical feedback how other visitors have answered this question. Further buttons on the interface lead to case-related information on the legal background in different countries, the ethical discussion, and additional facts—such how often the test is done in real situations, and that the probability in many cases significantly varies with other factors.

Seen from a technical point of view, the most prominent part of the genetic test media station consists of six facial masks mounted at eye level on the wall. Made of satined plastic, the faces are projected from the reverse side with two HD LED projectors, giving the visitor the feeling of talking face to face with the person and thus being immersed in the situation (Figure 6.1). Choosing the different stories as well as user feedback is handled via a touch screen terminal right in front of the wall.

Interestingly, the answers of visitors differ widely from real-life answers: visitors significantly more often vote for doing a test, thus—at least in the short time span in which they devote their thoughts to the problem—favoring the certainty of having a result at all over the fragile freedom of not knowing.

The media station featuring genetic tests was evaluated prior to the installation in the exhibition in a research project funded by the Leibniz-Gemeinschaft (Hauser, 2009; Reussner, 2007). The main goal of the research was to see whether it was possible for the visitor to gain a reflected and well-founded opinion on a genetic test in the relatively short time span of the story

Figure 6.1 Visitors in front of the genetic test media station.

told. Further foci were to test the effectiveness of the dialogue and the feedback system under experimental settings in a laboratory.

A 1 x 3 factorial design was used for this study, with overall 72 students being tested randomly, that is, n = 24 for each group. The single independent variable was the feedback given to the visitor with respect to his/her vote: (a) a congruent feedback ("86 % of the visitors answering agreed with your voting"), (b) a conflicting feedback ("86 % of the visitors chose the other answer"), and (c) no feedback at all. The focus of probing was on decision behavior and decision quality (Figure 6.2).

The results show that conflicting feedback, that is, a discrepancy between personal opinion and majority opinion, triggered a cognitive dissonance that test persons usually described as "unpleasant." However, the psychological discomfort discovered did not go along with a significant change of opinion toward the majority opinion, nor with a more reflected judgment formation. Seen across all three groups, the results indicate that the media station could assist in gaining a reflected judgment formation on genetic tests and the challenges associated with it. More details on the findings of this study are published in German in Hänle, 2012. But general results show the difficulty of fostering or facilitating tolerance to ambiguity, which is of central importance in a world of growing complexity. What can be defined as central elements of the term "tolerance ambiguity"? Another study (Knipfer, 2009), funded

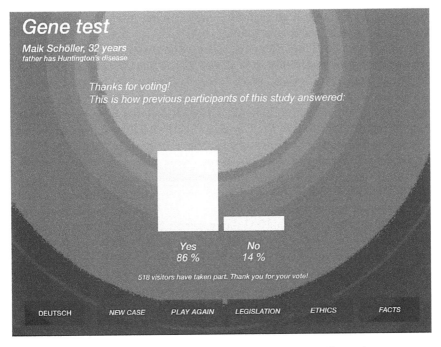

Figure 6.2 Sample of a feedback screen in the genetic test media station.

by the German Research Foundation, determines "critical thinking" and "reflective judgement," to be key ideas, based theoretically on integrated concepts from different psychological schools such as cognitive psychology and social psychology. Knipfer examines with positive results how the processes of these two defined concepts can be supported by "discussion terminals" at science museums.

Only a small sample of such examples and few research results exist on this important subject (compare The Hall of Human Life at the Museum of Science in Boston, for instance, http://www.vibug.org/mos.html; Pedretti, 2004). From our point of view the subject of dealing with controversy in science museums—and in other museum types as well—is of growing importance. There is a clear need to develop tools that deal with this, on-site and online—and these tools seem to be emerging in the context of the new role of museums.

BUILDING A CENTRAL ACCESS POINT TO CULTURAL HERITAGE IN EUROPE

Our second example looks at an initiative, launched jointly by the European Commission together with representatives from the cultural heritage sector in Europe, to create "the" central access point to cultural heritage from Europe. Involved are many cultural heritage institutions—not only museums, but also libraries, archives and media archives—which together form *Europeana* (www.europeana.eu). The aim is to make Europe's cultural heritage as accessible, sharable, and widely usable as possible.

Europeana is a large initiative with major political support, which has been under development since 2008. It is aiming to become the central portal for heritage in Europe, providing direct access to digitized and digital cultural heritage from all over the continent. Following Google's initiative to digitize large numbers of books from libraries, six heads of states from EU countries wrote to the president of the EU Commission advocating a European digital "Library" with rich search tools, expressly for European cultural treasures—conceived as a counterpart to Google and "Google books." The president and his EU Commission welcomed this initiative and issued a strategic plan "i2010: Digital Libraries," followed in 2006 by a "Recommendation on the digitization and online accessibility of cultural material and digital preservation" in EU member states. In 2007 the European Parliament adopted a resolution in support of the project. Also in 2007, the European Council of the EU invited the member states and the commission to jointly work on digitization and online accessibility of cultural heritage.

In November 2008, the first prototype of *Europeana*—the European Digital Library (www.europeana.eu) was formally launched. Political support continued, and in 2009 and 2010, the EU Commission encouraged the EU member states to continue and intensify their work on digitization in the cultural field, which was subsequently reflected in their contributions

to *Europeana*. Also in 2010, the European Parliament adopted a resolution that 'stresses that *Europeana* should become one of the main reference points for education and research purposes' and proposes that *Europeana* should be 'integrated into education systems' in order 'to contribute towards transcultural coherence in the EU'.

Beginning in 2011, a high-level expert group, the "Comité des sages" issued its report on the state and the future vision of digitization in the field of European cultural heritage. Another recommendation of the EU Commission followed late in 2011, reflecting the work achieved and the work to be carried out in future.

In order to ensure that all cultural heritage sectors are involved and represented, the initiative is overseen by the *Europeana* Foundation, a society operating under Dutch law. The *Europeana* Foundation brings together European cultural heritage associations, or European branches of international organizations. Museums are represented by ICOM-Europe, the Network of Museum Organisations (NEMO), the European Museum Academy (EMA), and the European Museum Forum (EMF). The development of *Europeana* is presently project based and mostly financed through European project funding, with cofunding from cultural heritage institutions from all over Europe and some annual support from several European member states. Currently there are plans to implement institutional funding to permanently secure the further development of this central access point to cultural heritage in Europe.

While *Europeana* is still under development at the time of writing in 2012, there are already over 22 million objects from more than 1,500 institutions in 32 countries that can be searched and found in the portal. Currently, content is grouped in four different types: *images* from paintings and drawings, and photos from museum objects; *texts* including books, letters, and archival documents; *sounds*; and *videos*. The website invites everybody to discover and browse European heritage. In addition, results can be filtered by language, date, and country. The idea is not only to provide access but also to develop an online service, which encourages sharing of information between cultural heritage institutions and their audiences, and allows collaboration and communication.

Every user of the *Europeana* portal has the possibility to create his or her own account, which allows he or she to save selected objects, tag them for individual usage, or to save searches. *Europeana* offers several bookmarks and sharing possibilities: it is present on Facebook and runs a blog. In 2011, Facebook counted 4,136 unique users and more than 10,000 likes (Figure 6.3).

IRN Research from the UK had been commissioned by *Europeana* to conduct two online user surveys (one in 2009 and one in 2011). Seventy-five percent of the users are over 35 years old. Both surveys show that while approximately three quarters of all users visit the site to satisfy their personal interest, approx. 50% of regular users (20 visits or more) use *Europeana* for work. The 2011 survey showed that *Europeana* is not seen as at the

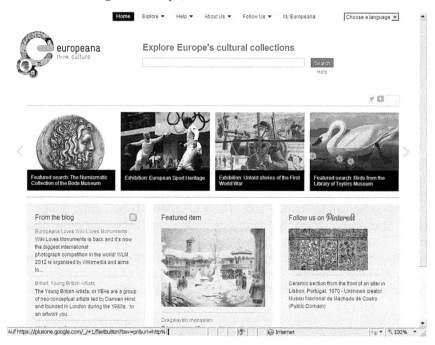

Figure 6.3 Screenshot of the *Europeana* website.

forefront of technical development; it is highly rated because it is seen as a trustworthy source (being based on cultural heritage institutions from all over Europe). So, even if the current platform does not yet offer a special infrastructure for teaching and learning, it is already in professional use.

Another survey, commissioned by *Europeana*, was conducted by CIBER Research Limited to illuminate how *Europeana* is used as a mobile web resource (Figure 6.4). The results were published in the report: "Europeana—Culture on the go" in 2011. One of the key findings was that users who enter the site via social media or blogs stayed longer on *Europeana* and ran a higher number of search queries.

Those survey results are reflected in the current 2011–2015 strategic plan for the development of *Europeana*, in which the "engagements," the following four goals, are specified: Firstly, to cultivate new ways for users to participate in their cultural heritage by offering more means of interaction and use of the information provided, combining it with user-generated content; secondly, to enhance the user experience by refining and improving the website and the services offered, and enriching the content provided by the cultural heritage institutions, offering more virtual exhibitions in order to contextualize the content from all over Europe; thirdly, to extend the use of Web 2.0 tools and social media programs in order to connect with different interest groups; and fourthly to broker new relationships between

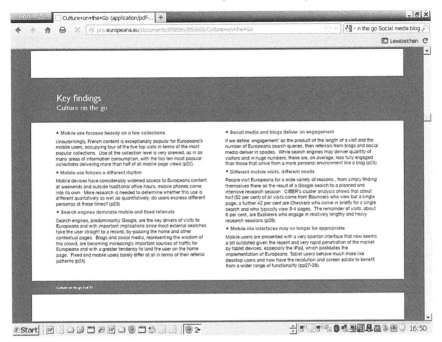

Figure 6.4 CIBER research result.

curators, content, and users by supporting user contributions. One example of the involvement of a wider user community is the organization of a series of collection days, which was launched in 2011 in Germany (Frankfurt, Munich, Berlin and Stuttgart) and was continued in the UK, Belgium, and Italy in the first half of 2012. During these collection days, members of the public are invited to bring private memorabilia from World War I: "While historians and experts are available to listen to the stories about the significance of the objects brought to this event, the objects are digitized and uploaded to the website." Besides participating in such a collecting day, members of the public can also contribute to the archive online at www.Europeana1914–1918.eu

This being a rather new initiative, there is as yet no evaluation concerning this activity, nor of the use of social media activities set up by *Europeana*, but we can conclude that the World War I project was well received, with each collecting event a huge success (collecting information on around 2,000 items of memorabilia in one weekend; Figure 6.5).

Besides these planned developments, *Europeana* aims to diversify its services to meet the needs of different target groups. As such it will be interesting to follow the role *Europeana* plays in digital learning and in building a bridge between various cultural heritage institutions, as well as between cultural heritage institutions and their users. And more in-depth research is

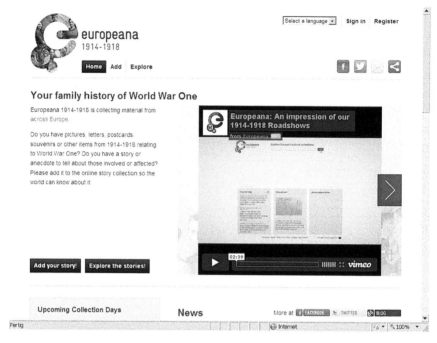

Figure 6.5 Screenshot from the WW1 project.

needed to examine how *Europeana* users currently employ *Europeana* for their work, and how this usage can be extended and better supported.

DISCUSSION

Looking back at the general framework and the two examples, there are some results that are interesting both for participation in museums and in social media. Firstly, political programs need participation aiming to make citizens competent in shaping societal development. Secondly, museums can be a central platform for those developments—and they are willing to adopt this role—and for the discussion of current research regarding visitors as dialogue partners (Chittenden et al., 2004). This new model from "deficit to dialogue" (Durant, 2004) corresponds with the conceptual change in museological and museum learning theories (Hein, 1995; 1998), and has also been transferred to the museum social media discussion: ". . . visitor experience is similar across all three spheres—physical, online and mobile—it's just the tools and the context that are different" (Kelly, 2011, p. 12). However, one has to consider that the latter two are growing together rather quickly: A study conducted by CIBER Research Ltd. in 2011 on the use of *Europeana* with a special focus on mobile access showed that "mobile and fixed users do not

differ in any significant way in terms of their pattern of referral to *Europeana*" (CIBER, 2011, p. 23).

For all three spheres, more research is needed to find answers that help to support dialogues relating to societal issues such as ethical dilemmas or other conflicts. In the light of this relatively new museum function, these dialogues are becoming more important as time goes on. How can we use the rich media toolbox in order to deal competently with conflicting evidence and to foster dialogue? The prospects of achieving this goal, at least, are slowly improving. Judging from a German perspective, there is growing interest, and there are rising subsidies available for interdisciplinary research in this field. For example, a new research program of the German Research Foundation invites students of cognitive psychology, pedagogical psychology, communication studies, and museums to collaborate and continue research on museums as informal learning environments, especially focusing on the communication of fragile and conflicting evidence (http://wwwpsy.uni-muenster.de/Psychologie. inst3/AEbromme/en/forschung/dfg-spp/DFG-SPP1409/ueberblick.html). But it is highly important for these programs that they prove successful, so that more museums and curators engage in this kind of research. One project within this research program investigates the role of authentic objects in communicating conflicting scientific facts and arguments in museums and exhibitions (http://www.deutsches-museum.de/en/research/projects/focal-point-iv/). In estimating and differentiating the impact of the three spheres, these results might be very helpful, because the central impact of objects in visitor experience is well known, and has a firm base in many evaluation or research projects (e.g., Csikszentmihalyi & Hermanson, 1995; Falk, 1998; Leinhardt, Crowley & Knutson, 2002; Paris, 2002; Thomas & Mintz, 1998; Treinen, 1993). However, studies comparing the outcomes or the quality of visitor experience using traditional media as opposed to new media are rare (compare Falk & Dierking, 2008). We agree with Falk and Dierking (2008, p. 28) in saying that "the museum experience is incredibly complex" and stating that it is becoming even more complex when museums present ethical dilemmas or other conflicts, and that we are therefore dependent on new media.

Although Falk & Dierking (2008, p. 28) are right in stating that "It seems fair to say that a full understanding of how digital technologies support museum-based meaning making lies more in the future than in the present. However, that future is not likely too distant," we may well be on the road to this goal right now.

An indispensable prerequisite for better informal learning opportunities and for establishing value-added online services is the existence of easy to reach, one-stop portals that give access to rich cultural heritage, as is presently under construction in *Europeana*. Digital cultural heritage content should come from many sources and should cover a broad range. It should also be sufficiently itemized so as to allow for individual choice and for individual research according to particular interests or topics. There should also be, however, various modes of organizing the itemized objects into meaningful

aggregations and of allowing contextualization through stories or online exhibitions. And finally, perhaps the most crucial factor in making these online services participative is the feature of such portals to allow contributions by users, to allow for discussion groups, blogs, and other forms of active interaction. Most obviously, such a portal will need to be connected to social media such as Facebook to ensure its rich content reaches a wide public. It is the understanding of *Europeana* that this portal will grow into just such a broad-based, trans-European, service.

These days, museums are no longer stand-alone institutions—this is not in the least reflected in ICOM's current definition of museums as "permanent institutions in the service of society." Rather, museums are hubs in modern society—they connect people, they connect activities, they connect people with activities. In this way, museums exert a high social influence, and such social influence and responsibility implies the fostering of participation at many levels—for citizens both at the neighborhood level, but also organized networks focusing on many different issues. At the same time, participation also demands the development of conflict-resolution patterns that are powerful and easy to handle.

Therefore, building participation and conflict-resolution patterns does imply the necessity of building network interconnection that both allows cooperation between content holders, and, more importantly, the interaction at many levels between users, citizens, the public, and "knowledge centers," including museums. The 'virtual' dimension of information (content) as it is offered online, is its ease of use, its rich quantity, and its dissemination (accessibility) to everyone at any time. This, in the end, forms an ever-stronger basis for participation. It is, therefore, vital that more research on this issue is carried out, and that this path of scientific discovery is strengthened so as to bring forward the research results needed to underpin participation, conflict handling, and interconnected knowledge provision in the future.

In any case, for the user—or visitor—the borders between the different ways in which information is offered are continually blurred. New, mobile media brings together both traditional and new dimensions and allows multiplatform experience: Whether you are discussing the meaning and the consequences of a genetic test with another visitor next to you at the museum or with other users on an online platform, whether you are gaining and sharing information on cultural heritage while sitting in your living room or strolling through a museum, it makes no big difference. Or rather, the key to an effective learning experience is common to both forms: information has to be well organized and presented.

Elaine Heumann Gurian, in her keynote speech at the ICOM 2007 General Conference in Vienna, (Gurian, 2007a) suggested that we need to interweave the real museum visit with all the virtual activities taking place on the web. She developed a vision for a museum of the future, the "Blue Ocean Museum" where she tried to demonstrate how museums can keep and share their trustworthiness and explained how the curator's role needs

to change from pure researcher and provider of information to information manager. She stated: "If one believes that accepting contrarian information in one's midst and participating in the ensuring dialogue is at the heart of democracy, then a new, slightly chaotic, democracy can be nurtured within the walls of the Blue Ocean Museum. In this new configuration, museums will rightfully become a useful forum for peaceable conversation." We fully agree with this—but we need to explore how we can best fulfill this.

REFERENCES

Auer, H., Böhner, K., Osten, G. v. d., Schäfer, W., Treinen, H., & Waetzoldt, S. (1974). *Denkschrift Museen: Zur Lage der Museen in der Bundesrepublik Deutschland und Berlin (West)*. Bonn: Deutsche Forschungsgemeinschaft.

Bandelli, A. (2010). *Real participation: From fear to trust*. Ecsite Newsletter (Eds.). Real participation: online tools. No. 82. Retrieved from http://www.ecsite.eu/sites/default/files/Ecsite_Newsletter_82_Spring_2010_-_Online_tools_for_participation.pdf

Black, G. (2012). *Transforming museums in the twenty-first century*. London: Routledge.

Chittenden, D., Farmelo, G., & v. Lewenstein, B. (Eds.). (2004). *Creating connections: Museums and the public understanding of current research*. Walnut Creek, CA: AltaMira Press.

CIBER Research Limited (2011). *Europeana. Culture on the go*. Retrieved from http://pro.europeana.eu/documents/858566/858665/Culture+on+the+Go

Csikszentmihalyi, M., & Hermanson, K. (1995). Intrinsic motivation in museums: Why does one want to learn? In J.H. Falk & L.D. Dierking (Eds.), *Public institutions for personal learning: Establishing a research agenda* (pp. 67–77). Washington, DC: American Association of Museums, Technical Information Service.

Doering, Z. D. (1999). Strangers, guests, or clients? Visitor experiences in museums. *Curator, 42*(2), 74–85.

Durant, J. (2003). From deficit to dialogue. Paper presented at *Neue Wege in der Kommunikation von Wissenschaft und Öffentlichkeit*. Seminarwoche des Deutschen Museums, Munich.

Europeana. (2011). Europeana strategic plan 2011–2015 (2011). Retrieved from: http://pro.europeana.eu/documents/866067/983523/D3.1+-+Europeana+Strategic+Plan+2011–2015

European Commission. (2011). Commission recommendation of 27.10.2011 on the digitisation and online accessibility of cultural material and digital preservation. Retrieved from http://ec.europa.eu/information_society/activities/digital_libraries/doc/recommendation/recom28nov_all_versions/en.pdf

European Parliament resolution of 5 May 2010 on a new digital agenda for Europe: 2015.eu Retrieved from http://www.europarl.europa.eu/sides/getDoc.do?type=TA&language=EN&reference=P7-TA-2010–133

Falk, J.H. (2005). Museums and free-choice learning. In K. Kaudelka & C. Schlichtenberger (Eds.), *Lernen—Erleben—Wissen. Learning—Experience—Knowledge* (pp. 27–37). Dortmund: Deutsche Arbeitsschutzausstellung der Bundesanstalt für Arbeitsschutz und Arbeitsmedizin.

Falk, J.H., & Dierking, L.D. (1992). *The museum experience*. Washington DC: Howells House

Falk, J.H., & Dierking, L.D. (1998). Audience and accessibility. In S. Selma & A. Mintz (Eds.), *The virtual and the real: Media in the museum* (pp. 57–70). Washington DC: American Association of Museums.

Falk, J.H., & Dierking, L.D. (2000). *Learning from museums: Visitor experiences and the making of meaning.* Walnut Creek, CA: AltaMira Press.

Falk, J.H., & Dierking, L.D. (2008). Enhancing visitor interaction and learning with mobile technologies. In L. Tallon & K. Walker (Eds.), *Digital technologies and the museum experience: Handheld guides and other media* (pp.19–33). Lanham, MD: AltaMira Press.

Falk, J.H., Dierking, L.D., & Foutz, S. (Eds.). (2007). *In principle, in practice: Museums as learning institutions* (pp. 121–135). Lanham, MD: AltaMira Press.

Genoways, H.H. (Ed.). (2006). *Museum philosophy for the twenty-first century.* Lanham, MD: AltaMira Press.

Goldmann, K.H. (2005). A framework for thinking about museum web site evaluation. In A. Noschka-Roos, W. Hauser, & E. Schepers (Eds.), *Mit neuen Medien im Dialog mit den Besuchern? Berliner Schriften zur Museumskunde* (pp. 42–48). Berlin: G+H Verlag.

Gurian, E.H. (2007a). Introducing the Blue Ocean Museum: An imagined museum of the nearly immediate future. Conference proceedings from *the 21st ICOM General Conference.* Vienna, Austria.

Gurian, E.H. (2007b). Peaceable with a small p. Presented at the Alaska Museums Association.

Hänle, M. (2012). Präimplantationsdiagnostik, ja oder nein? Förderung einer informierten und gut begründeten Entscheidung im Bereich Medizinethik mit einer multimedialen Lernumgebung im Museum. Munich: University Library, LMU München. Retrieved from http://edoc.ub.uni-muenchen.de/14875/1/Haenle_Martina.pdf

Hauser, W., Noschka-Roos, A., Reussner, E., & Zahn, C. (2009). Design-based research on D digital media in a museum environment. *Visitor Studies, 12*(2), 182–198.

Hein, G.E. (1995). The constructivist museum. *Journal of Education in Museums, 16*, 21–23.

Hein, G.E. (1998). *Learning in the Museum.* London: Routledge.

Hix, P., & Heckl, W.M. (2009). Public understanding of research: The open research laboratory at the Deutsches Museum. In D.J. Bennett & R.C. Jennings (Eds.), *Successful science communication* (pp. 372–383). Cambridge: Cambridge University Press.

Hooper-Greenhill, E. (1994). *Museums and their visitors.* London: Routledge.

Hooper-Greenhill, E. (2000). Communication and communities: Changing paradigms in museum pedagogy. In S. Lindqvist (Ed.), *Museums of modern science* (pp. 179–188). Nobel Symposium 112 Canton, MA: Science History Publications, USA, & The Nobel Foundation.

International Council of Museums Statutes (approved in 2007): Retrieved from http://icom.museum/fileadmin/user_upload/pdf/Statuts/Statutes_eng.pdf

IRN Research (2009). *Europeana: Online visitor survey.* Birmingham, AL. Research report: Retrieved from http://pro.europeana.eu/c/document_library/get_file?uuid=e165f7f8–981a-436b-8179-d27ec952b8aa&groupId=10602

IRN Research (2011). *Europeana: Online visitor survey.* Birmingham, AL. Research report: Retrieved from http://pro.europeana.eu/documents/10602/370691/Europeana+Online+Survey+Report+2011.pdf

Kelly, L. (2011). *Learning in the 21st century museum.* Paper given at LEM Conference, Tampere, Finland, October 12, 2011. Retrieved from http://www.lemproject.eu/library/books-papers/learning-in-the-21st-century-museum

Kelly, L., & Russo, A. (2008). *From ladders of participation to networks of participation: Social media and museums audiences. Museums and the Web 2008* (p. 83). Selected Papers from an International Conference. J. Trant & D. Bearman (Eds.). Toronto: Archives Museum Informatics, 2008, Retrieved from http://www.museumsandtheweb.com/mw2008/papers/kelly_l/kelly_l.html

Knipfer, K. (2009). Pro or con nanotechnology? Support for critical thinking and reflective judgement at science Museums/ Pro oder Kontra Nanotechnologie? Unterstützung von kritischem Denken und reflektiertem Urteilen im Museum. Retrieved from http://nbn-resolving.de/urn:nbn:de:bsz:21-opus-37615

Leinhardt, G., Crowley, K., & Knutson, K. (2002). *Learning conversations in museums*. Mahwah, NJ: Lawrence Erlbaum Associates.

Macdonald, S. (Ed.). (1998). *The politics of display: Museums, science, culture*. London: Routledge.

Paris, S. (1997). Situated motivation and informal learning. *Journal of Museum Education, 22–27*.

Paris, S.G. (Ed.). (2002). *Perspectives on object-centered learning in museums*. Mahwah, NJ: Lawrence Erlbaum Associates.

Paris, S.G. (2006). How can museums attract visitors in the twenty-first century. In H.H. Genoways (Ed.), *Museum philosophy for the twenty-first century* (pp. 255–266). Lanham, MD: AltaMira Press.

Pedretti, E. (2004). Perspectives on learning through research on critical issues-based science centre exhibitions. *Science Education, 88*(1), 34–47.

Prensky, M. (2001). Digital natives, digital immigrants. *On the Horizon, 9*(5). Bradford, England: MCB University Press. Retrieved from http://www.marcprensky.com/writing/prensky%20-%20digital%20natives,%20digital%20immigrants%20-%20part1.pdf

Report of the 'Comité des sages' (2011). Reflection Group on Bringing Europe's Cultural Heritage Online. The New Renaissance. Retrieved from http://ec.europa.eu/ information_society/activities/digital_libraries/doc/refgroup/final_report_cds.pdf

Reussner, E.M., Schwan, S., & Zahn, C. (2007). New technologies for learning in museums? An interdisciplinary research project. In J. Trant & D. Bearman (Eds.), Proceedings of the International Cultural Heritage Informatics Meeting. Toronto, Canada: *Archives & Museum Informatics*.

Russo, A., & Peacock, D. (2009). Great expectations: Sustaining participation in social media spaces. Museums and the Web 2009: Selected Papers from an International Conference. In J. Trant & D. Bearman (Eds.). Toronto: *Archives Museum Informatics, 2009, 23*. Retrieved from http://www.archimuse.com/mw2009/papers/russo/russo.html

Silverman, L.H., & O'Neill, M. (2004). Change and complexity in the 21st-century museum. *Museum News, Nov/Dec, 37–43*.

Simon, N. (2010). *The participatory museum*. Retrieved from http://www.participatorymuseum.org/web

Tallon, L., & Walker, K. (Eds.). (2008). *Digital technologies and the museum experience: Handheld guides and other media*. Lanham, MD: AltaMira Press.

Thomas, S., & Mintz, A. (1998). *The virtual and the real: Media in the museum*. Washington, DC: American Associations of Museums.

Treinen, H. (1993). What does the visitor want from a museum? Mass-media aspects of museology. In S. Bicknell & G. Farmelo (Eds.), *Museum visitor studies in the 90s* (pp. 86–93). London: Science Museum.

Weil, S.E. (2002a). Transformed from a cemetery of bric-a-brac. In S.E. Weil (Ed.), *Making Museums Matter* (pp. 81–90). Washington DC: Smithsonian Books.

Weil, S.E. (2002b). From being about something to being for somebody: The ongoing transformation of the American museum. In S.E. Weil (Ed.), *Making museums matter* (pp. 28–52). Washington DC: Smithsonian Books.

7 Curating and Creating Online

Identity, Authorship, and Viewing in a Digital Age

Glynda Hull and John Scott

It is now commonplace to observe that museums and libraries, those institutions charged with the collection, preservation, and provision of access to valued cultural artifacts, texts, and knowledge, are in the midst of a sea change. Digital technologies, the Internet, and the vast social shifts that have accompanied them have thrown open the doors of such institutions to new visions, purposes, practices, and challenges. Academic libraries are beginning to reframe themselves as providing a "learning commons," and they grapple in so doing with how to design social and physical spaces suitable for collaborative learning in networked digital environments (Keating & Gabb, 2005). Museums too have had to rethink their educational function, not only in the contexts of calls for lifelong and life-wide learning, but in the face of the affordances of digital archives and social media, which potentially dramatically broaden access to holdings and reconfigure relations to collections and curation (Russo, Watkins, & Groundwater-Smith, 2010; Tang, 2005).

Youth who are coming of age in our digital world perhaps represent the most challenging population for museums to serve. Many are startlingly savvy in terms of technical sophistication (albeit with patterned variations in expertise; see Green & Hannon, 2006), as well as startlingly distinctive from older generations in terms of their valuation and use of digital media practices, including a penchant for constant connectivity (boyd, 2008; Lenhart, Purcell, Smith, & Zickuhr, 2010). Despite differences in access to technology and cultural norms, and diverse though their social, cultural, and material millieux, one can increasingly speak of a global youth culture (Hull, Zacher, & Hibbert, 2009; Nilan & Feixa, 2006). Indeed, young people across the world stand today on the frontlines of intercultural learning, navigating and negotiating digitally mediated relationships and understandings, as they communicate with each other online, experiment there with representations of self and engage the representations of others, and address audiences both local and global by means of multiple symbol systems, media, and modes (Stornaiuolo, Hull, & Sahni, 2011).

What roles can museums play, appropriately reconceived in terms of their functions and practices in a digital world, in the learning and self-imaginings of global youth? How can such youth's communicative and creative practices,

especially via social media, benefit from juxtaposition to the specialized meaning-making affordances that museums provide? In particular, we have found it helpful to explore the concept of curation, often associated broadly with the preservation and display of cultural and historical artifacts, and traditionally the quintessential function of the museum specialist, as a potential means to characterize youth's participation on social networking sites. Conversely, we have drawn on youth's participatory social media practices on such sites to reconceptualize museums' modes of interaction with their patrons.

"Curation" is now used as a metaphor to characterize online identity and communicative practices, as young people cultivate representations of themselves on social networking sites such as Facebook, Tumblr, and Pinterest (cf. Thompson, 2008). As social networks become ever more ubiquitous, their users, especially the youthful ones, increasingly exploit such sites both as contexts for identity performances and as repositories for valued texts, images, music, video, and the range of digital artifacts. Curation as an organizing concept for social media activities seems, then, especially useful, joining the concepts of design (New London Group, 1996) and connectivity (Castells & Cardoso, 2005; cf. Appadurai, 1996) in remolding discourses about new literacies (Coiro, Knobel, Lankshear, & Leu, 2009; Kress, 2005; Prior, 2005), symbolic creativity (Willis, 1990), and youth media (Fisherkeller, 2011).

Recent calls for an artistic, aesthetic grounding for literacy studies (Hull & Nelson, 2009) resonate with abundant interest on the part of digital artists in exploring the boundaries of mode and media. Young people across the world have likewise embraced the opportunity to participate in inventive popular cultural art forms (i.e., Huq, 2006; Niang, 2006), what Muñoz and Marín (2006) describe as "active and creative engagement . . . in the production of meanings" (p. 130). The aesthetic turn among youth is mediated and amplified by digital and electronic technologies that themselves sometimes become extensions of the bodies of global youth—mobile phones; iPods; and formerly, boom boxes. And now, more and more routinely for some youth across the world, access to multimedia tools for creation and composition, and to the Internet for sharing with local and distant audiences, is the norm (cf. Hill & Vasudevan, 2008).

If digital artists and global youth have embraced new forms of symbolic creativity, social media, and participatory communication, and if social media have taken the digital world by storm, surpassing everyone's imagination in terms of their rate of popularity and viral spread, institutions like schools and museums have been much slower on the uptake. In the United States, schools are print-centric and are still organized for the most part by tools, space–time relationships, and participant structures that belong to a previous age; schools have been especially skeptical of the educational value of social media and especially alert to the risks of social networks and media sharing (Beach, Hull, & O'Brien, 2011; boyd, 2008; Greenhow, Robelia, & Hughes, 2009; Livingstone & Brake, 2010). As institutions not bound by state and/or national testing mandates and whose charter regarding

education is informal and broad, museums are better positioned than are schools at the moment to experiment with social media, to integrate a user perspective into their communication, and to capitalize on youthful interest in wide-ranging activities related to symbolic creativity.

To be sure, shifts are afoot, and they are reflected in an energized literature on learning in relation to museology. In an early article, prior to the influence of the digital revolution, Silverman (1995) emphasized how museum visitors make meaning by contextualizing what they encounter and called for museums to take into account how better to meet visitors' needs and desires. More recently, and in tune with digital advances, Tang (2005) identified types of representational practices in museums and highlighted how museums can be viewed as "semiotic phenomena" and as engaging in representational practices (p. 52). Russo, Watkins, and Groundwater-Smith (2009) advocate for the use of digital social networks in the design of informal learning environments in museums, and Russo, Watkins, Kelly, and Chan (2008) document how museums worldwide are beginning to use social media, integrating blogs, podcasts etc., into their communicative and educative practices. Still, the websites of most museums appear yet to operate from a knowledge-telling mode and to be designed via content management systems that facilitate this approach by providing only limited opportunities for interaction or engagement with holdings. Canonical categories for such sites now dominate: "today's events," "plan your visit," "exhibitions," "gallery talks," "memberships." Most museums, archives, and science centers face considerable challenges in integrating a user perspective into their communication, and doubly so when those users are digitally-oriented youth.

SPACE2CRE8: AN INTERNATIONAL SOCIAL NETWORKING PROJECT

With the rapid proliferation of social networking technologies across the everyday lives of young people, finding opportunities to situate these tools within a range of educational contexts is crucial if we are to understand their impacts on learning and knowledge production. We describe here one such effort, launched in 2008 and researched through 2011. This international social networking project has three components: (1) off-line extra-school or school-based programs in five countries (United States, Norway, India, South Africa, Australia), where youth participate in arts-based, literacy-rich activities such as digital storytelling; (2) a private social network, Space2Cre8,[1] where youth communicate with each other and share their digital artifacts; and (3) research on the evolution of the network, especially its intersection with identity formation and cultural knowledge development, and the roles that multimodal communication play in these processes (i.e., Hull, Stornaiuolo, & Sahni, 2010; Hull, Stornaiuolo, & Sterponi, in press; Stornaiuolo, 2012). In each country, teachers and researchers collaborate

with each other and a central research team to develop curricula on issues related to media representation, communication with distant audiences, and local concerns and personal interests. Youth share their digital stories, films, and other digital artifacts with each other on Space2Cre8, which, like Facebook and other social networking sites, allows participants to articulate lists of friends, make wall and blog postings, send private messages, chat, post videos, form groups, and view recent site activities.[2]

This project is an example of design-based research, which combines the design of tools and interventions with the development of theoretical knowledge and continuous improvement of practice (di Sessa, 2000; Hauser, Noschka-Roos, Reussner, & Zahn, 2009). Data were collected through observational field notes, audio and video recordings of classes and activities, periodic semi-structured interviews, participants' creative artifacts, and their online interactions and exchanges (captured via a tracking system embedded within the network). In this chapter we consider what lessons can be gleaned from this youth-oriented, arts-based social networking site as we consider how museums might foster productive informal learning activities for youth and integrate social media into their communicative practices. We look in turn at the architecture of spaces, the digital materials that are archived in such spaces, and the narratives that participants construct in interaction with spaces, contexts, and artifacts.

COMMUNITIES AND INTERFACES: THE CONTOURS OF MEANING IN DIGITAL CURATION

In ways similar to museum architectures, institutional discourses, and cultural identities of visitors, the Space2cre8 interface and user community influenced both curatorial practices and viewing perspectives by organizing users' interactions with artifacts. Like museum curators working within the design of a building, where museum architecture and object-displays frame the meanings of artifacts (Alpers, 1991), designers of online profiles likewise work within the contours of a user interface, juxtaposing texts, images, and sounds and exploiting their relationships, as they creatively negotiate the given constraints of such spaces of display in the construction and curation of an online identity. The interface of Space2cre8 and its tools for organizing and displaying artifacts and user interactions, like those of other social networks, contribute to the kinds of meanings and experiences that users gain in viewing and exhibiting artifacts. Space2cre8 organizes media across a variety of pages and viewing spaces, which can be imagined as individually and/or collectively curated or as system archives. At the archival level, all media uploaded to an individual's profile page on Space2Cre8 are also stored as part of Space2Cre8's searchable archive, which is organized by media type (photo, video, blog) and time of upload. Users can navigate this space through its chronological organization, but also through key word searches

and 'User Featured' tags. The home page of the site is a collectively curated space, where network activity is visualized in a time-based feed, and a viewer can wander through a record of 'Recent Events', which includes the ongoing work of the active user population. At the individual level, the curation of a personal profile page occurs initially through the assembling of biographical linguistic texts, profile pictures, and customizable background options, and continues as the user organizes and positions texts and media artifacts (user created and shared) across layers of the global community in the construction of a digital persona. This blend of curatorial spaces on SpaceCre8 thus positions artifacts across multiple pages of viewing where they are juxtaposed to other artifacts. For example, a photo posted by a user in India on her profile page can be viewed adjacent to other photos she has posted and in direct relation to the curation of her Space2cre8 identity. However, on the home page of the site, this same photo may appear adjacent to a photo posted by a user in South Africa, where it can be viewed in relation to the broader Space2Cre8 community. These individual and collective spaces for viewing, by continuously shifting the arrangement of artifacts, provide viewers with dynamic interpretative frameworks.

While interfaces shape meaning-making potentials, communities of participants also shape the uses of networking interfaces as well as the meanings constructed through them. For instance, although sites such as Facebook and Tumblr share some of the same tools, these tools may be put to use differently given the nature of the community that forms around them and the motivations for members of the community to join together. Similarly, although Space2Cre8 contains many overlapping design features with Facebook, it serves divergent ends, specifically in its effort to create a community of participants from diverse global locations who have the intent of developing intercultural understandings. Both the viewing and curatorial practices of Space2Cre8 participants reflect this overarching ambition of the project as well as the educational contexts from which the project originated. We consider, then, the possibility of a 'Social Network Effect' (or in this specific instance, a Space2cre8 Effect) in a manner similar to what has been termed the "Museum Effect," or "the process by which the meanings of artifacts are transformed as they are moved from their immediate social contexts where they are created and used to museums where they are displayed and looked at" (Tang, 2005, p. 54). In much the same way that the museum, as an institution, sets in motion particular discourses, ideologies, practices, and normalized behaviors around interactions between the objects on exhibition and the community of visitors, the organizing purpose and ideology behind the Space2Cre8 community's formation (or that of any social network) play a role in how interpretative processes synthesize meanings generated through circulating artifacts and networks of participation.

The Social Network Effect occurred on Space2Cre8 in two ways relevant to the dynamic construction of meaning. First, the educational context and research objectives of the community served to regulate behavioral norms.

As students viewed and curated media with their peers, they did so in light of concern, more or less keen, for how their curations might be (mis)interpreted by other members of their international community from different countries and cultures. Thus, issues around the appropriateness of content tended to be negotiated continuously, with localities forging their own notions of suitability and communicating these behavioral norms globally. Rather than a static process, or a process identical to the kinds of viewing and curating that sometimes characterize participation on other social networks or in museum spaces, such practices on Space2cre8 were molded by an ongoing negotiation of norms, a negotiation fostered by the contextual ambiguity of particular local-global interactions set within their respective educational spaces.

One specific interaction between a girl from South Africa, Layla, and girls from India, exemplified this ongoing negotiation of behavioral norms.[3] After the South African girl selected for her profile picture an image of a scantily clad nurse (appearing originally in an advertisement for athletic shoes), an intercultural dialogue began about femininity and exploitation where local meanings reshaped the context for viewing, and global perspectives informed a critical examination of self. The young women from India were initially shocked by Layla's choice of this image to represent herself, labeling it "scandalous." But conversation around the image eventually led one Indian girl to make a semiotic intercultural leap, correctly surmising that Layla was interested both in nursing and modeling, which in fact had been Layla's authorial intent. Instead of merely dismissing an artifact as offensive, or retorting with an accusatory or combative comment about the particular curatorial choice (as is often evidenced in the comment feeds of sites such as YouTube), the educational contexts that guide youthful interactions with Space2cre8 content prompt users to imagine meaning beyond their own immediate reactionary perspective, as well as to search out alternative meanings through online peer inquiry or off-line classroom discussion. This emphasis on negotiating meaning, understanding, and appropriateness through dialogue supported community participation while avoiding a standardized code of community conduct. The artifacts produced and shared by youth on Space2cre8 acquired a fluid viewing context shaped and reshaped across ongoing participation on the site and with each other.

Second, the Social Network Effect in this case influenced the creation of interpretative norms that regulated interpretative processes in viewing and sharing media. Just as a painting hanging on the wall of New York's Museum of Modern Art acquires enormous social and symbolic capital by virtue of the notoriety of the space it inhabits, thereby influencing how a viewer understands it, interactions with peers and media on Space2Cre8 operated via their own interpretative norms. Because the Space2Cre8 community includes local participants who know one another off-line (within the school space) as well as global participants who know one another only through their shared activity on the network, these identities crucially framed how viewers interpreted the meaning of shared artifacts. This was evidenced in

off-line conversations in which online peers were often referred to by their national affiliation (i.e., "a girl from India posted this").

In their efforts to imagine both a distant creator and audience, students drew on their own experiences and interactions with media related to these global locations, and they relied on this knowledge as well as new knowledge accumulated through an ongoing online dialogue with distant peers to construct a frame for viewing objects and unraveling meaning. For example, in a video exchange coordinated between students in Manhattan, New York, and Oakland, California, where a read-and-respond media project resulted in the production of a four-act collective video, students drew on available media narratives about their collaborators' city to frame a context for interpretation. A video that featured a New York participant throwing a bottle on the ground set to Goth rock music was interpreted by Oakland students without prompting as signifying a rude, uncaring New York attitude. Similarly, the New York viewers interpreted the eco-bottle that appeared in a response movie by Oakland as representative of California tree hugging and eccentric environmentalism, a common national media trope about Californians.

Through a series of explanatory blogs and guided off-line discussions, students came to discover more subtle, locally embedded reasons for such narrative choices that did not necessarily contradict these regional tropes, but rather added layers of meaning shaped by various constraints and local interactions in the viewing and curating of the media. By drawing on familiar national/global media narratives, and then engaging in a dialogue about more localized sources of meaning, the two geographically distant groups formed a mutually constructed knowledge base around a coauthored media artifact. As with the Museum of Modern Art where institutional prestige and other spatial factors affect the meanings generated by artifacts, Space2cre8 as a community shaped viewing contexts through the organization of its members, where local groups positioned across a global network had to imagine others through the artifacts of their creation and curation by fitting them into familiar media narratives representative of diverse community geographies.

When imagining social networks in the context of museums and other educational settings, we caution against generalizing about their functionality and potential and recommend instead a focus on the variety of curatorial and viewing opportunities that emerge by way of the divergent ideological purposes, media tools, and communities that shape the meanings of the artifacts circulating across them. As one such example, Space2Cre8 represents a quite specific and somewhat unique online community wherein participants engage in curation and viewing in order to communicate within a global community known only through mediatized interactions on the network. Its collective and individual curatorial spaces combined with a diverse user population offer multiple viewing positions from which to engage with both artifacts and the individuals curating them. By considering the multiple types and functions of social networks, we might better grasp how museums can employ existing social networking tools as well as create new ones in

order to strategically develop purposeful communities of participation with an enhanced capacity for user- or visitor-initiated curations and dialogues.

ARTIFACTS, AUTHORS AND AUDIENCE IN DIGITAL CURATION

While spaces, interfaces, and communities influence the practices through which people view and curate artifacts, we also consider how the artifacts themselves affect people's interactions with them. Specifically, we explore notions of authorship and audience as they emerge across digital artifacts shared on Space2cre8, where once again intersections of the local and global structure both inform and complicate processes of meaning making. Debates have long persisted amongst literary and art theorists regarding authorship and the autonomy of art objects, but digital remix cultures have emerged to challenge anew the very notion of ownership. Diakopoulos, Luther, Medynskiy, and Essa (2007) note that there are "two competing conceptions of the author: the author as lone creative genius and the author as collaborator," where the former represents a fairly recent "romantic notion of authorship that exalts the idea of individual effort," and the latter represents "the norm through history" where "the author is a collaborator in a system of authors and texts working together (p. 2)," a notion made popular by literary theorist Roland Barthes (1977) and his declaration of the author's death. Given the aforementioned tools and interactivity afforded by digital platforms, youth become readers-authors, viewers-curators, and consumers-producers, "generating a personalized text simply through the trajectory of links chosen" (Diakopoulos et al., 2007, p. 1). Under continuous re-authoring, digital artifacts acquire layers of meaning in relation to their shifting positions across curations.

Museums have traditionally focused curatorial efforts on the romanticized notion of the author/artist and the artifacts of his creation, engendering a discipline through which both author and artifact acquire meaning within the framework of an art history. Tang (2005) describes this attempt to "establish the autonomy of a work" as "object-centered" curation, where intrinsic meanings are unearthed through the work's aesthetic (p. 56). Within such spaces of exhibition, the viewer's role is relegated to that of recipient of information disseminated through the object and its framing by the curator, within both this history and the architecture of the museum as well as the collection of works on display. Other forms of artistic practice and curation, however, have emerged to challenge the 'object-centered' model, where "personal stories and community knowledge become significant components of the communication of cultural knowledge, [and] objects become the props and not the central message" (Russo, 2009, p. 159). Echoing the idea that a social networking profile is curated with media in the production of a kind of digital body, the "object-as-prop" perspective proposed by Tang intends to preserve some aspects of the original or intended meaning of an artifact while also reconstituting this meaning in relation to the personal narrative articulated by the curator.

On Space2Cre8, the ongoing curation of profiles varied significantly amongst users due to varying levels of participation on the site. In many cases, the curation of images and videos occurred in bunches, such as a batch import from a camera or a collection of downloaded images uploaded within a single session's time. For the latter, these images were often obtained from Google searches, and can be considered as a kind of "taste statement" (Liu, 2007). Given the community of participants, these batch uploads to the site were intended for both a local audience of peers as well as an unknown international audience of peers, both accessing the site primarily within school settings. These kinds of curatorial practices positioned students to re-author artifacts in the production of a profile page, and to channel meaning from the artifact to their digital personas. In some instances, curatorial practices were accompanied by text-based communications that posed questions, explained design choices, and discussed interpretative frameworks in search of more complete understandings not just of the artifacts, but of one another as well.

We focus here on the profile curation of Space2Cre8 participant Lil Wayne from South Africa to illustrate how such curations represented a significant source of meaning-making potential for the network community. In fact, his collection of images was selected as the subject of a guided conversation on hip-hop imagery and artistry amongst students at Space2Cre8 New York. Lil Wayne took his username directly from the world-famous rapper Lil Wayne (LW here to avoid confusion with the Space2Cre8 participant), and the theme of hip-hop permeated much of the South African student's profile page. In the span of two class sessions, Lil Wayne uploaded 54 images, including a profile picture (the only image produced in the physical space of the classroom) and a cascading background picture that dominated the appearance of his profile page. Lil Wayne provided no text to frame the viewing of his images, but we can bring to bear local knowledge about the South African students' online and off-line practices, especially their fascination with and knowledge of hip-hop, much of which was appropriated from American artists. From an analysis of the New York students' response to Lil Wayne's exhibition, we see evidence of how it linked local and global knowledge across the Space2cre8 community.

Even a cursory look at Lil Wayne's profile reveals an apparent fascination with hip-hop music and style. His profile page offers a self-portrait, a pose with a cockeyed peace sign (ubiquitous across hip-hop images), and the cascading, repeating image of LW's eyes staring at us with the remainder of the Young Money (LW's music label) artists posted in the foreground. Of the 54 images Lil Wayne uploaded to his profile, 36 can be categorized as directly representing hip-hop culture while others such as the "kixclusive" image that features different styles of Nike sneakers, a scantily dressed woman posing on a motorcycle, and Bob Marley smoking a joint (cannabis cigarette), all relate to and feature prominently throughout broader hip-hop imagery, notorious for its portrayals of consumer wealth, violence, drug use, and objectified women.

Given the complexity of the semiotic layers coloring hip-hop images, these artifacts were continuously re-authored by local participants who took meaning from the global and put it to use in their local context. This included appropriating hip-hop slang as identity markers in usernames, such as "Lil" (slang for the word "little," which in hip-hop culture signifies a term of endearment). The title of Lil was observed not just in the case of Lil Wayne in directly copying the name of a famous rapper, but across participating countries in unique ways, including usernames such as Lil T and Lil Player (South Africa), Lil MJ (New York), Lil Blackboy (California), Lil Miss Shorty, Lil Ray97, and SxCii_LiL_Jayer_Ox (Australia). The layering of global symbols with local meanings was also observed in the use of hand gestures, whereby Australian students posed with their fingers in the shape of the letter 'W'. This sign is said to have originated amongst California gang members to signify 'West' or 'West Side'[4] and emerged prominently across hip-hop imagery (Rapper Tupac Shakur infamously posed with a 'W' on the album cover "All Eyez on Me"[5]), but was deployed by the Australian youth to index their own local region within Australia. As artifacts in digital curations, such types of appropriations complicated viewing by adding localized layers of meaning to globally recognized symbols, and did so not merely through the sharing or replicating of artifacts, but by the strategic re-authoring of them to serve new purposes.

During a guided viewing session in which the instructor projected selected web pages from Space2cre8 and directed a class discussion on their content, New York students explored and critiqued hip-hop content posted on the Space2cre8 website, with a focus on Lil Wayne's profile curation. As high school students who grew up throughout the five boroughs of New York City, many of the participating students felt intimately connected to the hip-hop community, often living in the same neighborhoods that world-famous rap artists called home. Given that New York often proclaims itself as the birthplace of hip-hop, and considering as well the strong local affiliations that hip-hop artists have often maintained even amidst their rapid global proliferation, the New York students prided themselves as expert participants in hip-hop culture, assuming their specialized, local knowledge privileged them to understandings that their foreign peers simply could not obtain. For instance, during the viewing session, students shared stories about neighborhood interactions with famous rappers that offered insight into their 'real' personalities, as opposed to those merely projected through mainstream media outlets.

Even though the New York students acknowledged that the Internet has opened pathways to such 'insider' knowledge that might not have been previously available, some participants such as Ernesto were skeptical that Lil Wayne from South Africa could have been aware of the more subtle and complex meanings associated with his curated images. Ernesto doubted that Lil Wayne understood that the Styrofoam cup in LW's hand, for example, signified the rapper's drink of choice (syzzurp, a combination of Sprite soda,

codeine, and Jolly Rancher candy). Furthermore, New York students launched criticisms of Lil Wayne's curation as a coherent narrative and taste statement, claiming that the more 'hard core' hip-hop images of LW and other rappers did not mesh with images of pop artists such as Justin Bieber and Lil' Bow Wow. These apparent inconsistencies in taste and style of Lil Wayne's selected images of artists, combined with the seemingly random inclusion of images intended to be humorous (such as pictures of men with large mouths, which the New York students found more odd than funny), confounded them in their effort to come to any conclusions about the curation as a collection of artifacts in itself and as a representation of their South African peer. Some students even expressed concern for Lil Wayne and the rest of their international peers, whom they viewed as susceptible to what they described as 'fake' worlds that celebrated commercialism, violence, drug use, and sexism without regard for consequence—worlds that, as self-proclaimed insiders to hip-hop culture, they believed themselves equipped to navigate, but less so their foreign peers limited by geographic and linguistic boundaries.

This example of Lil Wayne's curation and the attendant conversation that developed amongst his New York peers around his selected images reveals several important characteristics of digital artifacts. For one, the original creator of all of the images was not prominently displayed or relevant to the meaning of any of them; that is, while the images contained subjects, they did not index authors. Second, images were textually identifiable through their tags or keywords, but no other contexts for viewing were supplied by Lil Wayne himself. Lil Wayne, therefore, assumed the role of author in supplying the referent for the collection of images assembled on his profile page, with every media artifact relating back to the narrative of his digital persona. In his role as author, as creator-curator within the Space2Cre8 community, divergent funds of local knowledge converged globally in the coconstruction of meaning. Even if no direct dialogue ever occurred between Lil Wayne and his New York peers, Lil Wayne's curation of globally circulated artifacts prompted the New York students to imagine these images and their attendant meanings from multiple perspectives. This afforded a critical position for identity work by providing opportunities for the New York students to engage with images prevalently curated across many spaces of their everyday, but now with a fresh context for viewing, as they tried to imagine them from a geographically distant peer's localized cultural perspectives.

Museums can help to service these kinds of critical inquiries by "engag[ing] in participatory communication using social media to help people navigate online content, and determine its authenticity and reliability" (Russo, 2008, p. 23). Such participatory communication can stimulate knowledge construction pertinent both to the authoring and interpreting of curated selves online, and can also provide common or shared threads of understanding between diverse communities, serving as a catalyst for dialogue in the exploration of the many levels of meaning produced through the global circulation of artifacts. Beyond just serving as a forum for communication

or an arbiter of authenticity, museums can provide opportunities for the convergence of authors and audiences around a multitude of artifacts, laying out the trajectories of the artifacts' circulation across local and global networks, continuously revealing new meanings as these artifacts appear, disappear, and reappear across fresh contexts for viewing. As was evidenced in the interaction between Lil Wayne's curation and his New York audience, although the New York audience had been exposed countless times to these and other hip-hop images, their interactions with and understandings of those artifacts shifted in relation to this new author. Museums, we believe, can help in facilitating such explorations by paving new paths of circulation through which to experience and re-author cultural artifacts.

CURATING NARRATIVES OF SELF

As evidenced in the example of Lil Wayne, the emphasis of many social networking sites such as Space2cre8 on the production of a profile page positions the curation of digital artifacts as a crucial context for identity work for youth. Such curatorial practices can take form in other kinds of digital designing, such as with digital storytelling, where personal narratives emerge with content that is configured through the organizing of artifacts circulating across global networks. Richardson (1995) notes, "At the individual level, people make sense of their lives thorough the stories that are available to them, and they attempt to fit their lives into the available stories. People live by stories" (p. 213). Digital narratives position the profile page as a medium for communication and draw upon an array of semiotic resources in both the creation and ongoing curation of this identity. These life narratives are represented as multimodal texts for relating life experiences, cultural knowledge, and personal interests to others, where youth "undertake a form of editing and filtering of information to create knowledge which is accessible and meaningful to them and their peers" (Russo, 2009). Such reflexive practices associated with narrating social identities require a continuous decoding of the social contexts through which digital artifacts circulate, both by authors and audiences, whose roles as such shift amidst ongoing processes of viewing and producing.

While the aforementioned object-centered approach to organizing museum artifacts has mediated the museum visit historically, Tang (2005) notes three other kinds of representational schemes employed by museum curators, of which he argues "narrative-structured exhibitions [as] the most capable of conveying a message that evokes common memory and a sense of 'imagined community'" (p. 56). The community that emerges around this shared narrative experience forms collective identities, but also introduces content for appropriation by new narratives, particularly for digital profile curations such as those on Space2cre8, where ever-shifting contexts provide fresh layers for reappropriation. Like the unfolding identities they intend to represent, these

"new narratives are likely to be less complete, more fragmentary, and to consist of the elements of many narratives that can be combined in a range of ways, rather than to be the complete finished story" (Hooper-Greenhill, 2000, pp. 30–31). Across these fragments, dialogue amongst participants becomes a means of filling in the gaps and generating shared contexts for interpreting and understanding others through curated selves.

Both contexts of viewing and contexts of curating affect how artifacts are used as the content of an identity narrative. In one related instance on Space2cre8, a user from South Africa, Alvin, employed the song "Don't Worry Be Happy" by Bobby McFerrin as background music for a digital story about his life. In an interview he explained that he chose the song because it was by a singer that he liked—Bob Marley. Knowing that this music had not been authored nor its lyrics sung by Marley, we searched for it on YouTube, trying to understand Alvin's process of appropriating it for his video. We discovered that one of the most popular videos yielded in the search contained the title "Bob Marley-Don't Worry Be Happy"[6] and that it also included a black-and-white image of a smiling Marley. While the top-rated comments on the video page explained that the singer was actually Bobby McFerrin, and despite the fact that even the Mp3 purchase link, embedded by the YouTube content recognition system, displayed an Amazon link to "Artist: Bobby McFerrin," some posts in the comment feed continued to laud Marley as the singer or more broadly as an icon for what the lyrics of the song intend to describe.

The persistent refusal to acknowledge fact of authorship demonstrates how the song, given its framing by the YouTube video, mobilizes an ulterior context for understanding and point of community dialogue. In this example, viewing context is shaped by the pop-cultural symbols associated with Bob Marley, such as being blissful and carefree via the effects of marijuana, which in turn create a conversation around these topics adjacent to or even disconnected from dialogue related only to authorship. This symbolic layer of meaning is perceived and discussed from within the YouTube community at least partly in relation to the nature of a user's encounter with the video and song. For instance, a user who discovers the video during a sequence of searches related to Bob Marley, regardless of whether this visitor knows the correct singer, may be inclined to interpret the video as both a tribute to the man Bob Marley as well as a symbolic expression of Marley's iconic character. This layered context for viewing, therefore, shapes the interpretative positions of individuals while initiating dialogue amongst participants and provoking new meanings as media are continuously re-authored across social networks and digital media environments.

Although we do not know exactly how Alvin arrived at this video or this song, when we spoke with him about his digital story, he mentioned Marley at the outset of the interview. Given that the song appears adjacent to information about Alvin's life, we might interpret this selection of audio both to set a happy, cheerful tone for the video but also to express his interest in Bob

Marley. It is not then surprising that upon watching the video, Alvin would believe the singer to be Marley because information about Bobby McFerrin appears only in English text on the YouTube web page, and not in Alvin's native Afrikaans, and also because Alvin might have stumbled upon this video via links from actual Bob Marley songs, given that many of YouTube's suggested related videos feature Marley but no Bobby McFerrin songs. The song moves from being an object in a YouTube video featuring Bob Marley to an object in Alvin's narrative about his life, and in this transferal, acquires levels of meanings contingent upon the interaction between authors and their respective artifacts of creation. While Alvin's peers may know the same "Don't Worry Be Happy" YouTube video and thereby interpret Alvin's choice both as setting a joyful tone for his digital story as well as expressing his personal interest in Bob Marley, members of the community who know the actual singer of the song would not likely associate it in any way with Marley and the many cultural values connected to him as a symbol. To this extent, local meanings emerged from (mis)understandings of a circulated, re-authored artifact, wherein global audiences could gain access to such meanings only through dialogue engaged in bringing to light these concealed layers. Such dialogue could serve to clarify ambiguities in context and meaning, but more importantly, to bring community members together in authoring a collective identity that accounts for the convergence of local perspectives around globally shared artifacts.

Although a dialogue of this nature never precipitated from Alvin's digital story as far as we know, this instance demonstrates how narratives can diverge in meaning given the ephemeral contexts through which artifacts circulate online. It also highlights the possibility that diverse communities can orient the coconstruction of knowledge across spaces of self-curation in a mutually constituting relationship between creators and viewers. Such communities can foster the creation of "collective stories that deviate from standard cultural plots [to] provide new narratives [and where] hearing them legitimates a replotting of one's own life" (Richardson, 1995, p. 213). As Gehl (2009) points out, bloggers "scour the [digital] archive in search of the object that will fit the particular narrative they are constructing," and in many cases, these objects of curation are discovered, scavenger-like, within communities of participation where the continuous processes of producing and sharing media supplies diverse materials for narrating equally diverse stories (p. 51). Further, such communities can serve to produce knowledge for viewing that accounts for locally and globally oriented perspectives, and they can inform dialogue about participants' narratives, converging around areas of ambiguity or confusion, such as was the case with the "Don't Worry Be Happy" song.

While the digital curation of a life narrative affords many possibilities for innovative, reflexive curation, we also consider more spontaneous, stream-of-conscious curations as a common practice of youth on Space2cre8. This was true in the instance of Lil Wayne. Amidst such curatorial behaviors,

meanings are framed by this very spontaneity, and we should exhibit some restraint in overthinking the semiotic relationships between objects of view and the curator's life narrative while focusing analysis around the ad-libbed, performative nature of the curation of artifacts. The gaps, ambiguities, and inconsistencies that linger across the fragments of these narratives can catalyze critically informed dialogues about the images and cultural tropes that circulate across media archives and in some cases serve to reproduce social hierarchies and dominant discourses, whose "power comes not from the mere collection of objects, but from arranging archival objects into 'facts' about or cultural memories of the world" (Gehl, 2009, p. 49). Students might not necessarily be entirely aware of the social, political, and moral implications of these spontaneous narrations, particularly when viewed by local peers with numerous shared interpretative contexts from which to forge common knowledge. However, this awareness can be catalyzed—between viewers and curators alike—across the global, where fresh interpretative contexts complicate representations of life narratives and promote self-reflection in imagining the underlying symbolic workings of not only the images themselves, but the methods by which such images become visible across the social landscape.

Such methods include the Google algorithm, which effectively organizes the images of our social worlds by way of tags, keywords, popularity, notoriety, and other numerical calculations. A Google image search for the word "doctors," for instance, yielded 1,960,000,000 results (0.26 seconds),[7] but an image of a male doctor of color does not appear until 60 images into the search. Equally telling, the first image of a black doctor is a copyrighted stock photo tagged "African Doctors," whereas many of the previous images of white doctors were not designated for their race, but rather represented advertisements of various kinds. The digital stories created by students in South Africa often narrated students' career goals, some of which related to the fields of medicine and law. In these cases, students curated their stories with media promoted through the Google algorithm and had to make choices about the races of the people in their images. The sociocultural complexities surrounding race in post-Apartheid South Africa only added to the political dimensions of this curatorial practice, where images of white professionals were used by students of color to identity their desired future work environments.

Added layers of meaning can serve a vital purpose in opening up dialogue amongst community participants about the vast interpretative dimensions of images. In the above examples, the curatorial efforts of the South African students provided an expansive exhibition of digital materials, many of which contained images recognizable to students in New York and other members of the Space2cre8 community in other national contexts. The familiarity of these images not only provided a shared context for understanding the narratives of geographically distant youth, but also compelled the viewers to imagine these everyday images from the perspectives of other youth whose own everyday was shaped by these same images. Such

activities of the imagination invite students not only to explore the narratives authored by their peers, but also to consider these new meanings in relation to their own lives. In viewing the exhibitions of their South African peers, New York students engaged in critical dialogue around issues of representation in hip-hop and sharing communities.

Due to various logistical difficulties, these initial viewings did not result in sustained critical dialogue between the two groups of students. However, we can see how such digital curatorial practices as well as viewing experiences (both of which often happen simultaneously online) can promote dialogue amongst diverse youth as well as inject in this dialogue a greater social and cultural awareness of one another based upon each other's curations of commonly identifiable media. We can also imagine digital museums as playing a vital role in a number of the issues raised in the above examples. In their work in archiving cultural histories, museum collections could be organized to purposefully challenge the visual politics at work in search algorithms, which often are slanted by commercial interests vying for consumer visibility. Such an effort by museums may focus on bringing attention to those images that remain outside the common gaze, or juxtaposing unrelated images to reveal fresh narrative possibilities. Through such counter-normative assemblages of new media, which can also be facilitated by engaging the visitors themselves in curatorial participation, digital museums can generate sharing and learning communities that empower participants to explore diverse notions of self and other.

21ST CENTURY MUSEUMS: FROM WALL TO WIKI

A recent exhibit at the Frye Art Museum in Seattle, Washington (USA), offered 22 paintings chosen by a 90-year-old patron of this museum, Frieda Sondland.[8] Sondland, a resident of the local neighborhood, had visited the Frye almost every day for 10 years, enjoying the exhibits in the company of her husband, now deceased. Each painting in the exhibit, which is entitled "Beloved," included a gallery label along with a brief paragraph written by this patron-curator and printed in small black font on laminated white paper. The paragraphs were Sondland's explanations of why she chose a particular work for the exhibit. In most cases, she referred to the content of the painting or its form, but she also commented on its personal connection to her, relating her conversations with her late husband around the pieces. For the museum, Sondland's curation was part of a continuing inquiry into the relationship of art to viewer. "Who 'owns' the reading of a painting?" they ask—the curator, the art historian, the theorist of aesthetics, the patron?

For us, Frieda Sondland's selections and reflections are an illustration of the powerful personal narrative that can be written through curation. To walk through the exhibit was to walk through Sondland's life with her husband, as mediated by the walls of the museum and her favorite objects of art.

Sondland reframed the meanings of the artifacts by positioning them within the context of her personal experience, her own semiotic universe. This activity parallels the kind of interactions we have seen between youth and digital media, specifically in the ways they wear media as a kind of digital skin, authoring their own life narratives through an electro-skeleton of materials, if you will, charged with layers of meaning framed through rapid circulation across hyperspace. Works of art have always served to mediate our personal experiences by representing culturally accessible metaphors, but the digital, by increasing access to the sharing and re-authoring of artifacts, potentially enables more people to play the role of Frieda Sondland in narrating a self through the organization of media. The ongoing effort to develop pedagogical strategies for integrating museum learning into hyperspace can benefit greatly, we have hoped to suggest, from an exploration of the practices of youth in media-sharing networks, as well as the curational and authorial challenges they represent, and through an investigation of how these practices might be reappropriated for the creation of innovative digital museum experiences.

We have explored how digital interfaces, communities, and artifacts produce conditions ripe for diverse curatorial practices as a crucial means for the narration of self. Our research on young people's participation on a social network has highlighted for us that the construction of narratives of self via visual and multimodal means is far from a politically innocent process, but is produced, rather, in concert with social norms and hegemonies. In fact, the very act of searching for media online to add to one's array of self-illustration unveils a politics of visuality, where certain images tend to dominate our understanding of related topics. We suggest that digital museums have a role to play in enhancing and extending searchability: that is, providing users with access to more diverse media and more legitimate sources of knowledge about the 'original media', as well as allowing users to access a diverse archive of material for the purpose of authoring/curating an equally diverse life narrative.

We also hope to have revealed the intriguing and complex conditions offered by social media tools in regard to digital curation, and how the practices associated with these tools may lend themselves to imagining new possibilities for digital museums beyond merely the archival and organizational. Although museums have traditionally directed visitors' attentions toward the historical and aesthetic dimensions of objects and artists, and purposed themselves as vanguards of this history while disseminating expert knowledge to their visitors through carefully crafted curations, we can imagine possibilities for hybridizing the kinds of digital curatorial practices of youth with those of museums. By designing innovative interfaces, bringing together diverse communities, and providing ample opportunities for participants to interact with artifacts and reposition them socially in the construction of their own identity narratives, digital museums can play a role in mediating and informing the interactions between these participants

and tracing out the unique histories that artifacts accumulate under continuous, diverse curation. In such ways, the museum can maintain its own authorial role in narrating the voice of art history while opening up pathways for visitors to inscribe *their* stories into this history, unraveling new and unintended meanings from artifacts as they enter global spheres of circulation and appropriation. Within and across these curations of self, dialogue serves as a primary means for unearthing buried layers of meaning through explorations with online peers, helping to promote intercultural understanding and a cosmopolitan disposition for imagining and understanding others.

NOTES

1. Please see www.space2cre8.com for more information about the project and a demonstration site for the social network itself.
2. However, Space2Cre8 differs from commercial sites in several respects, including being shaped architecturally, functionally, and aesthetically by the needs and desires of its members, undergoing four major design phases to date. It differs as well by being a private site that is open just to members of our designated programs; by including a data collection mechanism for research purposes; and, in fostering friendship networks that privilege online-only relationships. Further, in contrast to most social networking sites where place is implicit, on Space2Cre8, national identities are represented overtly and frequently.
3. See Hull & Nelson, 2009; and Hull, Stornaiuolo, and Sahni, 2011, for more detailed discussions of this interaction.
4. See urbandictionary.com at http://www.urbandictionary.com/define.php?term=WestSide&defid=2815206
5. Release Date: February, 1996; Death Row and Interscope Records.
6. http://www.youtube.com/watch?v=Oo4OnQpwjkc
7. Search conducted on 8/25/2012
8. See http://fryemuseum.org/exhibition/4391/

REFERENCES

Alpers, S. (1991). The museum as a way of seeing. In I. Karp & D. Lavine (Eds.), *Exhibiting cultures* (pp. 21–32). Washington, DC: Smithsonian Books.

Appadurai, A. (1996). *Modernity at large: Cultural dimensions of globalization.* Minneapolis: University of Minnesota Press.

Barthes, R. (1977). The death of the author. (Howard, H. trans). In *Image, music, text.* Retrieved from http://evans-experientialism.freewebspace.com/barthes06.htm

Beach, R., Hull, G., & O'Brien, D. (2011). Transforming English language arts in a Web 2.0 world. In D. Lapp & D. Fisher (Eds.), *Handbook of research on teaching the English language arts*, 3rd Edition (pp. 161–167). IRA & NCTE.

boyd, d. (2008). Why youth ♥ social network sites: The role of networked publics in teenage social life. In D. Buckingham (Ed.), *Youth, identity, and digital media.* Cambridge, MA: MIT Press.

Castells, M., & Cardoso, G. (Eds.).The networked society: *From knowledge to policy.* Washington, DC:

Coiro, J. Knobel, M. Lankshear, C., & Leu, D.J. (Eds.) (2009). *Handbook of research on new literacies.* New York, NY: Routledge.

Diakopoulos, N., K. Luther, Y. Medynskiy, & I. Essa. (2007). Remixing authorship: Reconfiguring the author in online video remix culture. Retrieved from //hdl.handle.net/1853/19891

Fisherkeller, J. (Ed.). (2011). *International perspectives on youth media: Cultures of production and education*. New York, NY: Peter Lang.

Gehl, R. (2009). YouTube as archive: Who will curate this digital Wunderkammer? *International Journal of Cultural Studies, 12*(1), 43–60.

Hauser, W., Noschka-Roos, A., Reussner, E., & Zahn, C. (2009). Design-based research on digital media in a museum environment. *Visitor Studies, 12*(2), 182–198.

Hill, M.L., & Vasudevan, L. (Eds.). *Media, learning, and sites of possibility*. New York, NY: Peter Lang. http://tls.vu.edu.au/portal/site/research/resources/Learning%20Commons%20report.pdf

Hooper-Greenhill, E. (2000). Changing values in the art museum: Rethinking communication and learning. *International Journal of Heritage Studies, 6*(1), 9–31.

Hull, G., & Nelson, M. (2009). Literacy, media, and morality: Making the case for an aesthetic turn. In M. Prinsloo & M. Baynham (Eds.), *The future of literacy studies* (pp.199–227). Houndmills, UK: Palgrave Macmillan.

Hull, G., Stornaiuolo, A., & Sahni, U. (2010). Cultural citizenship and cosmopolitan practice: Global youth communicate online. *English Education, 42*(4), 331–367.

Hull, G., Stornaiuolo, A., & Sterponi, L. (in press). Imagined readers and hospitable texts: Global youth connect online. In D. Alvermann, N. Unrau, & R. Ruddell (Eds.), *Theoretical models and processes of reading*. 6th Edition. International Reading Association.

Hull, G., Zacher, J, & Hibbert, L. (2009). Youth, risk, and equity in a global world. *Review of Research in Education, 33*(1), 117–159.

Huq, R. (2006). European youth cultures in a post-colonial world: British Asian underground and French hip-hop music scenes. In P. Nilan, P., & C. Feixa (Eds.), *Global youth? Hybrid identities, plural worlds* (pp. 14–31). London: Routledge.

Keating, S., & Gabb, R. (2005) *Putting learning into the learning commons: A literature review*. Working Paper. Victoria University, Melbourne, Australia.

Kelly, L. (2007). *Visitors and learners: Adult museum visitors' learning identities*. Sydney: University of Technology.

Kress, G. (2005). Gains and losses: New forms of texts, knowledge, and learning. *Computers and Composition, 22*, 5–22.

Lenhart, A., Purcell, K., Smith, A., & Zickuhr, K. (2010). Social media and young adults. *Pew Internet and American Life Project.*

Liu, H. (2007). Social network profiles as taste performances. *Journal of Computer-Mediated Communication, 13*(1), article 13. http://jcmc.indiana.edu/vol13/issue1/liu.html

Muñoz, G., & Marín, M. (2006). Music is the connection: Youth cultures in Colombia. In P. Nilan & C. Feixa (Eds.), *Global youth? Hybrid identities, plural worlds* (pp. 130–148). London: Routledge.

New London Group. (1996). A pedagogy of multiliteracies. *Harvard Educational Review, 66*(1), 60–92.

Niang, A. (2006). Bboys: Hip-hop culture in Dakar, Sénégal. In P. Nilan & C. Feixa (Eds.), *Global youth? Hybrid identities, plural worlds* (pp. 167–185). London: Routledge.

Nilan, P., & Feixa, C. (Eds.). (2006). *Global youth? Hybrid identities, plural worlds*. London: Routledge.

Prior, P. (2005). Moving multimodality beyond the binaries: A response to Gunther Kress' "Gains and Losses." *Computers and Composition, 22*, 23–30.

Richardson, L. (1995). Narrative and sociology. In J. V. Maanen (Ed.)., *Representation in ethnography* (pp. 198–221). Thousand Oaks, CA: SAGE.

Russo, A., J. Watkins, & S. Groundwater-Smith (2009). The impact of social media on informal learning in museums. *Education Media International, 46*(2), 153–166.

Russo, A., J. Watkins, L. Kelly, & S. Chan (2008). Participatory communication with social media. *Curator: The Museum Journal, 51*(1), 21–31.

Silverman, L.H. (1995). Visitor meaning-making in museums for a new age. *Curator, 38*(3), 161–170.

Stornaiuolo, A. (2012). The educational turn of social networking: Teachers and their students negotiate social media. U.C. Berkeley: Unpublished doctoral dissertation.

Stornaiuolo, A., Hull, G., & Sahni, U. (2011). Cosmopolitan imaginings of self and other: Youth and social networking in a global world. In J. Fisherkeller (Ed.), *International perspectives on youth media: Cultures of production and education.* New York, NY: Peter Lang.

Tang, M.C. (2005). Representational practices in digital museums: A case study of the National Digital Museum Project of Taiwan. *The International Information & Library Review, 37*, 51–60.

Thompson, C. (2008, Sept. 7). Brave new world of digital intimacy. *The New York Times.* Retrieved from nytimes.com

Willis, P. (1990). *Common culture: Symbolic work at play in the everyday cultures of the young.* Buckingham: Open University Press.

Part III

Facing Dilemmas, Designing Solutions

8 Communication Interrupted

Textual Practices and Digital Interactives in Art Museums

Palmyre Pierroux and Sten Ludvigsen

Since the 1970s and '80s, innovations in museum communication have been driven by trends in digital technologies and more recently, social media, spearheaded by curatorial and marketing departments and their respective interests in engaging publics through new forms of dialogue and participation (Heusinger, 1989; Pierroux, Krange, & Sem, 2011). From stand-alone multimedia kiosks to mobile tweeting, tagging and posting on Twitter, Flickr and Facebook, digital and social media have interrupted the external flow of information from museum to visitor and world at large but also internal communication among museum professionals: curators, educators, new media specialists, exhibition designers, marketing and public affairs departments (Gates, 2010; Kelly & Russo, 2008; Pierroux, 2001). Importantly, as social media and diverse types of digital *interactives* have been increasingly introduced alongside traditional textual practices in art museums, they have also entered into the larger, enduring discourse regarding the relationship between text, image, gallery space, and work of art in meaning making processes (Adams & Moussouri, 2002).

The use of text, mainly in the form of object labels, is intertwined with the history of museums dating back over 400 years (Parry, Ortiz-Williams & Sawyer, 2007). Therefore, while gallery labels and wall texts are for curators a presupposed 'communicative genre' (Linell, 1998) when mounting exhibitions, digital interactives in gallery spaces may be viewed as an interruption in existing textual practices. Moreover, there are long-standing tensions regarding the types and uses of textual means to enhance visitors' meaning making, and the role of the museum in balancing these views. At the crux of these tensions are differing perspectives on what constitutes an art experience, ranging from an emphasis on curatorial 'hangs' that attend to the aesthetic and formal qualities of each individual object (Cuno, 2004), to art historians' narrative interests in connecting the dots and explaining relationships between works, artists, and stylistic trends (Bann, 1998; Preziosi, 2006), to education curators' concerns with visitor-centered interpretation and learning experiences (Czajkowski, 2011; Soren, 1992).

This chapter explores analogue and digital multimodal textual practices in art museums beyond the object label, focusing on the disciplinary work

involved in the design of multimodal content and digital interactives in gallery settings. As a point of departure for exploring these issues, we draw on data collected from a research project conducted in collaboration with the National Museum of Art, Architecture and Design in Norway. The aim of the study was to explore the design and use of new digital resources for the permanent exhibition of Edvard Munch's art in the National Gallery building in Oslo, which dates from the late 1800s, with a particular outreach focus on teens and young adults (15–25 years). Participants in the project included learning researchers, interaction designers, visitors, and staff from the museum's curatorial, education, and communication departments. The overall focus of the research collaboration was educational, with aims that were twofold: to experiment with designs for meaning making activities using digital and social media, and to investigate the ways in which such interactives may actually engage young people in learning about the art of Edvard Munch.

In this chapter, we focus on processes and outcomes related to the former, that is, the design aspects of the collaboration. We analyze interventions in existing practices related to label and text production within the museum, and we reflect on what such breaks may mean for the art museum viewing experience when teens and young adults are the inscribed audience for different types of digital interactives. Not unlike other historical National Museum buildings, the existing interior architecture of the National Gallery is largely untouched by digital media, with the exception of mobile devices visitors may carry with them, and the infrequently used audio tours available for loan in the gift shop. Therefore, we analytically frame the design intervention as 'communication interrupted' to investigate the following research questions: What are the educational, spatial, and disciplinary challenges to existing textual practices and curatorial content when implementing digital interactives in the art museum? In what ways may theoretical perspectives on meaning making inform the design of social media and interactive activities for young adult visitors?

TEXTS IN MUSEUMS

In museum studies, the design and use of texts and labels in exhibitions—curated content—are researched from different perspectives, applying methods from linguistic, social semiotics, and ethnographic approaches. While linguistic approaches identify themes, functions, and structures of museum texts through detailed formal analysis of content (Atkins, Velez, Goudy & Dunbar, 2008; Purser, 2000; Ravelli, 1996), semiotic approaches often contextualize texts in the exhibition setting, paying particular attention to relations between modalities of expression and the spatial organization of the museum (Hofinger & Ventola, 2004; Insulander, 2010; Solhjell, 1998). In keeping with the trend toward visitor-centered interpretation, both linguistic and semiotic approaches have been used in museum education research

and practice to develop 'best practice' guidelines for text legibility and comprehension among different visitor types. However, the relevance and application of such guidelines to digital content and multimodal texts is less than clear, as this writing process typically involves additional domains, expertise, and external specialists, for example, producers, interaction designers, writers, music and sound engineers, linguists and operations staff.

Research that applies ethnographic methods to the study of museum texts shifts focus from the text itself to the role that such professional practices play in the overall exhibition design, which includes texts and object labels. These studies follow and observe the writing process from ideas to implementation, describing tensions, compromises, and breakdowns that may occur along the way. Importantly, they show how 'authorship' is realized through an often messy but collaborative process, with specific content areas and disciplinary knowledge negotiated in a space that also includes different types of expertise and understandings of visitors and their meaning-making processes. This is typical of existing practices in the National Museum as well, where texts for exhibition labels, brochures and walls are circulated among curators, educators, designers, and marketing staff for comments and revisions until negotiations produce content that is acceptable to key exhibition team members.

Studies of such processes have been conducted from both 'insider' and 'outsider' positions in different types of museums to better understand organizational and disciplinary practices related to text production in exhibition-planning groups. In an early study, American researcher Lisa Roberts (1997) documented from an insider, participant perspective the emergent and increasingly central role of a museum educator in the design of a new exhibition in a botanical garden, studying the beliefs, actions, and power dynamics of three different disciplinary specialists as they collaborated on the overall exhibition narrative and writing of texts.

In her study of how scientific knowledge becomes represented in exhibitions, British researcher Susan Macdonald (2002) described the thrill as a university researcher 'outsider' of moving behind the scenes at a science museum, observing interactions between internal and external specialists and the exhibition team. Macdonald documented the ways in which a broad range of both anticipated and unexpected influences impacted the exhibition team's concept, development of texts, selection of objects, and final design of a new exhibition. Tensions between the team of interaction designers and the education section were most prominent, Macdonald reported, due to the groups' respective sense of interference and infringement on the content domain. In other words, these groups struggled with the impact of the interaction design on the disciplinary content, and vice versa.

American education curator Jennifer Czajkowski (2011) at the Detroit Institute of Arts also reported on a design process from the inside, describing cross-departmental collaboration on new textual resources developed for a reinstallation of a permanent art exhibition. The educator team first

developed 'interactive interpretive models' with 'visitor-centered outcomes' based on visitor studies, aesthetics research, constructivist learning theory, and the specific content areas represented in the museum's collections. During a three-year process, the educator team worked closely with visitor groups, curators, and a design team, and negotiated with museum director, collections management staff, and marketing personnel to develop thirteen different kinds of low-tech and high-tech interactives applicable to different content throughout the museum. In this case, theoretically informed learning models were in the foreground, closely integrated with the curatorial content, and followed by design experiments with different modes of interaction and media for specific contexts and audiences. This process, in principle, is similar to the design approach presented in this chapter, although our project has a much shorter time frame and is framed by a sociocultural rather than constructivist perspective on museum learning.

In the following sections we examine more closely developments in the use of interactives in art museums, considering design sensitivities from curatorial and educational perspectives and how these are relevant when young people are the target group. We then provide an account of the sociocultural perspective on meaning making that frames the research in this study, with a particular focus on the notion of digital interactives and other semiotic resources as 'mediating tools'.

INTERACTIVES IN ART MUSEUMS

In general, designing digital media for use in a gallery setting is a challenge for art museum curators and educators, as technologies may intrude into the unique environment and experience, either as physical-spatial disruptions or in the form of learning activities often considered incompatible with art viewing (Adams & Moussouri, 2002; Durbin, 2002). Some of the design and learning issues are related to interactions, perception and attention when orienting to screens (vom Lehn & Heath, 2003), and problems of 'information overload' when visitors are presented with seemingly unlimited access to multimodal content (Parry et al., 2007).

Different types of social media, with their participatory and content generation features, relative ease of use, ubiquity, and low cost of development, have also introduced significantly new modes of communication into nearly all aspects of museum practice. The integration of social media in the gallery space, inviting visitors to contribute to or access others' content, represents new logics of participation in the design of interpretive resources in the art gallery. These new logics are focused on transgressing time and space, bridging in quite specific ways a range of dialogical gaps, for example, between visitor-museum, online-onsite, novice-expert, and school-museum. Art museums, for example, have used social media to experiment with 'label folksonomies' for improved access to collections (Trant, 2006), 'live' labels for museum objects

in gallery settings updated by curators and the visitors alike (Parry et al., 2007), and the crowd-sourced curation of art exhibitions (Bernstein, 2008).

Applying these new logics of participation to exhibition design, American researcher Nina Simon (2010) introduced the notion of 'social objects' for developing object-centered interactions in museums, emphasizing the potential of social media to create experimental design approaches that fully involve visitors in the process. A similar design approach is reflected in the recent crowd-sourced experiment with visitor engagement at the San Francisco Museum of Modern Art (SFMoMA), in an 'art game laboratory' that invites visitors to participate in developing game activities for the galleries (Gangsei, 2012). In contrast to the aim of soliciting visitor participation in either design or meaning making activities through social media, the *Munch and Multimodality* project purposefully integrates social media as a secondary rather than a primary mode of interaction. The rationale for this decision was in keeping with the overall focus on designing for young people's interactions with new multimodal content, and exploring challenges to the museum's existing curatorial and educational textual practices.

MEANING MAKING AND MEDIATION

In art museum education research, studies of the design and use of digital technologies and social media in gallery settings may be framed by constructivist, aesthetic, or sociocultural learning perspectives, which often serve to develop a set of hypotheses or preferred outcomes for specific types of visitor learning and behavior, that is, 'interactive interpretative models' (Czajkowski, 2011). Research typically takes the form of short-term experiments and small-scale studies, conducted in-house or with consultants, to evaluate visitor satisfaction with specific exhibitions, design features, and textual resources. In a comparative analysis of visitors' use of analogue versus digital resources in a contemporary art exhibition, for example, American education curator Peter Samis (2007) found that while visitors clearly preferred analogue texts—labels, wall panels, and reading room—they also reported learning more and engaging more deeply with art historical content when using the digital resources available in the learning lounge space. This is a frequent finding in visitor studies, which often describe visitors' satisfaction with digital technologies in museums and conclude that they generally contribute to a positive museum experience (Andrews, Gavarny, Lounsbury & Silvia, 2010; Holdgaard & Simonsen, 2009).

While evaluative studies are important for capturing visitor satisfaction and attitudes, they are complemented in the museum learning research by studies that go beyond evaluation, investigating the specific ways 'gap-closing' features of contextual resources may support meaning making among different types of visitors (Pierroux, Bannon, Kaptelinin, Walker, Hall & Stuedahl, 2007). This research has increasingly focused on the social and personal

aspects of museum visits for families, friends, and couples to account for the central role that talk and interaction play in what American researchers Falk & and Dierking (1992) call 'free-choice learning' contexts. A sociocultural perspective on learning (Ludvigsen, Lund, Rasmussen & Saljö, 2011; Vygotsky, 1986; Wertsch, 1985) frames analyses of visitors' processes of meaning making, as these are mediated through social interaction, museum artifacts, texts, and other historically developed semiotic resources in exhibitions (Leinhardt & Knutson, 2004; Pierroux, 2003). Further, the sociocultural perspective emphasizes dialogue as foundational to learning. This dialogical orientation stems from Russian literary theorist Mikhail Bakhtin (1986) and recognizes both relatively stable communicative genres and the expressive and situated aspects of utterances in meaning making (Pierroux, 2011; Rowe & Wertsch, 2002; Wertsch, 2002). A conceptualization of interpretation as intersubjective and as such always incomplete (Rommetveit, 2003) also aligns with contemporary perspectives on interpretation in art history and aesthetics (Burnham & Kai-Kee, 2011), and served in this study as the guiding principle for the design of multimodal art education resources for young people.

From a sociocultural perspective, then, design rationales for social, digital and mobile resources in museums may be seen as embracing an understanding of museum visits as social activities in which identity, motivation, and learning are strongly intertwined (Leinhardt & Knutson, 2004; Pierroux et al., 2011; Russo, Watkins, Kelly & Chan, 2007). Therefore, when targeting young people, museum education departments often develop technology-enhanced activities based on hypotheses of this group's use of social media in identity-building, ownership of mobile devices, and literacy in all things digital (Bennett et al., 2008; Prensky, 2001). Museum activities may incorporate smartphone applications that encourage young people to learn, share, and discuss artworks as they move through the gallery (Cromartie, 2012), or mobile blogging platforms for school field trips (Pierroux et al., 2011; Vavoula, Sharples, Rudman, Meek & Lonsdale).

However, studies also suggest that while young people may find the design and use of such applications appealing, their skills or interests in mastering both technology and content should not be taken for granted (Pierroux, 2012). Therefore designs that effectively support learning often draw on established pedagogical approaches and practices in museums, for example, guided face-to-face interactions, the use of tasks and relevant questions, and object-oriented talk (Burnham & Kai-Kee, 2011; Pierroux et al., 2011).

The well-known discrepancy between design intentions and actual use points to two aspects in the conceptualization of 'meaning making' that are similarly important: meaning potential and meaning realized (the making). The term 'meaning potential' (Bakhtin, 1986; Linell, 1998) implies that words and concepts have a history and conventions for interpretation, forming a foundation for experimentation with exhibition and textual practices in museums. However, as with design intentions, it is important to recognize

that potentials do not determine the meaning realized. Studies of meaning making will account analytically for both aspects, but it is through analysis of social interaction that we can study how meanings are realized, coordination takes place, and 'gaps' in understanding become closed through design.

RESEARCH DESIGN

The *Munch and Multimodality* study was organized based on key principles of design research projects (Krange & Ludvigsen, 2009), which views the institution's participants as owners of the design. The study is part of the nationally funded CONTACT project, a four-year university-museum collaboration conceived in terms of 'mutually beneficial infringement' (Lund, Rasmussen, & Smørdal, 2009). This approach fully acknowledges that interventions in established practices enter into, negotiate with, and perhaps contribute to change in a longer institutional history (Engeström, 2008). Overlapping interests of university researchers and museum curators and educators, and understandings of existing problems in practice, thus shaped the design collaboration. Interviews and focus groups with young people were also conducted at different phases of the design process, and this participation was particularly relevant for the development of interaction design features. The design process incorporated a number of iterations, in which ideas and prototypes were tested out with the target group.

The research was inspired by a plan of the chief curator of education in the Old Masters department to conduct an in-house study of visitors' use of textual resources in the existing Munch gallery: labels; short texts; information sheets; and an audio guide, which is currently the only digital resource made available by the museum to visitors. Through conversations between researchers and museum partners, the notion of 'text' in the study was extended to encompass multimodal content, social media, and different digital platforms, and a project proposal was developed. Multimodality is a term that points to the range of semiotic modes of expression made possible through digitization, for example, audio, video, animation, extending the traditional text-image grammar of visual design (Kress & van Leeuwen, 1996, 2001). The study was anchored internally by referring to the museum's strategic goals, and through approval by the new curator to allocate a gallery space to the project for twelve weeks. Other aims of the museum partners were to improve the museum's visitor research methods and learning perspectives, to develop outreach strategies for young people as a target group, and to improve educational practices using digital resources. Each of these aims is addressed in the overall scope of the research project, but we focus in this chapter on disciplinary and textual challenges related to designing digital interactives, with young people as the inscribed users.

The first phase of this one-year project involved a small study conducted in collaboration with the museum over four weeks to track visitors' movements and use of existing resources in the Munch gallery. The gallery mounting comprised 19 paintings by Edvard Munch. In addition to traditional object labels, four of the most familiar and important works were included on an audio tour and had slightly larger text panels with more information in both English and Norwegian. The study showed, among other findings, that visitors (with and without the audio tour) spent more time in front of these paintings than the other artworks in the room, often reading the longer wall texts. The purpose of this initial study was to provide background material for the design process, including insight into visitor demographics, patterns of movement, types of behavior, use of contextual resources, and how these behaviors aligned or contrasted with curatorial and educational aims. Following this study, seven months were used for design, testing, and implementation phases, with observations then conducted in the museum for three months.

METHODOLOGICAL APPROACH

Research on the design and use of the interactives was conducted using ethnographic methods, as applied in sociocultural approaches to interaction analysis (Derry et al., 2010; Jordan & Henderson, 1995; Pierroux, 2006). We draw also on approaches in media ethnography as described by Danish researchers Schrøder, Drotner, Kline, & Murray (2003) to analyze disciplinary challenges related to designing interactives and multimodal content. Specifically, we approach media "as articulations of meaning-making, processes that call upon attention to the ways in which these articulations are textually produced and made to make sense by somebody" (Schrøder et al., 2003, p. 72). We refer above to such articulations as meaning potential. We consider in the analysis the technology (what), the modalities of articulation (how), the contexts of use (where, when), and the modes of experience/sense-making (what, who) (Schrøder et al., 2003). We adopt an analytic-narrative stance in describing these design sensitivities and the ways that young people are inscribed into the design as users, weaving each data source into the analysis. The data sources comprise

1. Prototypes of the 'interactives' implemented in pilot
2. Texts (existing texts in Munch gallery and new texts written for interactives)
3. Recorded (audio and video) and transcribed dialogues between museum staff (curators, educators, webmaster, communication department, research department, carpenter), university researchers, and external consultants (architect, graphic designer)

4. Recorded (audio and video) of meetings with young people during focus groups and testing
5. Researchers' notes of meetings and events
6. Semi-structured interviews (video and audio) with the chief curator of education for the Old Masters department, the previous head of education for the National Museum, the curator for the previous mount of the permanent collection (including the Munch gallery), and the new department head and curator for the new hang of the permanent collection
7. Wiki-based project calendar and notes documenting meetings between InterMedia researchers, programmers and technology consultants

IN *MUNCH'S WORLD*

The gallery used for the project room is in near proximity to the Munch gallery, although not directly adjacent. Several metaphors for the design of the project room were explored, including a café metaphor proposed by the research team. This is because cafés are social places for young people where talk is common, encouraging a different kind of interaction and behavior than elsewhere in the galleries. The café metaphor also links to the Grand Café and artists from Christiania Boheme (the Norwegian capital Oslo was called Christiania until 1925) with whom Munch associated, providing both a theme of relationships between friends and a historical context. A café design was explored that combined period furniture with digital technologies. However, museum partners were concerned about this approach, in that the building itself is from this period, and they saw a problem introducing the 'new' cloaked in the old.

After several meetings where ideas were presented for activities and resources using different 'café' interactives, the chief curator of education came to a meeting prepared with a different model for organizing the content of the interactives, based on an existing education program that the museum had successfully implemented in high schools, one of the age groups targeted in this study. The educational model entailed organizing content about an artist and his or her work along four points of access or 'interpretive themes': *My Self*, *My Friends*, *My Place* and *My Media*. This approach was subsequently embraced by the project team as the framework for developing content for four digital interactives, respectively titled, and shifted the design of the project room away from the café metaphor to a more open theme, titled *Munch's World*.

This shift also allowed the overall design of the project room to reflect the experimental, 'lab-like' character of this intervention into National Gallery's communication and education practices. As the museum's first exploration of digital interactives in a gallery space, the project was viewed with some skepticism among curatorial staff, and it was important to signal the experimental aspect of the research. The researchers developed the design of the stations in collaboration with an architect who served as external

consultant, while carpenters on staff at the museum were responsible for labor and materials. InterMedia supplied the hardware, and our programmers developed the interaction design under the direction of the researchers. A shared set of general aims was developed early on by the project team to inform design work with the different themes. These were based on a sociocultural perspective on meaning making, previous learning research on interactives in art museums, and the exploratory aspect of the design. Although young people are the main research interest in the study, the objectives took into account the fact that the project room would be accessible to all visitors during the eight-week installation period. The 'meaning making aims' may be summarized as the following:

1. to support collaborative and dialogic inquiry in different types of art historical information related to Munch, his art, and his artistic process;
2. to engage visitors in activities that involve cocreation and sharing personal reflections and experiences related to Munch and his art;
3. to encourage back-and-forth movement between the digital interactives and the authentic artworks by Munch, fostering meaning making through scaffolded concentration on details, technique, and composition; and
4. to motivate visitors to explore relations between artworks by Munch and other artists in the exhibition.

In the following section we describe the design of the four interactives, highlighting the ways in which these aims are realized in terms of media properties, the modalities of articulation, the contexts of use, and the modes of meaning making.

My Media

From a content perspective, the first purpose of this activity is to communicate an understanding of Munch's processes, techniques, and uses of media as expressive means. Munch would often use his own sketches and studies from different places and times as a point of departure for his paintings, freely combining elements in new compositions and experimenting with techniques to develop them in different directions. He might 'rework' his paintings in the form of lithographs and woodcuts, making several versions with slightly different expressions of the same motif. The second purpose of the activity is to explore the role that Munch's writings—short texts, notes, and poems—had in his artistic production. The medium of writing was both a means of expression and a source for his art, and he often produced different versions of his texts as well. Munch's practice of making several versions of motifs and texts is explained in a brief *My Media* wall text mounted next to the interactive station, and describes this process with two works in particular: *Scream* and *Melancholy*.

To scaffold visitors' understandings of these aspects of Munch's art, the interaction is designed as a game on a multitouch table (Figure 8.1). The table, and its media properties, was selected for the *My Media* interactive for several reasons. Not unlike artist's tools, the modalities of articulation involve gesture or touch-based manipulation of rich visual content and representations, although in this instance, in prearranged sequences rather than a creative, artistic process. There is also a sensitivity in the design to modes of meaning making, specifically the role of dialogic inquiry, with features that prompt collaborative reasoning, attention to visual and textual content, and the coordination of gestural interaction among visitors. The table invites people to gather and interact as a mode of meaning making, and there are multiple access points to art historical content through both forced and more open sequences of action. The interaction design is also sensitive to the context of use, which invites visitors to walk up to the table and participate in the activity without prior instruction. Therefore, there are three clearly marked 'places' at the table with the simple instruction 'touch to start'.

There are two rounds to the first task, which relates to Munch's production of different versions of *Scream* and *Melancholy*. The task entails sorting chronologically three versions Munch made of *Scream* and *Melancholy*, respectively: "Arrange these in the order that they were made." Each version is in a different media (e.g., lithograph, painting, sketch), and there is a correct sequence that illustrates how Munch 'typically' used media for different purposes in his artistic process. The visitors are required to agree on which work to select before they can find out if their chronological arrangement is correct, in a 'forced move' (Pickering, 1995) in the interaction design intended to foster discussion and conceptual thinking. If they agree, but the selection is incorrect, they are informed and must reselect. A text then appears on cue on a wall-mounted screen at the head of the table, providing information useful for solving the task. The purpose of the wall screen is to distinguish between the mode of reading texts on museum walls, and the gesture-based interactions with images and visual content on the tabletop. When participants have made correct selections, these also appear on the screen at the head of the table. The challenge of getting a 'correct' answer illustrates the very real challenges curators have in doing the very same activity of dating works, and understanding an artist's process and production. This is particularly difficult in Munch's case, as explained in text on the wall screen upon completion of the task, since his process and use of media varied, and he seldom dated his works.

The second game in the multitouch activity also presents three works to be sequenced, and requires agreement among players. However, the sequencing task is different, as players are instructed to rank the works according to which best expresses the meaning of a text written by Munch, visible on the wall-mounted screen. Although the players must agree to post their selections, there is no 'correct' answer, balancing forced moves from the previous activity with more open-ended reflection. The curated

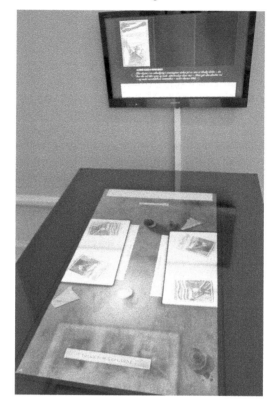

Figure 8.1 My Media interactive.

content for the *My Media* interactive is designed with the following modes of articulation:

1. digital images of artworks by Munch, on table;
2. text on paper board, mounted next to interactive, on wall;
3. pop-up 'object labels' for each image, on table;
4. gesture-activated 'clue texts' for each artwork about technique or process, on wall screen above table;
5. instructional texts related to the game, on table;
6. quotes from Munch's writings, on wall screen above table; and
7. art historical texts about challenges in dating Munch's works, on wall screen above table.

My Self

The aim of this activity is to increase awareness of the techniques Munch used in his self-portraits to convey inner emotion, state of mind, and self-image.

These artistic means include compositional features like posture, gaze, facial expression, and setting, but also symbolic and expressive, painterly qualities. The *My Self* wall text next to the station explains that Munch painted many self-portraits during his life, some that showed what he looked like and others that expressed how he felt. Different artistic means were used accordingly; in some works, resemblance was important, while in others there was emphasis on conveying an emotion or mood through form, color, composition and the use of symbols.

The visitor is invited to mimic, or recreate, Munch's self-portraits in a photograph of herself. The media properties are both analogue and digital, inviting visitors to first select one of Munch's self-portrait posters from a bin and to physically hang it on the wall (Figure 8.2). An RFID tag on the back of the poster is read and triggers the display of a digital image of the work on a screen adjacent to the poster, along with textual information about this particular self-portrait. This brief text is quite descriptive, uses short sentences, and directs the visitor's attention to key features or traits through direct reference to the image. On a control panel below the screen, the visitor is invited to 'pose like Munch'. As in the *My Media* interactive,

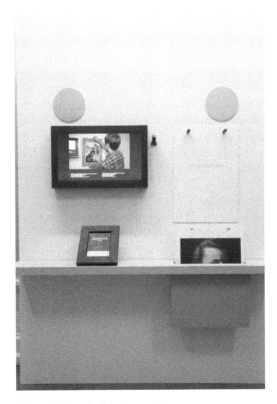

Figure 8.2 My Self interactive.

the purpose of a separate screen is to distinguish between instructional texts and the disciplinary content integrated into the interaction.

Clicking 'yes' to participate, the wall-mounted screen displays Munch's self-portrait on one side, and a camera view of the visitor on the other side. The visitor assumes Munch's pose, adjusting and checking her position, gaze and expression against the digital and analogue reproductions. Building on research on embodiment and museum technologies (Pallud & Monod, 2010), the visitor is invited to engage in the activity of reenacting the emotion and nuances of expression in Munch's self-portrait through careful observation and mimicking. Clicking 'take picture', the visitor has a five-second countdown before the snapshot is taken. If not satisfied with the result shown on the screen, she may try again. When satisfied with the self-portrait, she is invited to add a caption and share the photo on the museum's *Flickr* stream, visible both on the museum's website and on a screen near the entrance to the room. She is also invited to have the photo sent to her e-mail for personal use.

To extend this experience of careful looking, and to support visitors in applying knowledge about self-portraits to other works in the museum, a short film (approximately three minutes) is shown on the screen immediately after the interaction is finished. The curator is standing beside an artwork in the museum. He explains how this work, by a different artist, is related to Munch's self-portrait, and prompts the visitor to seek it out in the galleries.

There are three design sensitivities to modes of meaning making that may be highlighted in this interactive. First, there is design sensitivity to the act of attentive and prolonged viewing, a perception skill that is valued in art and may be applied to encounters with other works. Second, the design is sensitive to young people's motivation to participate in self-representation through social media, and similar experience with staging and creating self-portraits. The third design sensitivity builds on the participatory features of social media, involving the visitor in publicly sharing a photo of her self-portrait with Munch with other visitors, a familiar and engaging activity particularly for young people.

The curated content for the *My Self* interactive is designed with following modes of articulation:

1. text on paper board, mounted next to interactive, on wall;
2. images of Munch's self-portraits, printed on posters and presented on screen;
3. art historical texts about each of Munch's self-portraits, displayed on split screen with digital image;
4. instructional texts on iPad, on counter below screen; and
5. film script and performance, on wall screen.

Visitors' cocreated content, in the form of a captioned photo of the visitor posing alongside a self-portrait by Munch, is presented on both the

museum's website, and on a screen at the entrance of the room, introducing multimodal texts into the museum space for other visitors' engagement.

My Friends

The aim of this interactive is to provide insight into the times in which Munch lived through a better understanding of relationships and friends that influenced him, their beliefs, interests, writings, and artworks. Munch's association with artists and writers known as the Christiania Boheme is the content in focus, and many of these figures are rendered as subjects in his works.

The context for the activity, sitting around a table with friends, is familiar to visitors. At the head of the table is a large color reproduction of a drawing made by Munch depicting some figures associated with the Christiania Boheme, who are similarly seated around a table in a café (Figure 8.3). The wall text describes the significance of this group for Munch, and identifies the people in the drawing and what they meant to him. This text also describes the radical views of this loose-knit group, and refers to a text several

Figure 8.3 My Friends interactive.

of them wrote, titled *The Nine Commandments*. On the table, visitors can read a loose laminated copy of these commandments. 'Profiles' of Munch and three of his friends are also printed on laminated paper to read and share at the table. These texts describe each friend in terms of his or her relationship to Munch and their respective biographies.

The Nine Commandments—from the inspirational 'You shall write your own life' to the more provocative 'You shall *take* your own life' (italics in original)—was selected as a text to engage young people in reflecting on how the historical context surrounding Munch and his friends may be relevant today. Printed in 1889, the commandments are rules to live by, describing how the Christiania Boheme viewed their roles as artists and citizens in bourgeois society. The visitors are invited to 'tweet' a commandment that is relevant for them and their own friends, using *Twitter* and the iPad mounted to the table. The 40-character tweet limit corresponds with the text genre of the brief but pointed commandments, and the *Twitter* feed scrolls on a wall-mounted screen at the head of the table (Figure 8.3), and appears on the museum's website and *Facebook* page.

The design aims to support different modes of meaning making, from reading on paper art historical information about Munch, his friends and their writings, to sharing personal reflections through face-to-face interactions seated around a table, to involving visitors in the activity of collaborative writing. The casual and integrated presence of social media, essential to maintaining friendships among young people today, is a mode of articulation that aims to bridge the commandment writing activity and the theme 'Munch's friends'. Visitors' tweets become in this sense cocreated content, presented both on the museum's website and on a wall-mounted screen, aiming to engage other visitors and prompt discussion and reflection (Figure 8.5).

The curated content for the *My Friends* interactive is designed with following modes of articulation:

1. printed reproduction of Munch's *Kristiania Boheme II*, on wall;
2. text on paper board about the artwork and the depicted figures, mounted next to interactive, on wall;
3. text and portrait of four friend 'profiles' on laminated sheets of paper, on table;
4. text *The Nine Commandments* on laminated sheet of paper, with invitation to 'tweet a tenth commandment', on table;
5. instructions on iPad for writing tweet, on table; and
6. scrolling text on screen with visitor tweets, on wall.

My Place

The art historical aim of this interactive is to make apparent the significance of specific places for Munch and other artists in the museum. Munch traveled and lived abroad and in different places in Norway, and many of these

have been important to his artistic production. His experiences, especially in Paris, Berlin, and Christiania may be traced in his artworks, either in landscapes and interiors or in motives of love, death, and work. To motivate visitors to explore the importance of place in the artist's production, the design is based on movement and presence in the physical galleries, where postcards are placed in stands in front of selected artworks. The cards have a picture of the painting on one side, and on the other side the question is posed: "Why was (this place) important to Munch?" The card directs the visitor on a floor plan to *Munch's World*. The postcard is printed with a QR code as a stamp, with instructions to scan the code at 'My Place'.

In the *Munch's World* gallery, three wall-mounted screens are activated when a postcard is scanned using a reader on the counter (Figure 8.4). First, the location on a Google Earth map on a large screen moves from its pinpoint at the National Museum in Oslo to the location relevant to the picture on the postcard. One of the two small screens displays a photograph from an event in this place that was important to Munch, with a brief explanatory text. On the second small screen, an image of a work in the museum by a different artist

Figure 8.4 *My Place* interactive.

is shown, with a text that explains why this same place was also important for him/her. The use of image and text is intended to prompt visitors to view these works in the galleries and reflect on the ways in which place is important to Munch and other artists. Accordingly, a rich set of media properties and modes of articulation is drawn into this activity, which entails a commitment of time and movement across gallery spaces on the part of the visitor.

This content is challenging for visitors in the sense that relationships between an artwork and the place in which the artist lived and worked are not always directly discernible. As with other kinds of contextual information, such connections often need to be pointed out, and then explicitly related to the specific work, leaving space for conversation and reflection about the significance of this information for the interpretation process. The design for the main modes of meaning making, which are reading, conversation, and movement between digital information and authentic works of art, builds on research that visitors seek information in art museums that can lead to a more advanced understanding of an artist's life. The aim of this interactive is thus to mediate this mode of meaning making, with postcards serving as tools that prompt movement and reflection between information and works of art in the galleries.

The textual curated content for the *My Place* interactive is designed with the following modes of articulation:

1. images, texts, and instructions on paper postcards, on stands in gallery rooms;
2. text on paper board about the relevance of place in Munch's work, mounted next to the interactive, on wall;
3. digital texts, images and photographs linked to a postcard of a specific work by Munch, two screens, on wall; and
4. Google map 'fly-over' animations on large screen, on wall.

DISCUSSION

The interactives presented above are understood as interrupting and extending textual communication practices in the art museum gallery setting. In this section, we discuss these challenges along the lines presented above, that is, in terms of the technologies and contexts of use, the modalities of articulation, and the modes of meaning making when young people are the inscribed audience.

Technologies and Contexts of Use

The architectural challenge of integrating interactives and special resource rooms in art museums has been addressed in different ways in practice. In some instances, care is taken to situate such spaces remotely from the

galleries, for example, near the entrance of the museum, accessible as learning lounges or experience centers and often designed for family use. From a use context perspective, such remote locations concedes the material and experiential differences between technologies and artworks, the different motivations and needs of visitors, and tensions between perception-based interactions and the more intense social and physical character of engaging with technologies and interactives.

However, studies have shown that proximity to artworks is needed for interactives to support the kinds of cognitive and social activities relevant for meaning making, that is, capitalizing on content and points of reference that are immediate and adjacent (Czajkowski, 2011; Holdgaard & Simonsen, 2009; Knutson & Crowley, 2010; Mortati, 2009; Samis, 2007). Art historical content, conversation, and close looking are central to meaning-making process in art museums, and content integrated into visitors' actual physical encounters with authentic artworks is thus considered the ideal context of use. Design implications drawn from this research seem at odds, then, with studies of the disruptive aspects of technology use in learning (vom Lehn & Heath, 2005), and point to the need for careful studies of technology-enhanced learning in art museum galleries.

Taking into account previous research and at the same time aiming to enhance modes of meaning making, the interactives in this project are located in proximity to rather than within the gallery space with authentic artworks. For this reason, several of the interactives were specifically designed to prompt interaction and movement between multimodal content in *Munch's World* and artworks in the other gallery rooms. The relevance of proximity for the visitors' social and cognitive activities, or meaning realized, will be explored in future studies as we analyze the data collected during the pilot study. In terms of challenges to textual practices, we found that wall texts in *Munch's World*, written to provide thematic information and frame the activity at each interactive, were largely overlooked by visitors. We conclude from this that the historically established context of use for wall texts, which builds on the close relation between a text and an artwork that is visually available, was not compatible with the experiential and multimodal aspects of the digital interactives.

Modalities of Articulation

From an education curator perspective, it is important that content for texts and labels is written and designed in ways that are sympathetic to comprehension by a range of visitor types, that is, sensitive to concerns with thematic clusters, typography, and relationships between text and image. However, the simplification and selection of content often creates dilemmas, as exclusion of information or changes in narrative approaches may be controversial and divisive for museum staff. Education curators are sensitive to curatorial critique of reductionism or oversimplifying curatorial content to reach a greater audience.

The introduction of interactives into gallery spaces thus adds another layer of complexity to existing textual practices, intermeshing printed text and images with multimodal representations and animations. Curated content for interactives entails concerns with overall structuring, chunking, and sequencing of multimodal content for gesture-based as well as perception-based interactions. This means selecting content and designing graphic and visual elements that move and are made tactually and visually available on cue. As interactions become more complex, prompts and instructions—not established communication genres in art museums—must also be written and designed for different visitor types. Combining curated content with visitors' tweets, photos and captions (Figure 8.5) further challenges expert knowledge and authorship in the art museum, as do collaborations with external interaction design partners.

In this study, university researchers and interaction designers worked closely with education curators to select and develop content to integrate into the *Munch's World* interactives as both print and multimodal media. In this sense, the collaboration itself intervened in existing exhibition practices, in that other departments were less involved in the design and development of texts, particularly the curatorial staff. The collaboration nonetheless allowed for shared reflections on the 'modalities of articulation' introduced into the museum's gallery communication practices. In the diagram below (Figure 8.5), we map media properties and technological specificities (what, how) along a horizontal axis, moving from existing practices with static

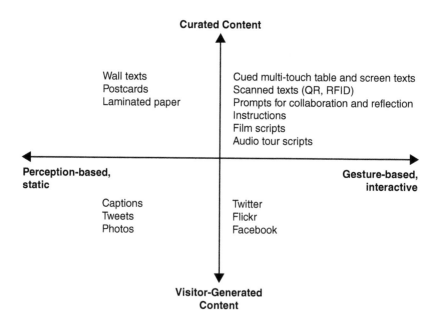

Figure 8.5 Modalities of articulation.

print media that is read on walls and handouts to multimodal media that entail gesture-based interactions and are read on screens and tables. The content and modes of meaning making (what, who) may be traced on the vertical axis, illustrating the adaption of curators' art historical texts to media properties that support collaborative interactions on multiple technological platforms. This axis includes visitors' modes of meaning making using various social media and the visualizations of these modes as texts.

Young People and Modes of Meaning Making

The participative, collaborative, and creative aspects of art museum interactives introduce an interpretive experience, or mode of meaning making, that differs from the traditional school field trip or family visit interactions that are familiar to young people. A striking difference from the more perception-oriented activities in a traditional museum experience is the richness of interactions; historically speaking, we can claim that communication is interrupted. In the thematically organized activities, young people can understand how Munch used different techniques, how and where he lived his life, and what this meant for his work. They can reflect on aspects of identity in self-representation from a historical perspective, a convention closely linked with their own self-portrait practices on *Facebook*. They can discuss hypotheses about the use of different media in Munch's creative process, including his own writings. And friends can discuss and contrast their views on contemporary society with those held by people their own age from a different time, and reflect on how Munch's friends, radical views influenced the artistic and literary works by the Christiana Boheme. In sum, the four interactives presented a number of social and cognitive challenges to young people that are firmly grounded in art historical interpretive practice, which include describing, analyzing, contrasting, and reflecting on works of art, and mobilizing previous knowledge to make connections between artwork and the context in which the artist lived. During testing in design development, and based on preliminary analysis of interaction data in the museum, young people's engagement with these resources appears to advance meaning making in a conceptual direction. As such, *Munch's World* represents an entry point to understanding central aspects of art history as a knowledge domain.

AUTHORS' NOTE

We gratefully acknowledge contributions to the research and design of the interactives by Research Fellow Rolf Steier at InterMedia, along with InterMedia programmer Jeremy Toussaint and other lab staff. We are particularly thankful for the professional and research contributions by Special Adviser Anne Qvale, Senior Curator of Education Frithjof Bringager, and Nils Ohlsen, Director of Old Masters and Modern Art at the National

Museum of Art, Architecture and Design in Oslo. The National Museum is a collaborative partner in the CONTACT project (2009–2013), funded by the Research Council of Norway.

REFERENCES

Adams, M., & Moussouri, T. (2002). The interactive experience: Linking research and practice. In *Interactive learning in museums of art conference proceedings*. Victoria & Albert Museum, London.

Andrews, J., Gavarny, M., Lounsbury, N., & Silvia, A. (2010). *The use of digital technologies for learning at the Victoria and Albert Museum*. Worcester Polytechnic Institute.

Atkins, L. J., Velez, L., Goudy, D., & Dunbar, K. N. (2008). The unintended effects of interactive objects and labels in the science museum. *Science Education, 93*(1), 161–184.

Bakhtin, M. M. (1986). *Speech genres and other late essays*. Austin: University of Texas Press.

Bann, S. (1998). Art history and museums. In M. A. Cheetham, M. A. Holly, & K. Moxey (Eds.), *The subjects of art history*. Cambridge: Cambridge University Press.

Bennett, S., Maton, K., & Kervin, L. (2008). The 'digital natives' debate: A critical review of the evidence. *British Journal of Educational Technology, 39*(5), 775–786.

Bernstein, S. (2008). Where do we go from here? Continuing with Web 2.0 at the Brooklyn Museum. In J. Trant & D. Bearman (Eds.), *Museums and the Web 2008: Proceedings*. Toronto: Archives & Museum Informatics. Retrieved from http://www.museumsandtheweb.com/mw2008/papers/bernstein/bernstein.html

Burnham, R., & Kai-Kee, E. (2011). *Teaching in the art museum: Interpretation as experience*. Los Angeles, CA: J. Paul Getty Museum.

Cromartie, N. (2012). ArtClix mobile app at the High Museum of Art. In N. Proctor & R. Cherry (Eds.), *Museums and the Web 2012: Selected papers from an international conference*, Museums and the Web LLC.

Czajkowski, J. (2011). Changing the rules. *Journal of Museum Education, 36*(2), 171–178.

Derry, S. J., Pea, R. D., Barron, B., Engle, R., Erickson, F., Goldman, R. et al. (2010). Conducting video research in the learning sciences: Guidance on selection, analysis, technology, and ethics. *Journal of the Learning Sciences, 19*(1), 3–53.

Durbin, G. (2002). Interactive learning in the British galleries. In *Interactive learning in museums of art conference proceedings*, London, May 17–18.

Engeström, Y. (2008). From design experiments to formative interventions. In *Proceedings of the 8th international conference for the learning sciences*, Vol. 1, 3–24, Utrecht, The Netherlands, June 23–28.

Falk, J., & Dierking, L. D. (1992). *The museum experience*. Washington, DC: Whalesback Books.

Gangsei, E. (2012). SFMOMA's Art game laboratory: Real-life mad science experiments in visitor engagement. In N. Proctor & R. Cherry (Eds.), *Museums and the Web 2012: Selected papers from an international conference*, Museums and the Web LLC.

Gates, J. (2010). Clearing the path for Sisyphus: How social media is changing our jobs and our working relationships. In J. Trant & D. Bearman (Eds.), *Museums and the Web 2010: Proceedings*. Toronto: Archives & Museum Informatics. Retrieved from http://www.museumsandtheweb.com/mw2010/papers/gates/gates.html

Heusinger, L. (1989). Computers in the history of art. In A. Hamber, J. Miles, & W. Vaughan (Eds.), *Computers and the history of art* (pp. 1–22). London: Mansell.

Hofinger, A., & Ventola, E. (2004). Multimodlaity in operation: Language and picture in a museum. In E. Ventola (Ed.), *Perspectives on multimodality* (pp. 193–209). Amsterdam: John Benjamins.

Holdgaard, N., & Simonsen, C. (2009). *Digitale borde på Statens Museum for Kunst.* Copenhagen: IT-University of Copenhagen.

Insulander, E. (2010). *Tinget, rummet, besökaren: Om meningsskapande på museum.* Doctoral thesis, Stockholm University.

Jordan, B., & Henderson, A. (1995). Interaction analysis. *The Journal of the Learning Sciences, 4*(1), 39–103.

Kelly, L., & Russo, A. (2008). From ladders of participation to networks of participation: Social media and museum audiences. In J. Trant & D. Bearman (Eds.), *Museums and the Web 2008: Proceedings.* Toronto: Archives & Museum Informatics. Retrieved from http://www.museumsandtheweb.com/mw2008/papers/kelly_l/kelly_l.html

Knutson, K., & Crowley, K. (2010). Connecting with art: How families talk about art in a museum setting. In M. K. Stein & L. Kucan (Eds.), *Instructional explanations in the disciplines* (pp. 189–206). New York, NY: Springer.

Krange, I., & Ludvigsen, S. (2009). The historical and situated nature of design experiments: Implications for data analysis. *Journal of Computer Assisted Learning, 25*(3), 268–279.

Kress, G., & van Leeuwen, T. (1996). *Reading images: The grammar of visual design.* London: Routledge.

Kress, G., & Van Leeuwen, T. (2001). *Mulitmodal discourse: The modes and media of contemporary communication.* London: Arnold.

Leinhardt, G., & Knutson, K. (2004). *Listening in on museum conversations.* Walnut Creek, CA: AltaMira Press.

Linell, P. (1998). *Approaching dialogue: Talk, interaction and contexts in dialogical perspectives.* Amsterdam: John Benjamins Publishing.

Ludvigsen, S., Lund, A., Rasmussen, I. & Saljo, R. (Eds.). (2011). *Learning across sites: New tools, infrastructures, and practices.* London: Pergamon Press.

Lund, A., Rasmussen, I., & Smørdal, O. (2009). Joint designs for working in wikis: A case of practicing across settings and modes of work. In A. Edwards, H. Daniels, S. Ludvigsen, A. & Y. Engeström (Eds.), *Activity theory in practice: Promoting learning across boundaries and agencies* (pp. 207–230). London: Routledge.

Macdonald, S. (2002). *Behind the scenes at the science museum.* Oxford: Berg.

Mortati, M. (2009). *2 learning lounges we like.* Retrieved from http://museums-now.blogspot.com/2009/01/2-learning-lounges-we-like.html

Pallud, J., & Monod, E. (2010). User experience of museum technologies: The phenomenological scales. *European Journal of Information Systems, 19,* 562–580.

Parry, R., Ortiz-Williams, M., & Sawyer, A. (2007). How shall we label our exhibit today? Applying the principles of on-line publishing to an on-site exhibition. In J. Trant & D. Bearman (Eds.), *Museums and the Web 2007: Proceedings.* Toronto: Archives & Museum Informatics. Retrieved from http://www.museumsandtheweb.com/biblio/how_shall_we_label_our_exhibit_today_applying_the_pri

Pickering, A. (1995). *The mangle of practice: Time, agency and science.* Chicago, IL: University of Chicago Press.

Pierroux, P. (2001). Information and communication technology in art museums. In G. Liestøl & T. Rasmussen (Eds.), *Internett i endring (Internet and Change)* (pp. 87–103). Oslo: Novus.

Pierroux, P. (2003) Communicating art in museums: Language concepts in art education. *Journal of Museum Education, 28*(1): 3–8.

Pierroux, P. (2006) *Meaning, learning, and art in museums: A situated perspective.* Oslo: Unipub.

Pierroux, P. (2012). Real life meaning in second life art. In S. Østerud, B. Gentikow & E. G. Skogseth (Eds.), *Literacy practices in late modernity: Mastering technological and cultural convergences* (pp. 177–198). Creskill, NJ: Hampton Press.

Pierroux, P., Bannon, L., Kaptelinin, V., Walker, K., Hall, T., & Stuedahl, D. (2007). MUSTEL: Framing the design of technology-enhanced learning activities for museum visitors. In *International Cultural Heritage Informatics Meeting Proceedings*. Toronto, Canada, October 24–26.

Pierroux, P., Krange, I., & Sem, I. (2011). Bridging contexts and interpretations: Mobile blogging on art museum field trips. *Mediekultur: Journal of Media and Communication Research, 50,* 25–44.

Prensky, M. (2001). *Digital natives, digital immigrants.* MCB University Press.

Preziosi, D. (2006). *The museological object: Art museums and the staging of knowledge.* Lecture, University of Oslo, Norway, November 17.

Purser, E. (2000). Telling stories: Text analysis in a museum. In E. Ventola (Ed.), *Discourse and community: Doing functional linguistics* (pp. 169–198). Tübingen: Gunter Narr.

Ravelli, L. (1996). Making language accessible: Successful text writing for museum visitors. *Linguistics and Education, 8,* 367–387.

Roberts, L. C. (1997). *From knowledge to narrative: Educators and the changing museum.* Washington, DC: Smithsonian Institution Press.

Rommetveit, R. (2003). On the role of "a psychology of the second person" in studies of meaning, language and mind. *Mind, Culture and Activity, 10*(3), 205–218.

Rowe, S., & Wertsch, J. (2002). Linking little narratives to big ones: Narrative and public memory in history museums. *Culture & Psychology, 8*(1), 96–112.

Russo, A., Watkins, J. J., Kelly, L., & Chan, S. (2007). Social media and cultural interactive experiences in museums. *Nordic Journal of Digital Literacy, 1,* 19–29.

Samis, P. (2007). Gaining traction in vaselin: Visitor response to a multi-track interpretation design for Matthew Barney: DRAWING RESTRAINT. In J. Trant & D. Bearman (Eds.), *Museums and the Web 2007: Proceedings.* Toronto: Archives & Museum Informatics. Retrieved from http://www.museumsandtheweb.com/mw2007/papers/samis/samis.html

Schrøder, K., Drotner, K., Kline, S., & Murray, C. (2003). *Researching audiences.* London: Hodder Arnold.

Simon, N. (2010). *The participatory museum.* Available from http://www.participatorymuseum.org/

Solhjell, D. (1998). *Formidler og formidlet (Disseminator and disseminated).* Oslo: Universitetsforlaget.

Soren, B. (1992). The museum as curricular site. *The Journal of Aesthetic Education, 26*(3), 91–101.

Trant, J. (2006). Exploring the potential for social tagging and folksonomy in art museums: Proof of concept. *New Review of Hypermedia and Multimedia, 12*(1), 83–105.

Vavoula, G., Sharples, M., Rudman, P., Meek, J., & Lonsdale, P. (2009). Myartspace: Design and evaluation of support for learning with multimedia phones between classrooms and museums. *Computers & Education, 53*(2), 286–299.

vom Lehn, D., & Heath, C. (2005). Accounting for new technology in museum exhibitions. *Marketing Management, 7*(3), 11–21.

Vygotsky, L. S. (1986). *Thought and language.* Cambridge, MA: MIT Press.

Wertsch, J. (1985). *Vygotsky and the social formation of mind.* Cambridge, MA: Harvard University Press.

Wertsch, J. (2002). *Voices of collective remembering.* Cambridge: Cambridge University Press.

9 Weaving Location and Narrative for Mobile Guides

Mike Sharples, Elizabeth FitzGerald, Paul Mulholland, and Robert Jones

Museums are designed as social spaces. They are places where people can talk, share experiences, and create collective memories. The spatial layout of exhibits allows groups of visitors to view and converse. Talk is encouraged and staff are employed to support families, school groups and tours. Yet much of the computer technology that has been introduced into museums is for individual rather than collaborative use. Handheld guides have been designed to be held up to the ear and multimedia museum displays usually have a single small screen. Recent developments such as museum guide applications for mobile phones continue the theme of supporting the solitary museum visitor. It is not surprising that some curators regard computer technologies as barriers to social engagement with the museum (Tallon & Walker, 2008).

Since the 1960s, attempts have been made to design more social museum technology, including dual earpieces for audio guides (Tallon, 2008), quiz questions for pairs of museum users equipped with communicating handheld devices (Yatani, Onuma, Sugimoto & Kusunoki, 2004), multimedia displays that allow visitors to leave opinions and arguments relating to museum exhibits for others to view and respond (Hsi, 1997), and the use of social media to provoke conversations around museum collections (Johnson et al., 2010). While these have had varying success in connecting and engaging visitors, they can create a fragmented experience where the visitor's attention is divided between the museum environment, the technology and the social interaction. In this chapter, we explore how narrative structures can create threads of experience that connect visitors with museum exhibits and with the narratives woven by other groups of visitors through their conversations and interactions. Computer technology can be designed to anchor these narratives to locations and enhance them through social interactions to create memorable experiences that can be replayed and shared.

The chapter draws on the model of 'explicit interactivity' proposed by the US game designer Eric Zimmerman (Zimmerman, 2004), where interactive objects in the environment combine to tell a story, presenting individuals or groups (who may variously be termed audience, players, readers or users) with opportunities to affect the content of the story as it is being delivered.

The human participants, computer applications, and locations intermingle to form narratives that unfold through a combination of human-computer interactions and physical movements around the space.

Our aim is to offer museum curators and exhibit designers some ways of enabling visitors to create connected story interpretations of their museum experiences by engaging with software that is preprogrammed yet responsive to location and physical movement. This leads to a phenomenon known as the 'Interactive Dilemma': "the inevitable conflict between author's determinism and interactor's freedom" (Peinado & Gervas, 2004: 1). In relation to museums, it is the perennial tension between guiding visitors in where to go, what to see, and how to understand, or allowing them to wander freely and construct their own interpretations.

If a human tour guide is replaced by a location-sensitive multimedia device, then the visitor has greater power to break from the well-trodden route and create a personal interpretation, but must also expend more effort in creating connected meaning out of the fragments of situated experience. A tempting compromise for designers of interactive guides might be to ease this effort by providing a variety of suggested routes or tours, adapted to user profiles, but our early experience of developing a location-based guide (Naismith, Sharples & Ting, 2005) suggests that this might be the worst of both worlds, with the visitor frustrated at being presented with an order of locations to visit and without sufficient influence over the form or content to gain a satisfying experience. We attempt to resolve this dilemma by presenting narrative structure as the key feature in such experiences, an artifact designed for storytelling that can be controlled by an implicit partnership of systems designers, museum curators, and visitors.

MOBILE COMPUTER-BASED STORYTELLING

Mobile computer-based storytelling emerged from the commentary of a tour guide delivered as an audio tour on a portable handset. Some, such as Wapping Audio Tour, present a mixture of performance and sightseeing, narrated by actors: "The artists alternated between uncovering the existing history of this part of the docklands and creating their own through writing stories, staging a wake, talking to the people who live in the area and guiding tourists from the records of their walks"(Wapping Audio, 2012). Interactivity comes from the visitor moving round the environment and keying in codes to get a commentary linked to the location. Recent projects have extended the interactivity by providing multimedia guides with touch screens to call up additional content (Proctor & Burton, 2004), or by automatically sensing the movement of the visitor to adapt the content to the user's route and length of time at the current location (Lonsdale, Byrne & Beale, 2005). A good introduction to interactive handheld guides is provided by *Digital Technologies and the Museum Experience: Handheld Guides and*

other Media (Tallon & Walker, 2008), including an entertaining history of audio guides.

Recent work has focused on digital mobile storytelling as a tool for learning (Jenkins, 2004; Nisi et al., 2004; Paay et al., 2008; Sprake, 2011). Properly executed, locational stories are an effective method for presenting educational history materials in an enjoyable manner (Aylett, 2006). Coherent and well-structured interactive stories can have inherent value, as interactivity helps audiences "to more intensely internalize the material" (Vorderer, 2003: 147) by laying down an episodic memory of events connected to physical locations and social experiences. Therefore, an understanding of locational storytelling can assist in the construction of successful learning materials as well as offering engaging stories in and about places.

THE MOBILIZED VISITOR

The UK design researcher Juliet Sprake considers the different kinds of relation between guide, tour and visitor, as author, text, and reader, as well as architect, building and user (Sprake, 2011). A tour is a continual work in progress, so a progressive dialogue between a (human) guide and visitors can be considered as analogous to an understanding of a text as a decentered system of language that can never be collapsed into finite meanings by an author (Barthes, 1986). Conversely, it could be argued that to give a building such as a museum a tour is to impose a limit on that building that encapsulates and closes its design. Thus, a tour is a temporally repeated point of tension between a predesigned environment and an unfolding story of its use.

The mobilized visitor is both an observer of and an actor in this tense drama. Tours comprise the visiting experience and the documentation of that experience in the form of narratives. These texts might be read by people before they visit a location, to understand its history and to plan the trip. So, even before they arrive, visitors are designated as readers of a pre-prepared text, yet they are also active producers of meaning by their actions in constructing the visit and interacting with the guide and the location. Sprake draws on the notion of 'creative users' (Hill, 2003) of a building to suggest that learning through touring can be understood through the kinds of new knowledge and experiences interactively evolved by spatiotemporal processes of touring.

Sprake (2011) proposes three attributes of the mobilized visitor as learner: stumbling upon, noticing, and connecting. Visitors stumble upon spaces in unexpected ways and in so doing create their own narratives of experience. They notice some parts of the environment in ways that are prescribed, and others in ways that create personal meaning, so that touring is an interaction between the noticer and what is noticed, where that noticing develops personal knowledge of the object. Visitors accelerate and decelerate, view

from different perspectives, and enter into conversations and juxtapositions that create cognitive and social connections.

> Designing directions and navigation activities in tours that depend on the physical mobility of participants around and between buildings opens up opportunities for learning through making imaginative associations between people, objects and places. (Sprake, 2011: 38)

A FRAMEWORK FOR DESIGN OF LOCATION-BASED NARRATIVE

Narrative is the process of combining "different heterogeneous parts (actions, events etc.) into a coherent whole and crafting the relationships between these different parts" (Yiannoutsou & Avouris, 2010: 1). The mobilized visitor weaves a personal narrative by moving around a space, by noticing, or being informed about, the artifacts at each location and by making conceptual connections between them. This narrative may align or conflict with the prepared stories presented explicitly by tour guides or implicitly by the spatial layout of a museum or heritage site.

Significant research has already been undertaken in defining the many structural forms applicable to interactive narrative, and we propose a framework (Figure 9.1) to describe interactive narratives structures based on Ryan (1997) and Phelps (1998). By matching different types of narrative structure to locations and encounters over time, curators may be able to commission interactive narratives for a combination of handheld visitor devices and museum displays that offer visitors a connected flow of experience and the perception of an unfolding story of their visit.

In our use of these structures, the nodes represent information-rich locations (where information may be presented by some combination of computer device, physical object or label) and the links denote physical movements between locations. It should be noted that the links do not indicate the physical direction of the movement, rather that two locations are connected by a user

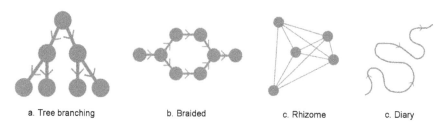

a. Tree branching b. Braided c. Rhizome c. Diary

Figure 9.1 Four types of narrative structure. a. Tree branching, b. Braided, c. Rhizome, d. Diary.

moving from the first location to the second. A story may be told explicitly at each location, or the user may create a personal narrative by connecting the pieces of information. In some cases a storytelling may continue as the user moves between locations, either to complete a story that started at a different location, or to provide a seamless continuity of telling.

The category definitions given in Figure 9.1. are not intended to be comprehensive, but they are relevant to the aim of exploring applications of different interaction structures to locational narratives in digital media. While examination of narrative structure takes prominence, it is also necessary to look at additional factors, including the extent to which these examples are digitally delivered, their stated purposes, the relationships between user and creator, and the degree of locational involvement.

Contextual factors affect, and are affected by, these structures. The entity controlling the narrative structure can at different time points be some combination of a computer-based system; or a human administrator who dynamically adapts the plot; or the user interacting with the environment and technology to start, stop and nudge the narrative. Thus, a visitor as user is both in a context (e.g., listening to an audio narrative at a specific location) and a creator of context, through interactions between personal goals, locations, artifacts, technologies, and other people (Lonsdale, Baber & Sharples, 2004).

These narrative structures can be exploited for specific educational purposes by the designers of interactive guides and experiences, depending on how they are perceived in relation to learning and technology. The structures can be seen as instances on a continuum from narrative instruction (branching) to personal story making (diary). Or they can be considered as design resources, to explore how narrative can be embedded into a museum experience that enables stories from curators, designers and artists to be interwoven with the conversations and journeys of visitors. Or they can be interpreted as functional flow diagrams for software developers to program narrative museum experiences.

Tree Branching

The tree-branching structure (Figure 9.1a) is divided into acts: From one initial act, the user is presented with a choice amongst several possible continuations. Having picked one, the user experiences that act before being presented with another choice as to which act should come next, and so on.

In moving from one act to the next, the user always progresses the narrative. The choice of acts is determined by the creator of the experience, and this determines the level of interactivity: the more branches that are available, the more interactive the story. Applied to locational narrative, a node in this tree is a piece of information accessed at a location, and a link is made by moving to another location. One direction of movement may lead down one branch of the narrative tree; another direction may follow a different branch.

Braided Multilinear

The braided multilinear experience (Figure 9.1b) comprises a core narrative that branches out into a number of plot directions; these plots then converge again and reintegrate with the core. A user may temporarily deviate from the core narrative but cannot avoid it or alter it.

The structure incorporates a traditional linear story but scattered with interactive branch elements. This gives it interactive flexibility, as the creators can control the exact number of branches and the points along the story at which they are encountered. An example would be a handheld guide where the user is directed down one physical route or another, based on the user's preference or profile, with each route creating a connected story.

Rhizome

In the rhizome structure (Figure 9.1c) all the nodes are interconnected. In theory, this can offer the user a large degree of agency: They cannot themselves define the narrative elements, but they can control which ones are included and how they are ordered. As the user moves around a physical environment and approaches a pre-prepared location, the device offers not a disconnected chunk of information, but a continuation of the narrative that is prompted by that location. This structure has similarities to a hypertext story such as the US author Michael Joyce's 'afternoon, a story' (Bolter & Joyce, 1987) where the user's choice of moves weaves a story out of elements of text and where revisiting a node may produce a different telling to the first visit. As a locational narrative, a well-designed rhizome structure may empower the user with freedom to roam between locations, yet engaged by a narrative flow that adapts to the (literal) moves and turns of the user and device. The stories of many visitors can be interwoven, so that tellings depend on paths taken by other people or how often locations have been visited.

Diary

A diary (Figure 9.1d) "capture[s] the particulars of experience" (Bolger, Davis & Rafaeli, 2003: 1). It records a chronological log of the user's activities and replays it to them. The developer of the diary application does not influence its content, but provides the tools that allow the user to generate these records. The user determines the content of each particular segment and the order in which these segments are encountered. From the perspective of location and narrative, a diary structure might be a series of objects or signs placed at locations with means for the visitor to record the experience of encountering them. A narrative might be constructed by creating fictional computer-generated characters at each location who engage in a dialogue with the user, or by encouraging users to tell and share stories of their visits using materials collected on the tour.

CASE STUDIES OF LOCATIONAL NARRATIVES

Having laid a foundation of narrative structures, we now provide some case studies of how these have been developed in practice for location-based guides, tales, and visitor experiences.

Tree Branching: A Chaotic Encounter

A Chaotic Encounter is an application, running on GPS location-aware devices, which delivers a short tree branching audio narrative whose content depends on the user's movement (FitzGerald, Sharples, Jones & Priestnall, 2011). The aim with this research prototype is for the user to hear an entertaining story, based on a Nottingham folktale, which can be played a number of times with each rendition being subtly different. For the prototype system, the tree has three levels (Figure 9.2), with three branches at each level, so from a single initial audio segment, there are three possible continuations, and then three continuations thereafter, making nine possible narratives.

The story follows a classic Exposition-Climax-Denouement sequence, but the transitions depend on the user's movement. The GPS in the device records its speed and direction, and as the system finishes playing each section of the story, its continuation depends on how often these change. If the user walks at a steady pace, then the story features few characters and is relatively mundane. If the user changes speed or direction then the story contains many characters and is more surreal. The transition from one segment to another is instant, so the user experiences a single flowing story.

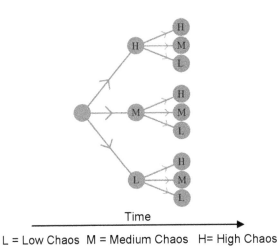

Time

L = Low Chaos M = Medium Chaos H= High Chaos

Figure 9.2 Narrative in a Chaotic Encounter (from FitzGerald, Sharples, Jones & Priestnall, 2011).

The system was tested with 10 participants in two modes: automatic and manual. In the automatic mode, the users were told that their movement had an effect on the narrative, but not how this was calculated. In the manual mode, the system did not respond to movement: At the end of each segment the audio stopped, and the user could select from one of three continuations. In each mode, the users could play the story as often as they wished. The users were interviewed at the end, and they also completed a short open-ended questionnaire to assess their attitudes to each version. The results of the trial were that the users generally preferred the automatic movement-sensitive version as it did not interrupt the story. However, the GPS was too inaccurate to give reliable information on speed and direction, which sometimes resulted in the same story being played a number of times. New 'smartphones' now contain accelerometers, and these would be more sensitive to changes in speed and direction. Over a larger physical space, a combination of GPS and accelerometer could offer tree-branching stories that change with both location and movement. The difficulty for the designer comes in creating a narrative sequence for each branch of the story. If the story had a further three levels, each with three branches, that would require 27 different story endings, a further level would need 71 new narrative sequences, and so on. For this reason, a braided multilinear structure, where the different narrative paths rejoin, would be more feasible for a longer narrative.

Braided Multilinear: Hidden Histories—to the Castle!

Hidden Histories: To the Castle! was a pilot project to investigate how visitors experienced, and learned from, two different types of historical audio tours that took place in Nottingham city center. One audio tour was led by members of a local community history group, who physically guided visitors along a planned route consisting of seven points of interest. An alternative technology-based audio tour was also created, which used a GPS-enabled smartphone application to deliver audio at the same points of interest, together with a map of the route for participants to follow (Figure 9.3).

The subject matter was the Reform Riot that occurred in Nottingham in 1831, with a core narrative that explored the background to the riot and the conditions under which it occurred, followed by a succession of events that happened during the riot itself, leading finally to the aftermath of the riot and the consequences for those involved. At each stopping point, participants in the tour listened to historical accounts (either performed in person by members of the local community history group, or through their audio recordings delivered through smartphones) related to that particular location and the relevance or importance of that location to the events in the riot. These narratives came from a variety of sources and were intended to convey different, sometimes conflicting, perspectives on aspects of the riot as they occurred.

Figure 9.3 The 'people-led' audio tour (left) and the 'technology-led' tour (right). Image © Elizabeth FitzGerald.

This project exemplifies a braided multilinear structure, where the flow of narrative is central to the experience, branches out to explore subplots or contrasting themes, then converges once more, and these side nodes are reintegrated into the core narrative. The different historical sources were analogous to subplots, where different perspectives could be compared and contrasted, such as 'official' sources (e.g., government or military reports) and eyewitness reports, which offered conflicting information about what was occurring at the time.

An initial evaluation of the project has analyzed participant data to find evidence of informal public learning, through a framework to examine how participants attained (a) historical literacy; (b) historical empathy; and (c) the development of interpretation skills when listening to differing, sometimes conflicting, historical sources (FitzGerald, 2012). Participant data were collected through the use of questionnaires (n = 16), researcher observations, and a post-walk group interview (n = 6). All participants on both audio tours showed evidence of historical literacy, and some participants demonstrated historical empathy and interpretation skills. However, it is not clear at this time to what extent other aspects of the walk (e.g., use of technology, group vs. individual experiences, the demographic and sociopolitical viewpoint of the participants) might have had an impact on participants' engagement with the historical content.

Rhizome: Context Aware Gallery Explorer (CAGE)

CAGE is an example of a rhizome structure for museum and gallery visiting. The project was an offshoot from the large MOBIlearn project (MOBIlearn, 2012), funded by the European Commission, whose aim was to explore context-sensitive approaches to informal, problem-based and workplace learning, based on innovations in mobile technology. A test site was installed

in an art gallery at Nottingham Castle to explore contextual mobile learning (see Figure 9.4). This consisted of an ultrasound system to provide accurate measurement of the location of a handheld device: an iPad multimedia personal digital assistant. The ultrasound transmitters can be seen placed on the radiators in Figure 9.4. When a visitor walked around the gallery, the technology located its position to within 10 cm and provided context-sensitive information about the paintings, based on the visitor's current location, how long he or she was standing at that location, the route he or she had taken, and specific preferences such as the visitor's language. As the visitor walked past a painting for the first time, the handheld device gave a short audio description of its title and artist. If the visitor stopped, the device offered a longer audio description. Then, if the visitor lingered for a longer period, the device provided a multimedia interaction where the visitor could see the painting on the screen of the device and click on parts of the image to get information about the painting's composition and technique.

One aim of the CAGE system was to deliver narratives through the handheld device that disrupted a visitor's procession along the line of paintings on the walls of the gallery. By indicating other paintings by the same artist

Figure 9.4 CAGE gallery explorer. Image © Mike Sharples.

or with similar composition in other parts of the gallery, the system was designed to find whether a multimedia device could encourage a visitor to make conceptual connections and conduct explorations of the gallery that would not be obvious from the physical layout of the paintings. Video and audio recordings of visitors using the guide showed that in this, the CAGE system was unsuccessful. Although some visitors glanced at paintings on the other side of the gallery when they were mentioned in the audio description, none of them actually moved across the gallery to continue their tour. It would appear that the physical design of a gallery or museum space, in this case reinforced by the long red carpet, exerts a strong linear pull that a simple suggestion to move elsewhere will not disrupt.

An alternative approach would be to design a more complex and adaptive rhizome narrative, where instead of suggesting specific connections, the visitor's movement around the gallery or museum would always progress the narrative, whatever path is taken. The example of hyperfiction (such as 'afternoon, a story') suggests that this is possible, but it would require careful design.

Where the CAGE software proved successful was in providing simple audio 'labels' that invited visitors to stop and look at paintings as they walked past, and in supporting group interactions where the multimedia commentary sparked a discussion of the painting. Although CAGE was implemented and tested in 2004, it remains one of the few indoor context-sensitive guide systems where an adaptive narrative can be generated simply by the user moving around a location.

Diary: MyArtSpace

MyArtSpace was a project that ran for a year from February 2006 in three UK venues: the Urbis museum of urban life in Manchester, the D-Day museum in Portsmouth, and the Study Gallery in Poole. Over 3,000 children engaged with the MyArtSpace service whose aim was to improve the effectiveness of school museum visits by connecting learning in classrooms and museums. The general method was for the teacher to discuss a forthcoming museum visit with the class and decide on one or more questions to be investigated. Then the children visited the museum and were loaned mobile phones running the MyArtSpace software (Figure 9.5), to create multimedia diaries of their visit that they could share and present back in the classroom.

Thus, the narrative structure for MyArtSpace is a diary created by the museum visitors on a mobile phone. The children generally worked in pairs, moving freely around the museum or gallery to collect evidence that would help them answer the inquiry question. Some exhibits had two letter codes (e.g., 'AX') beside them and on keying in the code to the phone, the MyArtSpace application provided a short multimedia presentation about the exhibit. The visitors could also take a photo, record a short voice commentary, or make a note. On pressing the 'Save' button, the presentation, photo,

Figure 9.5 Screenshots from the MyArtSpace phone application. Image © MyArt-Space Project.

recording or note, was automatically sent by GSM phone connection to a personal website, which could be accessed after the visit at home or in the classroom to see a 'timeline' record of all the items collected. These could then be viewed, shared with other children, and included in a group Power-Point presentation or a written story of the visit.

The MyArtSpace system was successful in encouraging children to spend longer engaging with the exhibits (an average of 90 minutes with MyArt-Space, compared to 20 minutes for a conventional school visit). It also encouraged the children to take a curatorial role, collecting and assessing evidence from the visit to form a narrative presentation that was not merely a record of the trip, but an attempt to address the inquiry question. For example, on a visit to the D-Day museum (which commemorates the Allied landings in Normandy during World War II), one group of children success-fully found and compared evidence to answer "Were the D-Day landings a success or failure?", while another group sought evidence for "What was the role of women during the D-Day landings?"

One difficulty with such a diary narrative structure is that the entries are contextualized. The visitor captures activity and experience at one set of times and locations, then views them at another where the contextualizing information—such as conversation, ambient sound and peripheral vision—is missing. A time-ordered list of entries can help in recapturing the particulars of experience, and this could be further assisted by showing a map of the route taken through the museum space and the points at which the items were collected or recorded. But the visitor's intentions in collecting the evi-dence are still lost, along with the original emotions and sensory experiences. A recurring theme from projects such as MyArtSpace, Ambient Wood (Rogers et al., 2004) and Savannah (Facer et al., 2004) is the difficulty in connecting experiential learning in the field with teaching back in the classroom.

More recent work in mobile learning has focused on how to create 'mi-cro-sites for learning' in the field (Vavoula & Sharples, 2009), where learn-ers can find, or be offered, the physical and conceptual space to reflect on their activity in progress, and to weave their collections and experiences into a meta narrative that links together the diary entries into a coherent strand

of interrelated evidence that addresses the inquiry question. The further the dissociation of this weaving in time and space from the original collecting of evidence, the more difficult the task becomes. Having the children work in pairs can help this process, if they are encouraged to question each other's evidence: asking why that photograph or recording is relevant to the inquiry question and whether it can be captured in a more effective form.

The company that implemented MyArtSpace has now developed it as a commercial service, named OOKL (OOKL, 2012) that promotes cultural venues and enables visitors to download information about cultural objects and events to their smartphones. The service also encourages visitors to become 'citizen curators' by capturing digital content (images and recordings) relating to objects in cultural places, which can then be submitted to the venue and shared with others who visit.

Modeling Curatorial Narratives: The DECIPHER Project

The previous case studies have described how each type of narrative structure (tree branching, braided, rhizome and diary) can be overlaid on a physical space by traversing locations of interest in an order selected by the designer, or chosen by the user, or both.

When the physical environment is a curated museum or gallery, as in the case of CAGE, the narrative produced by interacting with the handheld device has to coexist with the narrative layout of the museum space. A lack of cohesion between the two narrative structures may offer additional opportunities to the visitor, or could lead to disengagement with the technology if it suggests paths not cued in the physical space. An understanding of the narrative structure used in a museum space can inform the design of location-based assistance that is sensitive to, and extends, the physical museum.

DECIPHER is a cultural heritage project, supported by the European Commission, that aims to formally model aspects of the curatorial narrative structure built across heritage objects. This model is now being used to develop software assistance for narrative construction in a number of settings such as curation of a physical museum space, design of online museum resources, or development of handheld computer guides. The formal model has been realized as the 'curate ontology' (Mulholland et al., 2012). Development of the ontology drew on a review of the museum narrative literature and a detailed analysis of two museum exhibitions: Gabriel Metsu at the National Gallery of Ireland, and The Moderns at the Irish Museum of Modern Art. The paper by Maguire (2012) provides a full report of the analysis.

The DECIPHER project draws on structuralist accounts of films and novels to formalize interactive media narratives (Hazel, 2012) at three levels of description: story, plot and narrative discourse. A story can be defined as a conceptualization of the events that can be told. These events may be organized according to properties such as time and theme. A plot is defined as imposing an interpretation on the story in terms of relations between events,

in doing so defining which events are important and asserting dependencies between them. A narrative (or narrative discourse) is a presentation of the story and plot in a form such as a physical or digital exhibition.

At the story level, aspects of an exhibition can be understood as collections of events organized according to properties. For example, part of the Gabriel Metsu exhibition organized his works and associated events chronologically to show the development of his style during the early part of his career. The rest of the exhibition covering the later parts of his career, once his style had become established, were organized according to themes such as subject matter, and chronology was less important. At the plot level, exhibitions and their associated visitor materials often refer to relationships between events such as how the creation of an artwork was influenced by historical events or events related to the artist or their peers. The paper by Collins, Mulholland and Wolff (2012) describes plot relations identified in curatorial narratives. At the presentation level, a museum exhibition may emphasize story-level temporal or thematic properties such as the organization of art into schools and by time period (Wolff, Mulholland & Collins, 2012). Or it may focus more on the plot, for example, emphasizing how one artist was influenced by, or reacted against, the work of another. Lisa Corrin, the director of the Williams College Museum of Art in the United States, and colleagues (1997) describe how the work of Manet can be better understood if exhibited with the paintings he was reacting against rather than other impressionist paintings.

The 'curate ontology' of the DECIPHER project, with its levels of story, plot and narrative can be used to describe the four types of narrative structure (tree branching, braided, rhizome and diary) and how they reveal their underlying story and plot.

A branching structure could be realized as a narrative that emphasizes how the organizing dimensions such as time and theme can be interpreted hierarchically. For example, a component of the narrative relating a particular time or artistic movement could lead to further optional components that subdivide the time or theme. This could be understood as a more traditional, taxonomic narrative structure of a museum collection in which the visitor has the option to select greater or lesser levels of detail.

A braided narrative has a common start and end point and offers greater agency at intermediate stages. This structure is currently used in museum narratives. For example, as described in (Maguire, 2012), exhibitions may start with a primer space in which the visitor is introduced to ideas that can assist interpretation of the exhibition. The Moderns exhibition began with a primer space that introduced key concepts related to modernism. Exhibitions also often finish on a crescendo, associated, for example, with the most well-known artwork in the exhibition. Between the introductory and concluding sections, reading order may be less managed, providing a braided structure, in which the visitor can follow various aspects of the underlying story and plot.

A rhizome narrative can be understood as emphasizing the plot over the story. Here, priority is given to relations such as "influence" rather than story properties such as time. Plot relations may create a graph structure interconnecting heritage objects and their associated events. A rhizome narrative would allow the visitor to pursue these relations in any preferred way. A potential role for location-based technology in a physical museum space could be to support such plot-based navigation still sensitive to the narrative structure of the physical space. A key strand of ongoing work in the DECIPHER project is concerned with using the curate ontology to provide assistance in the construction, visualization and navigation of narratives by both curatorial staff and visitor groups.

A diary structure emphasizes the events of the story organized chronologically. For example, a narrative about the life of an artist organized by time could be interpreted as a diary narrative. In the area of narrative inquiry, the organization of events by time is referred to as a chronicle (Polkinghorne, 1998). Children in the MyArtSpace project created and shared chronicles of their museum visits to address the inquiry questions.

GUIDELINES FOR WEAVING LOCATION AND NARRATIVE FOR MOBILE GUIDES

Here we offer guidelines for designers of location-based narrative guides and experiences, based on findings from the projects reported in this chapter. The overarching need is to address the 'Interactive Dilemma' of conflict between the designer's desire for a coherent narrative flow and the user's freedom to explore a cultural venue and construct personal meaning from its space and the artifacts it contains. Every object tells a story. Every space offers multiple interpretations. Every visitor weaves a narrative. The greater the opportunity for participants to interact with their surroundings and with the technology, the more difficult it becomes to lead them through a pre-prepared story. "If interactivity is the property that makes the biggest difference between old and new media, it does not facilitate story telling" (Ryan, 2006: 99). The task for a designer of location-based narrative is to provide appropriate top-down structure, enabling the visitor as user to engage with well-formed narrative patterns that unify and interpret the visiting experience while giving a sense of freedom to explore and create.

Support the User to Create Narrative through Movement

Previous studies of multimedia guides in museums have emphasized the importance of a 'heads-up' museum experience, where the visitor is engaged with the physical artifacts rather than fiddling with a digital display (Hsi, 2003). This, of course, depends on what the display shows and whether it complements or detracts from the visiting experience. In general, the aim

should be for the technology to augment rather than replace the physical experience. One way to do that is to let the visitor weave a narrative through physical movement around the museum. The CAGE system, by tracking the user's route, allowed the user to wander, heads up, and offered simple audio prompts on passing each painting for the first time. The findings from the CAGE trials also indicated that if a visitor (or group of visitors) showed engagement with a painting, by standing in front of the painting and listening to the end of the audio description, then an interactive multimedia display could extend that engagement, by allowing parts of the painting and its composition to be explored in more depth.

Balance Structure and Freedom for Rhizome and Diary Structures

Tree and braided structures prescribe a preset narrative flow, as the user follows the directed links from one node to the next. For rhizomes and diaries the user has freedom to explore the informational and physical space, moving from any location to any other. Thus, they place demands on the user to construct a coherent story from the fragments. This finding for interactive fiction applies also to locational narrative:

> For a short work the audience may be willing to wade through all segments of a narrative in order to piece together a coherent story. For a longer work the tendency is for people to lose interest. (Phelps, 1998: 1)

A designer of a rhizome might support the user's construction of narrative by creating a structure whereby any tour produces a coherent story. But this is a hard labor, as it requires pre-plotting every combination of move between nodes (locations). For 6 locations, there are 15 possible connections, but that rapidly rises to 45 connections for 10 locations, and 190 for 20 locations, even without considering what happens if a person revisits the same location later in the narrative. Authors of hyperfiction circumvent this problem by a variety of 'cheats', such as leading the reader round in circles: having a small network of nodes but with different story text for each visit. That depends on the reader not being aware of his or her position in the story network—but for locational narratives the visitor knows very well where he or she is in the physical space of a museum or gallery. To create a coherent flowing narrative from even a medium-sized rhizome network is beyond the current state of artificial intelligence.

The alternative, for a rhizome or diary, is to provide tools for the user to construct their own narrative of the visit, by recording their tour through the space and allowing them to add notes and reflections. Then, at a later time, the tour can be replayed, so the user can re-create the visit and form the series of location-based events into a personal recollection or a public presentation. That was the structure of MyArtSpace, which provided the user with a website showing a time-ordered series of items collected during

the visit. A more sophisticated location-tracking system might also show a map with the visitor's route through the physical space.

Employ Appropriate Media and Be Sensitive to the Environment

Hidden Histories: To the Castle! made effective use of audio and historically relevant surroundings to inform the user and invoke a sense of drama. The CAGE system switched from audio to mixed media when the user stood still in front of a painting for longer than 30 seconds. Practical guidelines for effective audio experiences have been investigated in (FitzGerald, Sharples, Jones & Priestnall, 2011). They also discuss sensitivity to local surroundings such as heritage sites where local residents live, especially if visitors are encouraged to explore the area on their own. A further factor when considering movement through physical space is the need for participants to be aware of safety hazards in their immediate environment such as traffic, uneven flooring, or other people moving nearby.

CONCLUSIONS

This chapter has shown how narrative structures can influence the design and purposeful use of location-based guides for museums, galleries and heritage sites. Each structure offers a different range of possibilities: for the designer, to provide tools, media, stories and guidance that shape the activity; and for the visitor as user of the technology, to interpret stories, create narratives through action, and afterwards construct a coherent telling of the experience. A tree-branching structure can integrate the taxonomic structure of a museum collection into an unfolding story. A braided narrative can fit with the physical layout of a museum, with fixed start and end points and guided routes through the collections. A rhizome structure may allow visitors greater opportunity to create their own connections between exhibits and to intersect with the paths and stories of other visitors. A diary provides a chronological drive to explain a sequence of events or create a memorable recollection of a visit. In all these structures it is important to maintain a coherent sense of story, so the participant is not lost in a confusion of real and virtual narratives. We hope the discussion of structure for interactive narratives will lead to the design of new types of mobile guide and museum display that connect a strong narrative drive with freedom for the participants to enjoy stumbling upon, noticing, and connecting in their rich surroundings.

ACKNOWLEDGMENTS

MOBIlearn (IST-2001–37187) was funded by the EC Information Society Technologies program. MyArtSpace was funded by the UK Department for

Culture, Media and Sport through Culture Online. The DECIPHER project (270001) is funded by the EU 7th Framework Programme in the area of Digital Libraries and Digital Preservation. Hidden Histories: To the Castle! was funded by the Engineering and Physical Sciences Research Council (Towards Pervasive Media—grant number EP/H024867/1). Rob Jones's studentship is supported by the Horizon Doctoral Training Centre at the University of Nottingham (RCUK Grant No. EP/G037574/1).

REFERENCES

Barthes, R. (1986). *The rustle of language*. Oxford: Blackwell.

Bolger, N., Davis, A., & Rafaeli, E. (2003). Diary methods: Capturing life as it is lived. *Annual Review of Psychology, 54*, 579–616.

Bolter, J.D., & Joyce, M. (1987). Hypertext and creative writing. In *Proceedings of the ACM conference on Hypertext (HYPERTEXT '87)* (pp. 41–50). New York, NY: Association for Computing Machinery.

Collins, T., Mulholland, P., & Wolff, A. (2012). Web supported employment: Using object and event descriptions to facilitate storytelling online and in galleries. In *Proceedings of ACM Web Science 2012*, Northwestern University, Evanston IL, June 22–24, 2012 (pp. 104–107). New York, NY: Association for Computing Machinery.

Corrin, L.C., Kwon, M., & Bryson, N. (1997). *Mark Dion*. London: Phaidon Press.

Facer, K., Joiner, R., Stanton, D., Reid, J., Hull, R., & Kirk, D. (2004). Savannah: Mobile gaming and learning? *Journal of Computer Assisted Learning, 20*, 399–409.

FitzGerald, E. (2012). Assessing informal learning: A case study using historical audio guides. In *Proceedings of Computers and Learning Research Group (CALRG) Conference 2012, Milton Keynes, UK, June 19–20, 2012* (pp. 9–10). Milton Keynes: The Open University.

FitzGerald, E., Sharples, M., Jones, R., & Priestnall, G. (2011). Guidelines for the design of location-based audio for mobile learning. *International Journal of Mobile and Blended Learning, 3*(4), 70–85.

Hazel, P. (2008). Narrative and new media. In *Proceedings of the 5th International Narrative and Interactive Learning Environments Conference (NILE 08), Edinburgh, Scotland, August 6–8, 2008* (p. 40). Edinburgh: Heriot Watt University.

Hill, J. (2003). *Actions of architecture*. London: Routledge.

Hsi, S. (1997). *Facilitating knowledge integration in science through electronic discussion: The multimedia forum kiosk*. PhD Thesis, University of California, Berkley.

Hsi, S. (2003). A study of user experiences mediated by nomadic web content in a museum. *Journal of Computer Assisted Learning, 19*, 308–319.

Jenkins, H. (2004). Game design as narrative architecture. In N. Wardrip-Fruin & P. Harrigan (Eds.), *First person: New media as story, performance, and game* (pp. 118–130). Cambridge, MA: MIT Press.

Johnson, L., Witchey, H., Smith, R., Levine, A., & Haywood, K. (2010). *The 2010 horizon report: Museum edition*. Austin, TX: The New Media Consortium.

Lonsdale, P., Baber, C., & Sharples, M. (2004). A context awareness architecture for facilitating mobile learning. In J. Attewell & C. Savill-Smith (Eds.), *Learning with mobile devices: Research and development* (pp. 79–85). London: Learning and Skills Development Agency.

Lonsdale, P., Byrne, W., & Beale, R. (2005). Using context awareness to enhance visitor engagement in a gallery space. In *Proceedings of HCI 2005 Conference*

on *People and Computers XIX, Edinburgh, Scotland, September 5–9, 2005* (pp. 798–809). Berlin: Springer-Verlag.

Maguire, M. (2012). Museum practices report. *Public DECIPHER deliverable D2.1.1.* Retrieved from http://decipher-research.eu/documents/Decipher_deliverables/Decipher-D2.1.1-WP2-IMMA-(en)-Museum%20Practices%20Report-v07-PU.pdf

MOBIlearn (2012). *MOBIlearn project website.* Retrieved from http://www.mobilearn.org/

Mulholland, P., Wolff, A., & Collins, T. (2012). Curate and storyspace: An ontology and web-based environment for describing curatorial narratives. In E. Simperl, P. Cimiano, A. Polleres, Ó. Corcho, & V. Presutti (Eds.), *Proceedings of the semantic web: Research and applications—9th extended semantic web conference, ESWC 2012, Heraklion, Crete, Greece, May 27–31, 2012. Springer Lecture Notes in Computer Science 7295* (pp. 748–762). Berlin: Springer-Verlag.

Naismith, L., Sharples, M., & Ting, J. (2005). Evaluation of CAERUS: A context aware mobile guide. In H. van der Merwe & T. Brown (Eds.), *Mobile technology: The future of learning in your hands, mLearn 2005 book of abstracts, 4th world conference on mLearning, Cape Town, October 25–28, 2005* (p. 50). Cape Town: mLearn 2005.

Nisi, V., Wood, A., Davenport, G., & Oakley, I. (2004). HopStory: An interactive, location-based narrative distributed in time and space. In *Proceedings of the 2nd international conference on technologies for interactive digital storytelling and entertainment (TIDSE'04), Darmstadt, Germany, June 24–26* (pp. 132–141). Berlin: Springer-Verlag.

OOKL (2012). *OOKL: Love culture.* Retrieved from http://www.ooklnet.com/

Paay, J., Kjeldskov, J., Chritiensen, A., Ibsen, A., Jensen, D., Nielsen, G., & Vutborg, R. (2008). Location-based storytelling in the urban environment. In *Proceedings of the 20th Australasian conference on computer-human interaction: Designing for habitus and habitat, Cairns, QLD, Australia, December 8–12, 2008* (pp. 122–129). New York, NY: Association for Computing Machinery.

Peinado, F., & Gervas, P. (2004). Transferring game mastering laws to interactive digital storytelling. In S. Göbel, U. Spierling, A. Hoffmann, I. Iurgel, O. Schneider, J. Dechau & A. Feix (Eds.) *Proceedings of the 2nd international conference on technologies for interactive digital storytelling and entertainment (TIDSE'04), Darmstadt, Germany, June 24–26, 2004. Lecture notes in computer science, Band 3105* (pp. 48–54). Berlin: Springer-Verlag.

Phelps, K. (1998). *Story shapes for digital media.* Retrieved from http://www.glasswings.com.au/modern/shapes/

Polkinghorne, D. (1998). *Narrative knowing and the human sciences.* Albany: State University of New York Press.

Proctor, N., & Burton, J. (2004). Tate Modern multimedia tour pilots. In J. Attewell & C. Savill-Smith (Eds.), *Learning with mobile devices: Research and development* (pp. 127–130). London: Learning and Skills Development Agency.

Rogers, Y., Price, S., Fitzpatrick, G., Fleck, R., Harris, E., Smith, H., & Weal, M. (2004). Ambient wood: Designing new forms of digital augmentation for learning outdoors. In *Proceedings of the 2004 conference on interaction design and children: Building a community (IDC 2004)* (pp. 3–10). New York, NY: Association for Computing Machinery.

Ryan, M. (1997). Interactive drama: Narrativity in a highly interactive environment. *Modern fiction studies, 43*(3), 677–707.

Ryan, M. (2006). *Avatars of story.* Minneapolis: University of Minnesota Press.

Sprake, J. (2011). *Learning-through-touring: Mobilising learners and touring technologies to creatively explore the built environment.* Rotterdam: Sense Publishers.

Tallon, L. (2008). Introduction: Mobile, digital, and personal. In L. Tallon & K. Walker (Eds.), *Digital technologies and the museum experience: Handheld guides and other media* (pp. xiii–xxv). Lanham, MD: AltaMira Press.

Tallon, L., & Walker, K. (2008). *Digital technologies and the museum experience: Handheld guides and other media*. Lanham, MD: AltaMira Press.

Vavoula, G., & Sharples, M. (2009). Meeting the challenges in evaluating mobile learning: A 3-level evaluation framework. *International Journal of Mobile and Blended Learning, 1*(2), 54–75.

Vorderer, P. (2003). Entertainment theory. In J. Bryant, D. R. Roskos-Ewoldsen, & J. Cantor (Eds.), *Communication and emotion: Essays in honor of Dolf Zillman* (pp. 131–153). New Jersey, NY: Lawrence Erlbaum Associates.

Wapping Audio (2012). *Wapping audio tour: History*. Retrieved from http://www.wappingaudio.org/?page=history

Wolff, A., Mulholland, P., & Collins, T. (2012). Storyspace: A story-driven approach for creating museum narratives. To be published in *Proceedings of hypertext 2012, 23rd ACM conference on hypertext and social media, Milwaukee, WI, June 25–28, 2012*. New York, NY: Association for Computing Machinery.

Yatani, K., Onuma, M., Sugimoto, M., & Kusunoki, F. (2004). Musex: A system for supporting children's collaborative learning in a museum with PDAs. *Systems and Computers in Japan, 35*(14), 773–782.

Yiannoutsou, N., & Avouris, N. (2010). Reflections on use of location-based playful narratives for learning. In *Proceedings of the international conference for mobile learning 2010, Porto, Portugal, March 19–21, 2010* (pp. 149–156). Porto, Portugal: IADIS.

Zimmerman, E. (2004). Narrative, interactivity, play, and games: Four naughty concepts in need of discipline. In N. Wardrip-Fruin & P. Harrigan (Eds.), *First person: New media as story, performance, and game* (pp. 154–164). Cambridge, MA: MIT Press.

10 New Voices in the Museum Space
An Essay on the Communicative Museum

Bruno Ingemann

There are many objects in museums. In cultural history museums these objects carry great significance, but this significance does not emanate immediately from the objects themselves, because they have been produced and used in everyday life and not in order to be looked at in a museum (Baxandall, 1991). Objects in a cultural history museum demand an explanation, an insertion of the object into a context of other objects—and especially some form of explanatory anchorage. Such anchorage can both take the form of verbal text, or be photographs or sound, moving images or smells. In the cultural history museum, it is natural and necessary to work with the context in order to 'anchor' the objects, as Roland Barthes has formulated it, as a way to create one or more narratives from the relations between the different textual forms and the things (Barthes, 1977).

This focus on communicating objects emerges from the learning potentials that the objects in the cultural history museum possess, but which can be quite hard to release. In this respect the art museum is quite different. The art museum has a very different point of departure, namely, things, objects, works of art that have been produced in order to express and communicate something. Art objects have a clear sender: first, the artist; and secondly the museum and the curator. Sometimes this sequence is reversed so that it becomes the curator and the museum who assume the role of authoritative communicator-sender, while the artists with their works become a more contributory actor.

In the cultural history museum the objects can be used to tell many—and many different—stories; they can be inscribed into fascinating cultural and political contexts. In the art museum the emphasis traditionally turns out to lie on, well, art history itself.

These different communicative traditions in cultural history museums and art museums become visible when they are broken, and it is precisely in such communicative 'fault lines' that one can observe how the differences manifest themselves (Mirzoeff, 1999).

This chapter presents a case from the world of art museums that can be used to illuminate the fault lines in the communicative practices of the art museum, in order to invite a more general discussion about how fixed

communicative traditions can be broken and how new voices can find their way into the art museum space.

MARIKO MORI AND THE RINGS

In 2007 the Danish art museum Aros in the city of Aarhus showed a special exhibition of works by the Japanese artist Mariko Mori. Titled *Oneness*, the exhibition showed almost all the main works by Mariko Mori from the last 10 years and also included the most recent works from her.

As a visitor, when you enter the exhibition you are already influenced by the many mass-communicated pictures of interactive ufo-like sculptures and the humorous and uncanny blue alien figures. As a visitor, you build expectations of something very futuristic and technological that is at the same time frightening, playful, and poetic.

Next thing, there I am in a big empty white room, looking at a huge photo-on-glass in a light box (3 meters high, 6 meters wide)—a white space with a color photograph of a wood with the afternoon light coming from above, creating flickering shadows on the slim tree trunks (Figure 10.1). But apparently it is not quite just a photograph of a wood; the light and the shadows are somewhat out of sync—there is something artificial about the natural wood. This artificiality is underlined by layers of other pictures that have been manipulated into the photograph of the wood. One layer consists of powerfully

Figure 10.1 The author's drawing of Mariko Mori's giant light box with the manipulated photograph of the forest, of herself in three different roles, and with added building constructions with historical connotations. In order to see the work *Kumano, 1997–1998*, it is necessary to alternate between a distanced look and a close-up look, which enables the process of discovery in the work and promotes a kind of serene, meditative feeling.

colored building constructions, the other layer shows female figures that are toning into or out of the wood motif and the building constructions.

To the left, the building constructions look like something old—maybe a bridge, strongly red, mirrored into the forest floor, which is transformed into water. To the right there is a luminous blue house construction in a computer-generated style of drawing.

The three female figures are floating across the wood picture and are more or less transparent; they create a movement from the left and forward in the picture. They are evidently Japanese in their clothing and hair style, and are photographs of the same woman (Mariko Mori, presumably) playing different roles. One can read the title of the picture: *Kumano, 1997–1998* (Figure 10.2).

Presumably this is a rather typical experience of this work of art, supported by a fairly rudimentary communication consisting of very factual information guiding the visitor toward some good questions to work with in the interpretation of the work and oneself.

But then there is a 'fault line'! Inside the white room with the black floor there is something unusual. On the black floor are painted the silver rings,

Figure 10.2 An ideational sketch of the room with the three silver rings. When the user enters one of the silver rings, a sound is activated, which is transmitted from a directional loudspeaker placed many meters above the user. The sound lasts for 2–3 minutes. In this way the user is 'locked' in a position in which the work is observed for longer than what is normally the case, and in which an atmosphere and information are added that support the viewer's look at the vast surface of the picture.

three or four meters from the light box on the wall, which is a good viewing distance. The diameter of the three silver rings is approximately 40 centimeters. Your first reaction is to walk around the rings, because you are in an art museum, and what are you supposed to do with those silver rings? On second thought, they look fascinating and you feel you must step into one of the rings. Then comes the surprise: From somewhere above your head, a loudspeaker emits the gentle, ingratiating voice of a woman speaking English with a typical Japanese accent. She said:

> In 1997 I went to the Kumano forest to reach the Nachi Waterfall. I walked for twelve hours and on my way I had a series of magical and supernatural experiences which I portrayed in the picture *Kumano*. (Oneness: Mariko Mori, p. 22)

After two to three minutes the speech stopped, and I proceeded to the second ring, and the third, and learned a lot, about the mirror as a cultural symbol; about how her hairstyle in the picture is inspired both by Buddhism and Chinese emperors; about the Buddhist *Yumedono Temple*, which she first meets in a dream where she is walking in the forest and meets this temple with a golden room.

Here it is not the curator who performs the role of communicator. Here the visitor experiences that it is the artist herself who wishes to draw nearer to the visitor and add something to the work of art that extends it through her talking in her own voice about the artistic process, about the cultural symbols she uses and about the work itself. This is an exciting and surprising breach of traditional museum communication, which is thereby extended and changes the experience of the work of art.

CURATOR, ARTIST, USER

Irrespective of whether it is the curator or the artist who performs the role of communicator, then the underlying intention is the same: It is the expert who shows or convinces the less-experienced user about that which she finds important, about that which in a manner of speaking should be 'learnt'. This perception of learning is in many ways problematic—even if it is always sympathetic if the communicative process opens toward the user, instead of exclusively serving to define the user—as if the user ought to obtain the same knowledge and the same interest in art history as the curator or the artist herself (see, for instance, the Ten Dilemmas Professionals Face, in Ingemann, 2012, p. 353–360).

In art museums it would be possible to have the user much more in mind. When I consistently talk about 'the user', it is in order to underline the active co-creative capability, which the user ought to have in the exhibition. The visitor, the spectator, the guest—these are words that have other and more

passive connotations and which are in contrast to the user. As a user, one seeks knowledge; one seeks emotional experiences; one seeks cultural, religious and societal values; and one seeks an opportunity to get involved bodily in the museum experience (this idea is elaborated in Gjedde & Ingemann, 2008, pp. 115–120).

As a user one has the power to do as one likes—but it is the exhibition, the curator, the museum who create the framework of the extent to which the users are able to activate knowledge, emotions, values and body in the concrete encounter with an exhibition.

We can take our point of departure in the particular communicative form from Aros with the three silver rings and try to expand this concept and make it more involving for the users. Let us imagine that we have a work like *Kumano*. If the users are to be more involved, especially emotionally and bodily, it is not sufficient to have them stand in a silver circle and listen to a voice and then proceed to another silver circle and listen to another voice. They must become the voice. They must have the opportunity and the responsibility for creating an entirely new and never-heard-before sound, which can be used in one of the three loudspeakers over the three silver circles.

In this way the users become active communicative participants in the interpretation of the specific work of art. Such an opportunity to participate in in a creative process presupposes two things: First, some kind of limitation must be set up, which is a general requirement of creative processes. Secondly, the creative process must be scaffolded, that is, supported by people and materials that can help solve practical problems (Simon, 2010, p. 22).

The most important limitation is *time*: Users must produce a sound creation whose duration is no longer than two minutes. Interested users may collaborate about adding a sound creation to the work of art—finding a sound that produces a particular atmosphere; designing a sound of their own; remixing a sound; speaking a sound; interviewing a sound; reading a text aloud; etc.

The other limitation is *place*: The sound produced by the users must be brought back to the exhibition to be placed in front of the work for which it was intended. The sound produced must thus incorporate a kind of responsibility toward future users who will stand in front of the work, activate this particular sound, and hopefully expand their experience of the work.

A third limitation is *interval*: The concrete user-created sounds will continuously be replaced by sounds created by new users who will create and also hear *their* sound in connection with the work.

If a museum decides to engage in this kind of participatory activity, it must be scaffolded by making available different sorts of user-friendly media production equipment: A sound archive, microphones, 'instruments' for sound production, as well as professional pedagogical assistants who can be part of the creative process and ensure the feasibility of the sound production process.

THIS IS NOT ART

If a museum wishes to involve the users more actively in art experiences and learning, this means giving up some of its authority and making space for the users' bodily, emotional and knowledge-related competences, which are necessary in order to enable them to express their values and feelings in relation to the museums' works of art.

It is not sufficient to just add or superimpose some kind of user activity to the existing exhibition mind frame. If the museum wishes to be taken seriously by active users, the whole curatorial process is affected. From the very beginning of an exhibition, it must be designed in a way that genuinely incorporates the user's activity as voices in the exhibition space. This will often entail that the communicative professionals among the museum staff must be moved up front in the design process, and that the scholarly curators must take one step back.

Unavoidably this also entails organizational changes in the way museums produce exhibitions. The purpose is not to get users to produce art, but to involve them in dialogical processes in which they will be personally and culturally challenged and produce new insights. The art museum must set up a space of possibilities to be taken over by the users, whose ultimate use of this space is beyond the museum's control. This space of possibilities should be conceptualized and designed so as to emphasize the creative experiential frames, which is it the business of art museums to afford.

REFERENCES

Barthes, R. (1977). Rhetoric of the image. In S. Heath (Ed.), *Image, music, text* (pp. 32–51). New York, NY: Hill & Wang.

Baxandall, M. (1991). Exhibiting intention: Some preconditions of the visual display of culturally purposeful objects. In I. Karp & S.D. Lavine (Eds.), *Exhibiting cultures: The poetics and politics of museum display* (pp. 31–41). Washington, DC: Smithsonian Institution Press.

Gjedde, L., & Ingemann, B. (2008). *Researching experiences: Exploring processual and experimental methods in cultural analysis.* Newcastle: Cambridge Scholars Publishing.

Ingemann, B. (2012). *Present on site: Transforming exhibitions and museums.* Lejre, Denmark: Visual Memory Press.

Mirzoeff. N. (1999). *An introduction to visual culture.* London: Routledge.

Oneness: Mariko Mori (n.d.). Aarhus, Denmark: Aros.

Simon, N. (2010). *The participatory museum.* Santa Cruz, NM: Museum 2.0.

Contributors

Elizabeth FitzGerald, PhD, is a Research Fellow at the Institute of Educational Technology (IET) at the Open University, pursuing a program of interdisciplinary research into mobile and location-based learning. The research combines ubiquitous computing, usability and interaction design with education and pedagogy. Her current research focuses on the use of audio guides for location-based learning and effective visitor experiences; she is also examining the potential for geolocated user-generated content to provide ad hoc informal learning opportunities.

Monika Hagedorn-Saupe studied mathematics, sociology, psychology, and adult education in Bochum, London and Berlin. Since 1994, she is head of the department Visitor-Related Museum Research and Museum Statistics at the Institute for Museum Research in Berlin, Germany; she is Deputy Director of the Institute and is responsible for several European projects. Professor Hagedorn-Saupe teaches museology at the Hochschule für Technik und Wirtschaft in Berlin. She chairs the Special Interest Group on Documentation at the German Museum Association and the Museum Information Centres Group of CIDOC, the documentation committee of the International Council of Museums, ICOM. She is a member of the European Membership Expert Group on Digitization of Cultural Heritage. Currently she is a board member of the German Museum Association, and she represents ICOM-Europe at the Europeana Foundation Board.

Glynda Hull is Professor of Education in Language, Literacy, and Culture at the University of California, Berkeley. Her research examines digital technologies and new literacies, after school as a space for learning, community/school/university partnerships, and global schools. Most recently, with support from the Spencer Foundation, she developed a social network (space2cre8.com) and associated off-line programs to study cross-linguistic, cross-cultural, and cross-geographic communication and learning among youth in several countries. A recipient of UC Berkeley's Distinguished Teaching Award, Hull has taught undergraduate, graduate, and teacher education courses on literacy teaching, learning, and research in and out of school.

Bruno Ingemann, PhD, trained as a graphic designer and is an emeritus Associate Professor in Visual Communication at Roskilde University. His research currently focuses on three areas: Photography focused on memory of the mirror and how readers relate to the surface of reality; museology in the more narrow sense—focused on the reception of exhibitions and the visitors' creation of meaning from their experiences; and experimental reception studies focused on developing new methods of observing the observer. His most recent books in English are *Researching experiences: Exploring processual and experimental methods in cultural analysis* (Cambridge Scholars Publishing, 2008, coauthor Lisa Gjedde) and *Present on site: Transforming exhibitions and museums* (Visual Memory Press, 2012).

Robert Jones is a student at the Horizon Doctoral Training Centre in Nottingham, United Kingdom, whose research interests coalesce around issues of digital storytelling. He is particularly intrigued in the relationship between cognition and narrative engagement, and especially the role that interactivity plays in affecting the user's cognitive conception of story. Additional research interests include the relationship between spatial movement and knowledge, and the analysis of discourse in video games.

Lorenz Kampschulte studied micro- and nanotechnology at the University of Applied Sciences in Munich, Germany, and gained his PhD in Nanotechnology at Ludwig-Maximilians-University, Munich in 2007. He started working at the Deutsches Museum in 2006, and since 2009 he is head of the Center for New Technologies and curator for Nano- and Biosciences. Faced with communicating highly complex topics, he gained experience hands-on inside the museum, as well as in several research projects like the Special Priority Program 'Science and the Public: Understanding Fragile and Conflicting Evidence', funded by the German Research Foundation (DFG).

Lynda Kelly, PhD, is Manager of Online, Editing and Audience Research at the Australian Museum, Sydney. She has published widely in museum evaluation and the impact of social media/Web 2.0 on contemporary museum practice. She is particularly interested in visitor experiences and learning and how these can be measured, young children's learning, online and mobile learning as well as the strategic uses of audience research and new technologies in organizational change. Lynda is happily obsessed with all things Web 2.0 and curious to see how this will change the world that museums operate within and the ways people learn. Lynda is also the Director of Museum3, a not-for-profit social network site for museum professionals, with an active, global membership of over 3,000. In 2007 she completed her PhD in museum learning and visitor identities,

and in 2010 released *Hot topics, public culture, museums* (University of Western Sydney, coeditor Fiona Cameron).

Karen Knutson is Associate Director of UPCLOSE (University of Pittsburgh Center for Learning in Out of School Environments). Her interests include understanding visitor learning and organizational practices in museums, and the ways in which academic disciplines are designed and enacted in informal learning environments. She was a coeditor of *Learning conversations in museums* (Routledge, 2002) and was coauthor of *Listening in on museum conversations* (AltaMira Press, 2004), and has published articles in *Studies in Art Education, Curator, Science Education, Visitor Studies*, and the *Journal of Museum Education.*

Sten Ludvigsen is Professor at InterMedia, University of Oslo, Norway. He received his PhD based on a study of learning in medical institutions (1998). He is educated in education psychology and has specialized in research on the uses of digital learning resources and the relationship between colocated and distributed settings, in the educational sector and in the workplace setting. He leads the specialized PhD program in learning, communication and ICT at the Faculty of Education at the University of Oslo. He is involved in PhD training and supervision. Ludvigsen leads the national research school in educational science NATED, funded by the Norwegian Research Council 2008–2016.

Randi Marselis is Associate Professor at the Institute for the Study of Culture at the University of Southern Denmark. Her research interests include ethnic relations, media and museums in multiethnic societies with special focus on Denmark and the Netherlands. The aim of her current research is to examine the role of the web in the remediation of migration memories and heritage. She has published on these issues in *MedieKultur* (2011) and *Social Semiotics* (forthcoming).

Pam Meecham has worked as an art educator since 1971 and is currently a Reader in Museum and Gallery Studies at the Institute of Education, University of London. She is course leader for the MA in Museum and Galleries in Education and has a number of doctoral students working on aspects of museum studies. She lectures and publishes on a wide range of art historical and education subjects. Most recently she published 'Strangely delivered by pyrates: Illustration and the national curriculum' for Addison and Burgess (2012). In 2009 she cowrote with Julie Sheldon *Making American art* and in 2005 a second edition of *Modern Art: A critical introduction.* Her research interests include investigating old and new technologies and their relationship to museum cultures. In particular she is interested in paintings and their surrogates and the interaction between traditional museum displays, such as the diorama; and digital interventions.

Paul Mulholland, PhD, is a Research Fellow in the Knowledge Media Institute, The Open University. His research interests include technology-enhanced learning, digital narrative and knowledge visualization. He has been an investigator on a number of international and UK research projects in which he has been involved in the design, development and testing of learning technologies in formal education, museum and work contexts. He is currently an investigator on the EU-supported DECIPHER project, developing technologies to support the construction and use of museum narratives.

Annette Noschka-Roos studied educational science with the main emphasis on communication studies at Freiburg University of Education (PH), Germany. Subsequently she worked at the Deutsches Museum in Munich, Germany, where she also performed her doctoral studies on visitor research and visitor-oriented exhibitions relating to intelligible exhibit labels. Since receiving her doctoral degree, Professor Noschka-Roos has worked for several institutions, including the Institute for Museum Research SMB-PK in Berlin, Germany; and the Haus der Geschichte in Bonn (House of the History of the Federal Republic of Germany). Since 2006 she has been head of the Education Department of the Deutsches Museum and conducts research in the field of museum education at the nexus of empirical educational research and museology.

Ross Parry is Academic Director and Senior Lecturer in the School of Museum Studies at the University of Leicester. He is a founding trustee of the Jodi Mattes Trust (for accessible digital culture), is a Tate Research Fellow, and was previously national chair of the Museums Computer Group. His book *Recoding the museum: Digital heritage and the technologies of change* (2007) was the first major history of museum computing. His edited volume *Museums in a digital age* (2010) has helped define the curriculum and subject space of 'digital heritage' as an area of study and practice.

Palmyre Pierroux is Associate Professor at InterMedia, University of Oslo, Norway. Pierroux received her PhD in education psychology and has an undergraduate and professional background in art history, design, and architecture. Her research focuses on meaning making in museums and other semiformal learning contexts, and on the role of new media and technologies in different aspects of knowledge production. She leads the nationally funded CONTACT project (2009–2013), which explores the design and use of multitouch surfaces, social media, ubiquitous computing, and mobile personal technologies for meaning making in different museum settings.

Laura Maria Schütze is a PhD Fellow at the Department of Cross-Cultural and Regional Studies, University of Copenhagen, Denmark, and coresearcher

of a research project on alternative spaces where she studies the role of place, identity and religion in the displays of immigration at the Museum of Copenhagen and the Danish Immigration Museum, both located in Denmark. Her research interests include museums, identity, migration, memory and religion. She has published on these issues in the journal *Chaos: Dansk-norsk tidsskrift for religionshistoriske studier* (2008) and in an edited volume *Civilreligion i Danmark* (eds. M. Warburg, S. E. Larsen and L. M. Schütze, forthcoming).

John Scott is a doctoral student in Language, Literacy, and Culture at the University of California Berkeley. A former public school teacher in New York City, he has a Master's Degree in Special Education from Brooklyn College, and has worked with the Hull Research Group for the past three years, where he has served as the teacher-researcher on the Space2cre8 project in New York and currently in Oakland, CA. Scott has also worked as an adjunct at New York University's Steinhardt School of Education, Society and Culture, where he taught preservice English teachers. He is an exhibited artist whose works include paintings, community murals, and digital videos. His research explores new media technologies, aesthetics, global education, new literacies, and critical pedagogy.

Mike Sharples is Professor of Educational Technology in the Institute of Educational Technology at the Open University, UK. His research involves human-centered design of new technologies for learning. Recent projects include the Wolfson OpenScience Laboratory, the Personal Inquiry project developing inquiry science learning with mobile devices and a collaboration with Sharp Labs Europe to design mobile technologies for language learning. He is the author of over 200 papers in the areas of educational technology, science education, human-centered design of personal technologies, artificial intelligence and cognitive science.

Index

Note: page numbers with *f* indicate figures.